Latinx Photography in the United States

Latinx Photography in the United States

A VISUAL HISTORY

Elizabeth Ferrer

University of Washington Press

SEATTLE

Latinx Photography in the United States was supported by a grant from the Jacob Lawrence Endowment, established through the generosity of Jacob Lawrence, Gwendolyn Knight, and other donors.

This book was made possible in part by a grant from Furthermore, a program of the J. M. Kaplan Fund.

Publication of this book has been aided by a grant from the Wyeth Foundation for American Art Publication Fund of CAA.

Additional support was provided by a generous gift from Alida and Christopher Latham.

Cover and interior design by Katrina Noble
Composed in Calluna, typeface designed by Jos Buivenga
Cover photograph and frontispiece: Max Aguilera-Hellweg, *The Lovers*, 1989. Courtesy of the artist.

24 23 22 21 20 5 4 3 2 1

Printed and bound in China

UNIVERSITY OF WASHINGTON PRESS
uwapress.uw.edu

LIBRARY OF CONGRESS CONTROL NUMBER: 2020932708
978-0-295-74762-0 (hardcover), 978-0-295-74763-7 (paperback), 978-0-295-74764-4 (ebook)

The paper used in this publication is acid free and meets the minimum requirements of American National Standard for Information Sciences—Permanence of Paper for Printed Library Materials, ANSI z39.48-1984.∞

Dedicated to the memory of my father, Benjamin Estrada

Contents

Preface

The impetus for this book is derived from a basic fact: by and large, Latinx photographers are excluded from the documented record of the history of American photography. And yet they have been highly active practitioners of the medium, nearly since its inception in 1839. *Latinx Photography in the United States* focuses on Latinx photographic artists, primarily those who have been active since the late 1960s—the same period when the photographic medium gained broad acceptance as an art form and when civil rights movements among people of color were in full flourish. It also offers an introduction to a small number of figures in the latter part of the nineteenth and first half of the twentieth centuries active as studio or itinerant portraitists, photojournalists, and documentarians. These photographers represent ethnic groups that together now constitute some 52 million people and nearly 18 percent of the population of the United States.[1] The great majority discussed here are members of the largest Latinx populations in the United States, whose lineage descends from Mexico, Puerto Rico, and Cuba. Reflecting the growth and evolution of the Latinx community, this study also includes photographers residing in the United States whose family heritage is rooted in the Dominican Republic and in Central and South American countries.

The classification of artists or any individual as "Latinx" can be fraught with issues. This gender-neutral term is itself not universally embraced, but I adopt it here as an inclusive, forward-looking term because of its growing usage and as a means of recognizing gender diversity within our communities.[2] For purposes of this publication, I define a Latinx person as one who resides in the United States and whose family roots can be traced to a Spanish-speaking

country in the Americas. Although some may use the conventional ethnonyms *Latinx* (or *Latino*) and *Hispanic* interchangeably, I reject the latter term, which came into common usage after it was introduced in the 1970 United States Census, because of its inaccurate and colonialist emphasis on the Spanish ancestry of people whose heritage is in fact multiracial, and can often include indigenous American and African blood. In contrast, the traditional *Latino* is a shortened form of the Spanish *latinoamericano*, or person from a Latin American country. Nevertheless, it must be recognized that both *Hispanic* and *Latino* have acted as umbrella terms for vast and diverse populations. Some of us are from families that have been in the United States for many generations; others are newcomers. While many Latinx individuals suffer from inadequate levels of education and income, those representing second, third, and even older generations are typically members of the middle and professional classes. Some primarily speak Spanish; others have never spoken any other language but English.

We also embody vast regional differences. Mexican Americans (traditionally based in the Southwest but now living throughout the United States), Puerto Ricans (traditionally in the Northeast), and Cuban Americans (primarily in Florida) each have their own histories, traditions, and challenges. Even among Mexican Americans, there are nuanced differences between, say, urban dwellers in Los Angeles or San Francisco and rural dwellers living near the border in Arizona or Texas. As historian Vicki Ruiz states, "there is not a single hermetic Mexican or Mexican-American culture, but rather, permeable cultures rooted in generation, gender, and region, class, and personal experience."[3] The same is true of Puerto Ricans and Cuban Americans, whose presence in the United States spans several generations. While the Puerto Rican population is traditionally understood as centered in New York and parts of New Jersey, its demographics are changing rapidly—especially after Hurricane Maria in 2017, whose catastrophic effects began a migration of thousands from ruined homes and lost jobs to new lives in Central Florida, New York, and other stateside locales.

There are also issues related to nomenclature—we refer to ourselves in a multiplicity of ways. Many prefer such "hyphenated" terms as *Mexican American* or *Cuban American*, suggesting a dual allegiance to one's familial country of origin and to the United States. But newer arrivals often refer to themselves

only by their native country—*soy cubana, soy mexicano*. Particularly with the rise of the civil rights movement, many Mexican Americans, mostly those who were younger and politically aware, began to refer to themselves as Chicanos, a term of political awareness and of self-determination. Similarly, Puerto Ricans may refer to themselves as *Boricuas* (referring to Borinquen, the indigenous Taíno name for Puerto Rico), or in New York, which has the largest Puerto Rican population stateside, as *Nuyoricans*.

While the *Latinx* ethnonym is, indeed, an imperfect term to define people of highly varied cultural and social backgrounds, interests, and political perspectives, it is nonetheless valuable to consider the cultural production of these groups in tandem because of the many elements that bind us. They include, above all, the legacy of Spanish colonialism, which imposed the Spanish language, Roman Catholicism, and European institutional forms in the Americas. Colonization also gave rise to nineteenth-century struggles for independence and resistance to Eurocentric culture. We also share complex, bicultural outlooks, histories of immigration, and experiences with social, political, and economic marginalization. This latter fact has acted as a motivating force for photographers (and artists in general working with varied media) to work purposefully, driven by a deep sense of social and political commitment. But to complicate matters, among artists, while many fully engage in the discourse on Latinx culture in the United States, others stridently reject ethnic categorizations of their work, underscoring that they act as individuals, not as representatives of any particular group.

The work of each figure profiled in *Latinx Photography in the United States* is informed by a unique set of circumstances and ideals whose variety demonstrates that there is no monolithic category of "Latinx photography" (or more broadly, "Latinx art"), just as there is no singular mindset to be ascribed to Mexican Americans, Puerto Ricans, Cuban Americans, and other Latinx groups (and artists) across the United States. I offer this study of Latinx photographers to create recognition of their achievements, and with the hope that their oeuvres will be seen as integral to American photography and to critical discourses on the medium. *Latinx Photography in the United States* profiles the work of some eighty photographers; many other figures are also noted briefly as part of the historical record. My aim has been to present a comprehensive study that includes both well- and lesser-known photographers, the latter

category underscoring the fact that many Latinx photographers, particularly those of earlier generations, lacked the benefit of institutional support, collectors, or other support systems that help advance careers and preserve legacies. I used multiple criteria in selecting photographers for inclusion, focusing on those whose work has made significant creative contributions and who have dedicated their lives to working with the medium. A number have had sustained records of exhibitions in nationally recognized institutions and publications—figures like Laura Aguilar, Don Gregorio Antón, Louis Carlos Bernal, Harry Gamboa Jr., María Martínez Cañas, Delilah Montoya, Abelardo Morell, and Kathy Vargas. Others have had lengthy careers but remain known primarily in their communities. While I have focused on established photographers, I also include some younger figures whose innovative work represents new directions for the medium. I have striven to include as many historic photographers as possible to help fill gaps in our understanding of the scope of contributions made by Latinx individuals to the medium; nevertheless, more specialized research will surely uncover others. And while this study is meant to be comprehensive, it is not exhaustive, although I have briefly noted some photographers whose work is not illustrated. In addition, a few prominent figures that have worked with the photographic medium are excluded because they do not define themselves primarily as photographers, or out of respect for their desire that their work not be contextualized within an ethnic framework. The work of a handful of Latinx photographers discussed here could not be illustrated, but they are included because of their significant contributions to the history of American photography

My own consciousness of Latinx photography came belatedly and somewhat indirectly, after many years of working on exhibitions and publications focused on art and photography in Mexico. In 1993 I curated *A Shadow Born of Earth: New Photography in Mexico*, a major traveling exhibition that introduced a generation of young Mexican photographers beyond their country's borders. The first comprehensive survey of contemporary Mexican photography presented in the United States, *A Shadow Born of Earth* traveled to venues in many regions of the country in the mid-1990s, a period when Mexican art was enjoying a wave of interest in the United States and was the subject of several high-profile museum exhibitions. The new attention to Mexican art began earlier that decade, with the Metropolitan Museum of Art's 1990 blockbuster

exhibition *Mexico: Splendors of Thirty Centuries*. On the heels of the success of this exhibition (decidedly more popular than critical), cultural institutions throughout the country organized exhibitions and events to commemorate the 1992 Columbus Quincentennial. Attention was also being directed to Latin American art more broadly, exemplified by the landmark 1993 exhibition organized by the Museum of Modern Art in New York, *Latin American Artists of the Twentieth Century*. Significantly, courses and graduate programs in Latin American art began to appear in academic programs, training a generation of art historians and curators who have produced over the last two decades an extraordinary body of groundbreaking scholarship, often via exhibitions, of art from the Spanish-speaking Americas. Nevertheless, recognition of *Latinx* art, created by those of Latin American descent living in the United States, lagged. Appreciation for these artists remained largely within their own communities, even as curators, critics, and art historians were becoming more globally attuned.

Even if art by Latinx creators was little visible in mainstream museums and major commercial galleries, it was being seen, primarily in alternative spaces, many founded by artists to serve their own communities. Many such institutions were established in the late 1960s, including El Museo del Barrio in New York, Galería de la Raza in San Francisco, and Self Help Graphics & Art in Los Angeles; spaces like Mexic-Arte Museum in Austin, the National Museum of Mexican Art in Chicago (founded as the Mexican Fine Arts Center Museum), and the Mexican Museum in San Francisco came later, in the 1970s.[4] By the late 1980s, Latinx art gained greater visibility through major survey shows that were coming into vogue, like the 1987 *Hispanic Art in the United States: Thirty Contemporary Painters and Sculptors*, organized by the Museum of Fine Arts, Houston, and *The Latin American Spirit: Art and Artists in the United States, 1920–1970*, by the Bronx Museum of the Arts in 1988. Not all of these exhibitions were warmly received by the Latinx art community, especially *Hispanic Artists in the United States*, curated by two nonspecialists, Jane Livingston and John Beardsley, in an effort to increase awareness of Hispanic art among mainstream (i.e., white) audiences. The nationally traveling exhibition was criticized for understating the centrality of socially and politically driven art while privileging conventional artistic media like painting and sculpture, as well as the folkloric and stereotypical themes.[5]

One exhibition, however, provided a crucially needed model for introducing the work of Latinx artists to broader audiences within the context of a major, mainstream institution. *Chicano Art: Resistance and Affirmation, 1965–1985* was curated by a team of scholars who were specialists in Chicanx art, drawn from throughout the United States. Organized by the UCLA Wight Gallery in Los Angeles and inaugurated there in 1990, it then traveled to nine venues across the country, exposing Chicanx art to the largest and most diverse audience ever. This exhibition was a foundational influence for me, particularly because of the rigorous research and scholarship that went into its realization. It also underscored for me the need for more research, more publications, and more exhibitions. Despite the rich bibliographical record that existed even then, there is much that remains to be studied, documented, and seen, and much that could be lost if it is not recognized and preserved.

By the first decade of the twenty-first century, this situation had begun to change in part because the sheer number of exceptionally talented Latinx artists throughout the United States could no longer be ignored by the broader art world, especially one that was finally becoming attuned to socially engaged art. It is now common to see the work of Latinx artists in such major exhibitions as the Whitney Biennial and in major art fairs. One high-profile project, the 2017 Pacific Standard Time: LA/LA, a major initiative of the Getty Foundation in collaboration with numerous arts organizations in Southern California, represented a long overdue coming-of-age for Latinx artists. Comprising programs and exhibitions (many of which later traveled to other US venues) at over sixty museums and other cultural institutions, Pacific Standard Time brought national critical attention and broad public exposure to numerous Latinx artists. Despite these advances, the work of Latinx *photographers* has been vastly understudied and underappreciated.[6]

The scant awareness of Latinx photographers is in great part due, simply, to lack of exposure. There has been no single book on Latinx photography, no comprehensive museum exhibition, and to the best of my knowledge, no college-level course on the subject taught in the art history departments of American colleges or universities. Among the first exhibitions of work by Chicanx photographers in the United States was one focusing on photographers based in Los Angeles, *L.A. Iluminado*, curated by Glenna Avila and held in 1991 at the Otis/Parsons Gallery. Including eight photographers, primarily those

working with a documentary or "straight" mode, it proposed that communities—especially those viewed unsympathetically—must be portrayed and interpreted from within.[7] An exhibition with a more national scope, *From the West: Chicano Narrative Photography*, was presented by the Mexican Museum in San Francisco in 1995.[8] It brought together bodies of work by Robert Buitrón, Harry Gamboa Jr., Miguel Gandert, Delilah Montoya, and Kathy Vargas, all figures discussed in *Latinx Photography in the United States.* Curated by UCLA professor Chon Noriega, the exhibition sought to insert a Chicanx perspective into concepts of the American West—a region that plays a central role in American historical mythologies and in the history of American photography.

On the East Coast, En Foco, a photographers organization founded in New York in 1974, organized some of the first exhibitions of Nuyorican photographers beginning in the mid-1970s.[9] More recently, an exhibition curated by Dr. E. Carmen Ramos and presented at the Smithsonian American Art Museum in 2017, *Down These Mean Streets: Community and Place in Urban Photography*, focused on street photography from the 1960s to the present day by ten photographers, including several discussed in this book.[10]

In 1994, FotoFest, a Houston-based organization that biennially organizes the largest festival of photography in the United States, mounted a groundbreaking exhibition, *American Voices: Latino Photographers in the United States*. It was curated by a team of four individuals drawn from the Chicanx/Mexican American, Puerto Rican, and Cuban American communities. *American Voices* contained the work of thirty-eight photographers, many of whom are discussed in this book.[11] This was an ambitious effort, the first large-scale exhibition surveying Latinx photographers throughout the United States, primarily focusing on figures active in the 1980s and 1990s. A portion of *FotoFest '94*, the catalog of the organization's Fifth International Festival of Photography, was dedicated to *American Voices*, but a planned larger publication was never realized. FotoFest invited me to write an essay for that publication, and my research and conversations with the photographers for that project sparked my interest in pursuing this more comprehensive investigation, one that delves further back into history while also presenting a broader selection of photographers at work since the civil rights era.

In the 1990s I became active with the organization En Foco, founded in 1974 by a group of New York–based Puerto Rican photographers that included Charles

Biasiny-Rivera, Roger Cabán, and Phil Dante, among others. The photographers were producing work focusing on their own communities but had little opportunity to exhibit it, lacking access to mainstream cultural and media outlets. In its early years En Foco was a true grassroots organization that displayed photographers' work at summer block parties in the South Bronx, in neighborhood bodegas, and in coffeehouses. It also offered photography instruction and visual literacy courses in elementary schools in the South Bronx, then among the city's most beleaguered neighborhoods. The organization eventually broadened its programmatic scope beyond local Puerto Rican photographers to support photographers of African American, Asian American, Latin American, and Native American heritage throughout the United States. It also launched a magazine, *Nueva Luz*, established an annual competition to fund new bodies of work by photographers, and developed a permanent collection, the only one of its kind in the United States.[12] Through these activities, En Foco nurtured the careers of many Puerto Rican photographers in New York, David Gonzalez, Perla de León, Frank Gimpaya, and Sophie Rivera among them.

The establishment of En Foco was timely. In 1970 photographer Bruce Davidson (b. 1933) published *East 100th Street*, a book documenting a single poverty-stricken Harlem block that became the basis for a widely seen and discussed exhibition mounted at the Museum of Modern Art that same year.[13] Davidson chronicled everyday life in what was then one of the most impoverished neighborhoods in New York, at a time when the city was in a deep fiscal crisis and experiencing record levels of poverty and crime. He spent two years getting to know the people of East 100th Street and aimed to provide an in-depth, sympathetic study of urban poverty. His process, working slowly with a large-view camera set on a tripod, process was opposite that of the stealth photographer who works out of sight to capture snippets of life in a setting foreign to him. Davidson did not mean to exploit, but regardless of his intentions, he arrived in East Harlem as a person of privilege.[14] As critic A. D. Coleman wrote in 1970, "In the context of East Harlem, Davidson is inarguably not only an outsider, but an alien. He is neither black nor Puerto Rican, but white; he may, like the block's residents, 'love and hate' this ghetto, but unlike them, he has the option of leaving."[15]

In response to Davidson's MoMA exhibition, photographer Phil Dante (1934–2004), a cofounder of En Foco, wrote an opinion piece published in

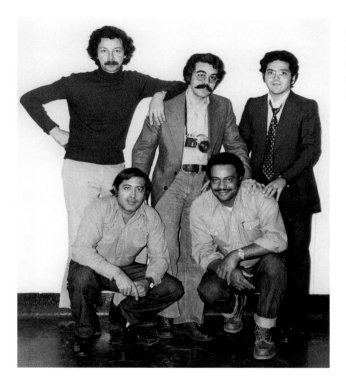

P.1. The founders of En Foco, ca. 1974. (*left to right, standing*) Charles Biasiny-Rivera, Roger Cabán, George Malave. (*kneeling*) Phil Dante, Nestor Cortijo. Courtesy of En Foco..

the *New York Times*. He criticized Davidson's many portrayals of the residents of East 100th Street in "garbage-strewn lots, rat-infested yards, bars, in their homes and in their beds." Dante continued, "Where is our soul? Where is the celebration of our love of life? The fire of our passion? The force of our artistry? . . . Why are the photographs so painfully absent of dignity, of decency?" Dante called Davidson's preoccupation with the vile a damaging, one-sided oversimplification, concluding, "'East 100th Street' is an essay so contrived and demeaning that it can in no way endure as an art—unless it is the function of art to desecrate."[16]

In these same years, there were also photographers of color at work in Spanish Harlem, Brooklyn, and other neighborhoods who represented a true local voice but whose work never had the exposure of Davidson's. In fact, one criticism A. D. Coleman leveled in his review of *East 100th Street* was that the Museum of Modern Art had never devoted a solo exhibition to a nonwhite photographer. MoMA was not alone in its ignorance. In 1969 the Metropolitan

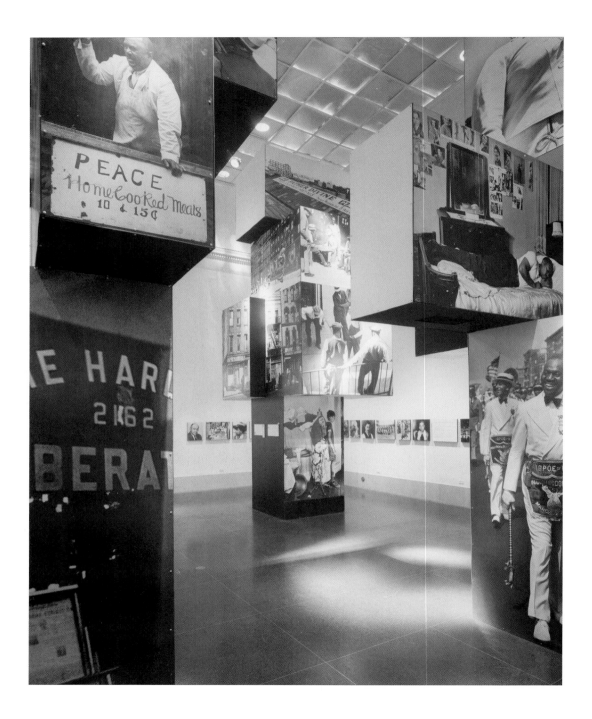

Museum of Art presented *Harlem on My Mind: Cultural Capital of Black America, 1900–1968*, a multimedia exhibition meant to illuminate the richness of New York's historic Harlem community and to promote harmony during a period of racial tension. The exhibition included over two thousand photographs, many printed as large photo murals (including some by African American photographers James Van der Zee and Gordon Parks), advertisements and other ephemera, recorded street sounds and music, and other documentation and texts that charted the evolution of Harlem through periods of vibrancy and decline. What was absent was the participation of the Harlem community in the planning of the project and, with the exception of the aforementioned photo murals, work authored by Black artists in the exhibition itself.[17]

The backlash against *Harlem on My Mind* was fierce, particularly from African American artists who protested their exclusion from the Met's galleries, and from art critics who did not know what to make of a sociological presentation of a community within the context of an elite art museum. The Black Emergency Cultural Coalition, founded by artist Benny Andrews, demonstrated against the Met, eventually leading to an apology by then director Thomas Hoving and a promise of an exhibition of contemporary African American art, which materialized some seven years later. *Harlem on My Mind* became a painful cautionary tale for American museums and led, over time, to the hiring of Black curators, including by the Met, and to the greater inclusion of Black artists in museum exhibitions in New York and beyond.

The Latinx community was even more invisible in museums and other cultural institutions in the 1960s and 1970s. But when represented in mainstream media, stereotypes abounded, exemplified by a 1967 article in *Time* magazine, "Pocho's Progress," about the state of the Mexican American community in the United States. The article painted a picture of "bleak barrios," "tar-paper colonias," and Mexican Americans who spoke "only Spanish or just enough English to deal with cops and employers."[18] The authors and photographers responsible for such essays were invariably white and outsiders. En Foco aimed to redress this inequity. Eager for outlets to show their work,

P.2. *Harlem on My Mind: Cultural Capital of Black America, 1900–1968*, Metropolitan Museum of Art, special exhibition galleries, January 18–April 6, 1969. © The Metropolitan Museum of Art. Image source: Art Resource, New York.

these photographers created their own, even if it was in borrowed or improvised spaces. And because these spaces were usually in the photographers' own neighborhoods, their local audiences had opportunities to see—for the first time—positive representations of a world close at hand. As the photographer/subject relationship shifted from outsider/insider to insider/insider, the photograph became less an ethnographic document than an autonomous and self-validating form of individual and community expression. As En Foco grew and continued to work with new generations of emerging photographers, it remained unique in the value it placed on fostering a sense of community among photographers who are linked in their understanding of the cultural, social, and political power a photographic image can possess.

My involvement with En Foco came by way of my curatorial work with Mexican photography. In 1996 the organization invited me to act as guest curator for an issue of *Nueva Luz* dedicated to the Mexican photographer Mariana Yampolsky (1925–2002). I later helped organize exhibitions and regularly reviewed the work of emerging photographers at their portfolio review meetings. Through my participation in these activities I met numerous photographers, young and old, and saw much work that simply was not reaching the audiences it deserved. Essentially none of these photographers were able to make a living through photography, so their daytime hours were consumed with teaching or office jobs while their creative work was squeezed into a few precious hours each week. I've seen photographers who have grown frustrated, devoting decades to careers that have been difficult to sustain. Indeed, only a handful of Latinx photographers are represented by major photography galleries in the United States and regularly sell their work. They include Abelardo Morell, María Martínez Cañas, and Andres Serrano, but beyond these few names, Latinx photographers have been largely excluded from the commercial gallery system, another reason why their work is little seen and appreciated and collected.[19]

What has also become clear to me as I've investigated Latinx photography is the near complete omission of older practitioners from the historical record. Inadequately studied and absent from standard texts on American photography, the oeuvres of earlier generations comprise what has been a great, unwritten history. The visual records that do exist are scattered, preserved in libraries, archives, museums, and historical societies small and large. But

much is clearly lost. Perhaps one of the richest veins of work can be found in old family collections, stored away in photo albums, shoeboxes, and today, in the digital realm.

It is high time, therefore, to recognize all of these voices—Latinx photographers in the Southwest, Chicago, Florida, the Northeast, and points in between, and both historic and living figures. It is also high time to appreciate these bodies of work as essential contributions to the visual history of this nation. In sum, this work reflects important dimensions of *American* identity and creativity; its omission limits our understanding of the art we call American. This book, then, offers a parallel history of photography in the United States, one that must no longer be seen at the margins.

Acknowledgments

I wish to express my immense gratitude to the many individuals and institutions that provided me with assistance and support throughout the long process of writing this book. First and foremost, I am grateful to all of the photographers who enthusiastically embraced this project and generously shared information and images. I also give special thanks to friends and colleagues who provided support and advice: Bill Aguado, director, and Miriam Romais, former director, En Foco, the Bronx, New York; Don Gregorio Antón, San Miguel de Allende, Mexico; Gil Cardenas, professor of sociology and founding director, Institute for Latino Studies, Notre Dame University, South Bend, Indiana; Armando Cristeto, Mexico City; Arlene Dávila, professor, founding director of the Latinx Project, and director of Latino Studies, New York University, New York; Ann ffolliott; David Gonzalez, journalist and photographer, *New York Times*; Joseph Wolin, critic, New York; and Tomás Ybarra-Frausto, preeminent scholar of Chicanx art. The curators responsible for *American Voices: Latino Photographers in the United States*, the first (and only) comprehensive exhibition dedicated to this subject and presented at FotoFest '94 in Houston, provided me with an introduction to many of the photographers included in this book. Many thanks to guest curators and photographers Charles Biasiny-Rivera, Robert Buitrón, Kathy Vargas, Ricardo Viera, FotoFest founders Wendy Watriss and Fred Baldwin, and Marta Sanchez Philippe for sharing information and ideas.

Thanks also to the many individuals who aided me with information and assistance in securing images for this book: Katrina and Lisa Brethour Bernal; LeRoy Chatfield; Jason Espada, San Francisco; Richard and Patricia Estrada, Los

Angeles; Scherezade Garcia, artist, Brooklyn, New York; Ryoko Gelpi, Brooklyn, New York; Xaviera Flores, librarian and archivist, UCLA Chicano Studies Research Center, Los Angeles; Dixie Guerrero; Marcela Guerrero, assistant curator, Whitney Museum of American Art, New York; Luis Gutierrez, San Juan, Puerto Rico; Susana Torruella Leval, New York; Miguel Luciano, artist, New York; France Mazin, Paris, France; Holly McHugh, the Felix Gonzalez-Torres Foundation, New York; Jim Moore, New York; Nelson Rivera, art historian, Puerto Rico; Pilar Tompkins Rivas, former director, Vincent Price Museum, East Los Angeles College, Monterey Park, California; Guadalupe Rosales, Veteranas and Rucas, Los Angeles; Jeremy Rowe, New York and Mesa, Arizona; Patricia Ruiz Healy, San Antonio and New York; Spencer Throckmorton and Norberto Rivera, Throckmorton Fine Art, New York; Esperanza Valverde, Los Angeles; Susan Sutton, Gallery Wendi Norris, San Francisco; Christopher Velasco, Laura Aguilar Trust, Los Angeles; Betty Wilde-Biasiny; Lindsay Dumas Wittwer, archivist, Center for Puerto Rican Studies, Hunter College, City University of New York; and Lizeth Zepeda, Arizona Historical Society, Tucson.

I am grateful to BRIC in Brooklyn, New York, for the sabbatical provided me during a critical period of writing; special thanks to its president during that period, Leslie G. Schultz.

Publication grants for this project were generously provided by the Wyeth Foundation for American Art Publication Grant, administered by the College Art Association, and by Furthermore, a philanthropic program of the J. M. Kaplan Fund.

I could not have completed this project without the able assistance and dedication of Sasha Anais So-Som Cordingley, New York.

I have deeply appreciated the time and dedication of the staff of the University of Washington Press in recognizing the importance of this history and bringing this publication to fruition. Special thanks to Larin McLaughlin, editor in chief; Hanni Jalil, assistant editor and Mellon University Press Diversity Fellow; Julie Van Pelt, project editor; and Beth Fuget, grants and digital projects.

Above all, I thank my husband, Gil Ferrer, and daughter, Allegra Ferrer, for their abiding support and love.

Latinx Photography in the United States

1

Roots and Antecedents, 1840–1960s

I N THE 2013 *ENCYCLOPEDIA OF LATINO CULTURE*, THE entry on Latino photography by Dolores Rivas Bahti begins with a broad survey of key nineteenth-century figures in Mexican photography, including Romualdo García, Agustín Víctor Casasola, and Hugo Brehme. The first Latinx figure discussed is the Arizona-born Louis Carlos Bernal (1941–93), who emerged as a photographer in the late 1970s. The entry then briefly discusses José Galvez, the first Mexican American photojournalist on the staff of the *Los Angeles Times*, Cecilia Arboleda, a Colombian-born photographer based in Florida, and a handful of other figures. It does not, however, even suggest the existence of Latinx photographers prior to the civil rights era of the 1960s.[1] Indeed, the history of nineteenth-century photography in Mexico is much better documented than that of Mexican American and other Latinx practitioners north of the border. Much of this early history—likely modest to begin with—has been lost, either never preserved or simply overlooked thanks to the frequency with which workaday photographs were published uncredited or with only the stamp of a studio, not of an individual photographer. And yet Latinx individuals have been active in photography since the

mid-nineteenth century. A few are surveyed here, representing figures in a history still to be discovered and documented.

The life of perhaps the very first Latinx photographer, **Epifania "Fanny" de Guadalupe Vallejo**, spans California's status as a territory of Mexico as well as its admission to the Union. Vallejo was born in 1835 in the Mission San Francisco Solano in Sonoma, California, to wealthy landowners Mariano Guadalupe Vallejo and Francisca María Felipa Benicia Carrillo Vallejo. Her father was Comandante General of Alta California, as the region was known while it was a possession of Spain and then of Mexico, making her a child of privilege. The family ranch in the Sonoma Valley encompassed some 175,000 acres of fertile land. Fanny enjoyed a level of education highly unusual for girls in this era; she was taught by private tutors, and her father, author of a history of California, maintained a library of some twelve thousand volumes. At the age of twelve in 1847, just before Mexico ceded California (and a large swath of the American West) to the United States, Fanny came into possession of a daguerreotype camera. Less than a decade after the invention of the photographic medium, Fanny Vallejo learned how to use the camera and made one of the first daguerreotype images in the state of California. Photographs by Fanny Vallejo are scarce, but she photographed both her father and her mother. It is believed that Mariano Vallejo wore a ring with a daguerreotype portrait Fanny made of his wife.[2] Little else is known about her involvement with photography; she may have given it up when she married Captain John Blackman Frisbie at age fifteen. The couple moved to San Francisco and later to Mexico. Fanny died of pneumonia in Cuautla, Mexico, in 1905.

Fanny Vallejo's handful of surviving images represent not only some of the earliest examples of photography in California but also the earliest instance of photography by a Latina. An essentially unknown figure, Fanny is emblematic of episodes and individuals in the history of American photography who have been ignored and are largely forgotten.[3]

Among the earliest documented Latinx photographers in California was Joseph James Vasconcellos, born in 1838 or 1839 in Madeira, in the San Joaquin Valley, and active in the mining town of Big Oak Flat around 1860. In that year, the United States census listed Vasconcellos as a "Daguerrean Artist." He may have also established a photography business in San Francisco in the mid-1860s.[4] Essentially nothing else is known about this photographer, but he is noted here

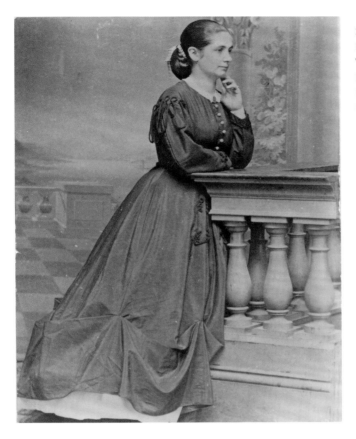

1.1. Portrait of Fanny Vallejo Frisbie, ca. 1865. Collection of Vallejo (General M. G.) Family Members and Descendants Photograph Collection. Courtesy of UC Berkeley, Bancroft Library.

as being among the earliest Latinx photographers. Others of this period, documented in the landmark study by Peter E. Palmquist and Thomas R. Kailbourn, *Pioneer Photographers of the Far West: A Biographical Dictionary*, include Felix Ochoa, active in San Francisco in 1862, and the Mexican Amado Palma, a Daguerrean in Mexico in the 1850s who advertised to visiting American clients and who later operated in the United States (location and dates unknown).

More information is known about **Adolfo Rodrigo**, who visited Arizona from Los Angeles in 1870 and established the Rodrigo Photographic Parlor in Tucson in 1874. The city's first permanent photography studio, it operated until 1875, when Rodrigo sold the business to Henry Buehman, a young German immigrant who had worked in the studio.[5] Little information exists about the Rodrigo Photographic Parlor, but a local newspaper, the *Citizen*,

reported that on September 9, 1875, Rodrigo and photographer Dudley Flanders would make a five-week excursion to San Carlos and Camp Apache "to take views of improvements and scenery." The California-based Flanders had already traveled through the Arizona Territory (it would not become a state until 1912), documenting an inhospitable landscape that was the subject of growing interest thanks to photographs of the Grand Canyon produced during the 1871 Wheeler and Powell survey expeditions. Rodrigo and Flanders traveled to San Carlos, some 120 miles north of Tucson, where they made portraits of General George Crook, military head of Arizona, as well as of the local Indian agents. They also visited an Apache reservation, photographing Apache chiefs Diablo and Casadora. At the conclusion of the trip Flanders returned to California, where he created and marketed stereographs of images marked with the title "A Photographic Album of a Trip Through Arizona by Flanders and Penlon," crediting one of his earlier collaborators.[6] Rodrigo's erasure from the historical record is presumably commonplace.

Mexicans and Mexican Americans also worked in the portrait studios that sprung up in towns throughout the Southwest as populations grew in the late nineteenth and early twentieth centuries. Their names and locations, and generally nothing more, can be found in directories and encyclopedias of early photography.[7] Better known, and instructive to this study, are the portrait studios that burgeoned in Mexican cities and small towns beginning in the mid-nineteenth century. They served affluent and working-class people alike, and many posed their subjects before elaborate, hand-painted backgrounds that provided artful settings for the auspicious occasion of having one's portrait made. Similar studios were common in barrio neighborhoods of cities like San Antonio, El Paso, and Los Angeles well into the twentieth century.[8]

One such studio photographer was **Jesús Murillo** (b. 1895, Morelia, Michoacán; d. 1971, Galveston, Texas), who studied art and architecture as a boy and was trained as a photographer before he migrated to Texas during the Mexican Revolution. Once in the United States, Murillo was employed by photo studios in Laredo, San Antonio, and Waco before he settled in Houston in 1920. There, he worked for the Shirley Studio and eventually opened his own firm, the Murillo Studio in downtown Houston and later in Galveston. In Houston, he specialized in portraits of actors and dancers who performed at theaters that served the growing Spanish-speaking population residing near the city's

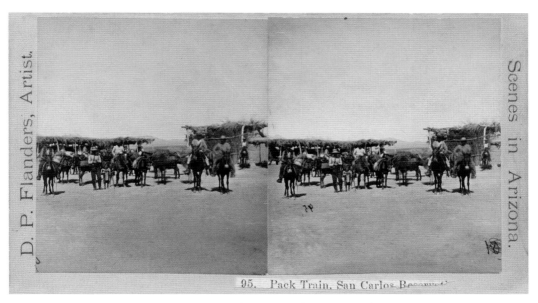

1.2. Jeremy Rowe, postcard, pack train for excursion from Tucson to San Carlos Reservation. Stereograph of the photographic party, including Dudley Flanders and Adolpho Rodrigo, taken at San Carlos Reservation, Arizona Territory, by Dudley P. Flanders, ca. summer 1874. © Collection of Jeremy Rowe Vintage Photography, http://vintagephoto.com. Courtesy of the artist.

downtown. Murillo also worked outdoors, documenting the construction of new buildings in a developing downtown Houston. Although much of his work was lost or destroyed over time by hurricanes and floods, the Houston Metropolitan Research Center of the Houston Public Library maintains a collection of his work.[9]

A handful of nineteenth-century Cuban immigrants in the United States also figure in the early history of Latinx photography. In the field of portrait photography, among the best known is José María Mora (1850 [or 1846?]–1926), a celebrated figure in his day. Born in Spain and raised in Cuba, Mora came to New York in the 1860s. He studied theater photography under the leading late-nineteenth-century American theater portraitist, Napoleon Sarony (1821–96). Working in Sarony's lower Manhattan studio, Mora retouched photos and gained expertise in hand-coloring prints and in posing and lighting sitters. In

1870 Mora opened his own studio at 707 Broadway in Greenwich Village and became Sarony's chief rival for the celebrity trade. He aimed to infuse his portraits with creativity and drama, posing the actors and musical performers who came to his studio in front of his collection of over 150 backdrops, many of which Mora painted himself. Mora dressed his subjects with hats, scarves, and other accessories and worked adeptly with natural light and shadow to create dramatic imagery. Tragically, he died a recluse living alone in a hotel room, worn down by family and legal troubles.[10]

Another Cuban American, Antonio Moreno (active in the 1880s and 1890s), was inspired by Mora's success and opened a studio on 14th Street in Manhattan, where he became known for celebrity portraits and for the cloud effects in his painted backgrounds. In the 1890s Moreno produced a series of genre scenes featuring female models that were published as cabinet cards. Moreno was also a technical innovator, mastering new printing techniques as they were introduced.

Of a subsequent generation, Cuban-born photojournalist Justo A. Martí (1920–90) began his career in the mid-1940s as a studio photographer based in Brooklyn. He went on to work for New York's principal Spanish-language paper, *El Diario La Prensa*, and was most active from the 1950s to 1970s. Martí documented the Puerto Rican and Latinx community in New York during an important period of growth—the post–World War II era when Puerto Ricans were arriving in the city in record numbers, drawn by an economic boom and the availability of jobs. His rich archive includes scenes of Fidel Castro in New York, celebrities and athletes, political protests at Rockefeller Center against the Dominican dictator Rafael Trujillo, beauty pageants, Puerto Rican Day parades, and everyday neighborhood businesses like laundromats and bodegas—the

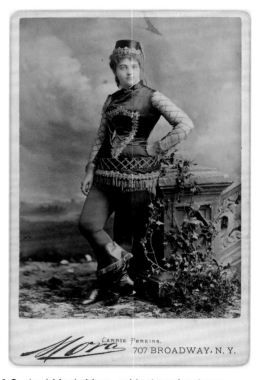

1.3. José María Mora, cabinet card, actress Carrie Perkins in burlesque, undated. Collection of the author.

latter photographs made for owners who needed to submit them for state liquor licenses. Although unseen outside their publication in *El Diario*, Martí's work stands as strong testament to the diversity and vitality of Latinx life in New York at midcentury, in opposition to the negative portrayals of this community that were more commonly seen in these years.[11]

In the mid-twentieth century a handful of pioneering photographers gained recognition for bodies of work ranging from documentary to architectural photography and portraiture. While these photographers were little aware of one another, their work acts as important testimony to the existence of Latinx photographers in an era when the creative contributions of Latinx individuals in the United States were largely overlooked.[12]

John Candelario (b. 1916, Santa Fe, New Mexico; d. 1993), a seventh-generation New Mexican, would have considered himself Hispanic, as those who trace their ancestry to the region's Spanish colonizers of the late sixteenth century are known.[13] While this background places him outside the strict scope of this study, he is included here as singular figure known for a body of work made primarily in the late 1930s and 1940s focusing on the people and customs of New Mexico. Candelario took up photography while running a curio shop

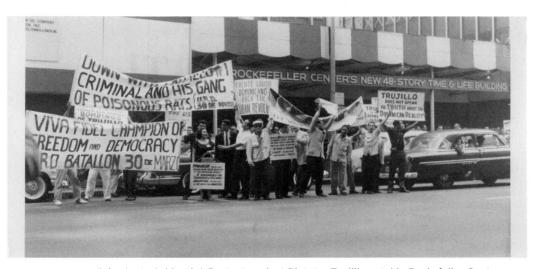

1.4. Justo A. Martí, *A Protest against Dictator Trujillo outside Rockefeller Center*, Justo A. Martí Photographic Collection, 1948–85. Courtesy of the Center for Puerto Rican Studies Library & Archives, Hunter College, CUNY.

1.5. John Candelario, *Unidentified Woman at Descanso Site, New Mexico*, ca. 1930–40. Courtesy of the Palace of the Governors Photo Archives (NMHM/DCA), 165857.

in Santa Fe that he inherited from his grandfather, where he came upon a 4×5 Graflex camera. He soon turned to 35mm cameras and, with a modicum of training, began to photograph the life around him. Candelario, who moved in the orbit of such photographers as Ansel Adams, Laura Gilpin, and Edward Weston, approached his work with a modernist sensibility. He also met Georgia O'Keeffe, who introduced his work to her then husband, Alfred Stieglitz, leading to exhibitions of Candelario's work at Stieglitz's gallery in New York, An American Place, and at the Museum of Modern Art in 1944.

Candelario was drawn to the small New Mexican towns where Hispanic influence dominated, places like Chimayó, Truchas, and Las Trampas, where he had an easy familiarity with the people he encountered.[14] He photographed

artisans at work, members of the Pueblo community inside their homes, rural church interiors and old adobe buildings, and the magnificent landscape that drew so many artists and photographers to the region in that era. Candelario worked hard at the technical aspects of photography and became known as a master printer. At the same time, under the sway of modernist photography with its emphasis on sharp focus and the use of filters to dramatize the open New Mexican sky, he created a classic body of work that reveals both an artistry and the deep respect he held for his native culture. Candelario's career was relatively brief but successful: in addition to his solo exhibition at the Museum of Modern Art, he photographed for such magazines as *Life* and *Look* before he turned to filmmaking.

A singular figure among Latinx photographers is **Pedro Guerrero** (b. 1917, Casa Grande, Arizona; d. 2012, Florence, Arizona), who has become broadly recognized for his iconic documentation of modern architecture and art. Guerrero grew up in a racially segregated Arizona and left the state in 1937 to study photography in Los Angeles. He returned two years later and sought out Frank Lloyd Wright, recently established in Scottsdale, where he built his winter home and school, Taliesin West. Guerrero showed the architect his portfolio, and Wright not only hired him but made him his exclusive photographer until Wright's death in 1959. Working with a large-format 4 × 5 camera, Guerrero documented the full range of the architect's projects over the course of two decades—Usonian houses and larger, commissioned residences; churches; commercial buildings; and the building and activities of Taliesin West. He also made many portraits of Wright and chronicled the day-to-day work of Wright's apprentices at their drafting tables and at construction sites. Guerrero not only fell in love with modern architecture but also became gifted at capturing the forms of buildings in relation to the landscape.

Pedro Guerrero eventually settled on the East Coast and became a sought-after photographer by such iconic midcentury architects as Philip Johnson, Eero Saarinen, and Marcel Breuer, as well as by artists Louise Nevelson and Alexander Calder. Guerrero had an enormous gift for interpreting the work of others; he understood how best to convey the sculptural form of modern buildings and the expressive qualities of three-dimensional, abstract art. At the same time, Guerrero was a talented street photographer. Among his lesser-known bodies

1.6. Pedro E. Guerrero, *United Church of Rowayton*, Rowayton, Connecticut (Joseph P. Salerno, architect), 1962. Silver gelatin print, 16 × 20 in. © Estate of Pedro E. Guerrero.

of work are street scenes made in the 1940s, depicting New York as a crowded working-class city with a vibrant street life.

Among the most cosmopolitan of Cuban photographers working in New York, **Jesse Fernández** (b. 1925, Havana, Cuba; d. 1986, Paris, France) spent his childhood in Cuba until his family left for Spain to escape the dictatorship of Gerardo Machado. The family was again uprooted as a result of the Spanish Civil War, and he returned to Cuba as an adolescent. There, he studied painting. Fernández came to the United States in 1942 with the intent of studying engineering. Instead, he enrolled at the Art Students League, where he took classes with George Grosz and Preston Dickinson. Fernández's period in the city, and his artistic formation, were marked by the friendships he developed with an international group of artists associated with surrealism—Wifredo Lam, Marcel Duchamp, Esteban Francés, and Frederick John Kiesler among

1.7. Jesse A. Fernández, New York, 1950s. Courtesy of the Estate of Jesse A. Fernández, Collection of France Mazin Fernandez.

them. Fernández turned to photography in the early 1950s. He had moved to Medellín, Colombia, to work for an advertising firm, and during this period he made a notable early body of ethnographic work in the Amazonian region of the country. "Photography," he stated, "became a form of contact with reality. This is where I developed my own technique. I didn't know anything about photography . . . but I locked myself up with tons of books and I learnt. I am highly purist and I was influenced by Henri Cartier-Bresson and Walker Evans."[15] After he returned to New York in 1957, Fernández worked for such leading publications as *Life*, *Time*, the *Herald Tribune*, and *Paris Match.* He became known as an astute recorder of mid-twentieth-century Latin American intellectual and cultural life, producing classic portraits in black and white of such notable figures as Lam, Cantinflas, Jorge Luis Borges, and Guillermo Cabrera Infante. He also photographed street life wherever he traveled, capturing memorable scenes of myriad aspects of life in Guatemala, Cuba, the United States, Europe, and Asia. In addition to his work as a photographer, Fernández was also a gifted painter, art editor, and educator.

2

The Rise of a Latinx Consciousness in American Photography, 1960s–1980s

West Coast

Latinx people have a long history of political activism in the United States, beginning with union activities in support of agricultural workers in California at the turn of the twentieth century, an initiative that continued sporadically in the Southwest over the next few decades. In the mid-1940s, Mexican Americans and Puerto Ricans successfully sued several school districts in California, challenging racial segregation practices. Similarly, in 1954, the Supreme Court's decision in *Hernandez v. Texas* struck down discrimination based on class and ethnic distinctions. Such efforts anticipated a broader, more sustained civil rights movement on both the West and East Coasts in the 1960s.

The Chicano civil rights movement coalesced around Cesar Chavez (1927–93), a migrant farmworker in California who became a community organizer in 1952 and who cofounded the National Farmworkers Association (later renamed the United Farm Workers, or UFW) with Dolores Huerta a decade later. Chavez and Huerta led an arduous but ultimately successful struggle to gain union representation and to improve the pay and working conditions of agricultural workers in Central California. Ultimately, the organization and its activities became the focal point for a broader social justice movement led by Mexican Americans, a populace that was rapidly growing in the 1960s and that had long suffered the effects of racial discrimination.

By the end of that decade, increasing numbers of politically aware Mexican Americans, particularly students, began to refer to themselves as Chicanos, a politically charged, self-defining, and self-legitimizing designation. Motivated by Chavez's activities on behalf of farmworkers, newly formed activist groups in California and throughout the Southwest organized to protest a long history of racism and to address numerous issues facing their communities—substandard schools, limited economic opportunity and high levels of poverty, inadequate political representation, police brutality, and a draft system that led to a disproportionately large number of Mexican American men serving (and dying) in the Vietnam War.[1]

Concomitantly, new expressions of ethnic and cultural pride flourished in the late 1960s in barrio communities of Los Angeles, San Francisco, San Antonio, and other cities with large Mexican American populations. The most visible public manifestations were the vibrant outdoor murals painted along the walls of public buildings, housing projects, schools, and local businesses. Typically depicting heroes of the Mexican Revolution, deities and symbols evoking the pre-Hispanic roots of the Mexican people, and the Virgin of Guadalupe—the patron saint of Mexico—the murals were the work of a new generation of socially and politically committed young artists who aimed to instill cultural pride and to reflect the traditions, values, and concerns of their communities. Often created collaboratively, these works articulated the ethos of a nascent Chicanx cultural movement, which became one of the most significant and distinctive art movements of the second half of the twentieth century.

This movement also included the Teatro Campesino, founded by playwright Luis Valdez in 1965 in Delano, California. The cultural arm of the UFW, Valdez

and his troupe staged plays on flatbed trucks parked in fields for audiences of migrant worker families. Artists also organized classes and community service projects; for example, the Royal Chicano Air Force, an art collective founded in Sacramento in 1970, operated a free breakfast program for children and offered art classes and vocational classes in such topics as auto repair while also organizing community projects.[2]

The earliest photographic reflections of the new Chicanx cultural consciousness can be found in the extensive visual documentation of the activities of the United Farm Workers. Chavez's work and UFW activities in the 1960s and early 1970s were extensively chronicled by Chicanx and non-Chicanx

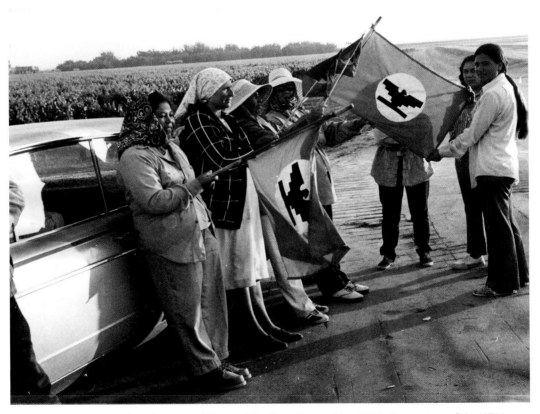

2.1. Cris Sanchez, strikers at the Paso Ranch, May 1973. Supporters of the UFW gather in the fields outside the Paso Ranch to wave flags during a strike. Courtesy of the Walter P. Reuther Library, Archives of Labor and Urban Affairs.

photographers alike. Photographers attracted to the movement included Victor Alemán, George Ballis, Robert Fitch, Nick Jones, Carlos LeGerrette, Cathy Murphy, Ruben Montoya, Cris Sanchez, and Hub Segur.[3] In its heyday, the UFW paid photographers the same as other volunteers, providing five dollars per week, basic housing, and a food allowance. Other photographers who created large bodies of work on the movement include Paul Fusco, employed by *Look* magazine; filmmaker Harvey Richards; and George Rodriguez.

The extensive documentation produced by these photographers (and others; this is not an exhaustive list) includes portraits of Chavez and Huerta and pictures of union meetings, migrant workers in the fields, migrants' living conditions, and protest marches. Some of these images were published in *El Malcriado*, the UFW newspaper published fortnightly from 1965 to 1970, which contained news about union organizing activities among the Chicanx community locally and in other parts of the United States, editorials on farmworkers' rights, cartoons, and historic, revolutionary themed prints by members of the Mexican Taller de Gráfica Popular.[4] *El Malcriado* was widely distributed among farmworkers in the Central Valley and played a key role in disseminating images, whether of hardship, solidarity, or progress. Moreover, it acted as an important model for the young Chicanx art movement in its employment of graphics and photographs as a strategy in communicating to and motivating audiences.

In addition to the well-established Spanish-language newspapers in the United States, such as the aforementioned *El Diario La Prensa* in New York (founded 1913), *La Prensa* in San Antonio (1913–63), and *La Opinión* in Los Angeles (founded 1926), numerous other newspapers were founded in the second half of the 1960s and into the 1970s to serve Spanish-speaking communities. A density of such publications appeared throughout the Southwest, especially in California and Texas, but others appeared in such midwestern cities as Milwaukee, Iowa City, and Toledo. With names like *El Machete* (Los Angeles, founded in 1964), *El Indígena* (Berkeley, 1969), *El Zapatista* (Pueblo, Colorado, 1968), and *Nuestra Lucha hasta la Victoria* (Our Struggle toward Victory; Toledo, Ohio, 1975), these newspapers—published by university Latinx organizations as well as by community groups—squarely identified with values and concepts central to the Chicano civil rights movement. They offered news, publicized events, and debated issues relevant to their communities,

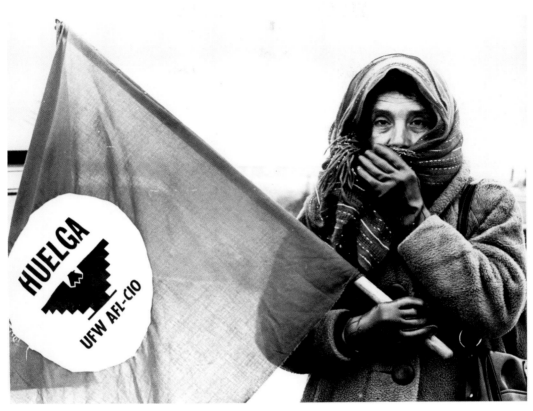

2.2. Ben Garza, photograph of a female striker holding a UFW eagle flag and covering her face to hide her identity during the 1974 San Luis strike, Arizona. Courtesy of the Walter P. Reuther Library, Archives of Labor and Urban Affairs.

and they also acted as crucial outlets for expression in an era well before the Internet made such information widely accessible.[5]

La Raza, a social justice newspaper (and later a magazine) published in Los Angeles from 1967 to 1977, was another key early outlet for the dissemination of photographs made with a consciously Chicanx political perspective. The underground tabloid-like newspapers that proliferated in major cities in the late 1960s offered an inexpensive and effective means of voicing alternative viewpoints on political and cultural issues, especially during the years of the

Nixon administration and the Vietnam War. *La Raza*, published during the heyday of the Chicano civil rights movement, aimed its coverage at a young community with a growing political consciousness. Founded by activists Ruth Robinson Rivera and Eliezer Risco (who also helped organize student walkouts in East Los Angeles), it operated with a volunteer staff that included a group of mostly self-taught photographers. The young volunteer photographers who contributed to *La Raza* understood the photographic medium as a tool of political activism; their images were meant to document, mobilize, and inspire. They included the kind of documentation of the farmworkers' activities captured by UFW photographers as well as urban scenes—the 1970 Chicano Moratorium in East Los Angeles and other protests, the East Los Angeles high school walkouts, incidents of police aggression and brutality, and portraits of young people and of political activists.[6] Many of the photographers risked their own safety while covering protest marches and demonstrations that often turned violent thanks to heavy-handed police tactics. And although most later went on to other careers, while working for *La Raza* they created powerful images representing the struggle for civil rights as a sustained, determined movement that encompassed the efforts of diverse members of the Chicanx community. *La Raza*'s photographers ultimately created an archive of some twenty-five thousand negatives and slides, now housed at the Chicano Studies Research Center at UCLA. The photographers included Raul Ruiz, who was for a period an editor of *La Raza* and who became a leader of the Chicano civil rights movement, as well as Pedro Arias, Manuel Barrera, Patricia Borjon, Oscar Castillo, Moctesuma Esparza, Luis C. Garza, Felix Gutierrez, Gilbert Lopez, Maria Marquez-Sanchez, Joe Razo, Ruth Robinson Rivera, Eliezer Risco, Devra Weber, and Maria Varela.[7]

Maria Varela (b. 1940, Chicago, Illinois; based in Albuquerque, New Mexico) is of note among *La Raza*'s photographers. Involved with the Catholic social justice movement as an adolescent living in the Midwest, Varela was recruited by the Student Nonviolent Coordinating Committee (SNCC), a major civil rights movement organization, to join in their efforts against racial segregation in southern states. Working with SNCC from 1963 to 1967, Varela was a field secretary in Selma, Alabama, under Father Maurice Ouellet, pastor of a Catholic church and a local civil rights leader. She was tasked with aiding registration efforts for African American voters and with creating materials

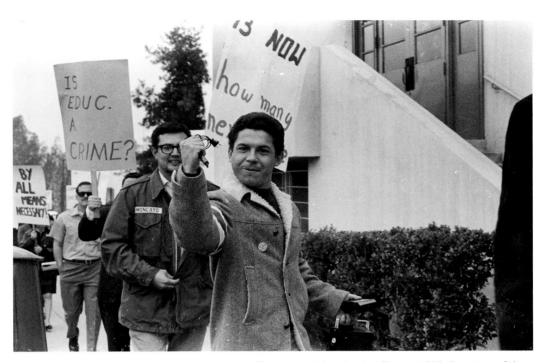

2.3. *La Raza* photographic staff, East LA high school walkouts, 1968. Courtesy of the artist and the UCLA Chicano Studies Research Center.

to promote adult literacy. Needing to produce booklets and filmstrips with content that would be relevant to poor African Americans, she was encouraged to make her own photographs; to this end, she studied for a period in New Orleans with Matt Herron, a leading civil rights photographer. Like other SNCC photographers, Varela documented mass marches in Mississippi as well as police harassment against protestors—challenging work in a region where, as she has stated, neither white nor Black people had experience with Latinx people. But photography allowed her to relate to people on a one-to-one basis. She also turned her camera on such scenes as voter registration drives, workers in the field, and the impoverished conditions of everyday life in Alabama and Mississippi. "Through the lens, I saw differently," she has stated. "Mirrored in the eyes of that youth was a strength and pride that had been freed from within."[8]

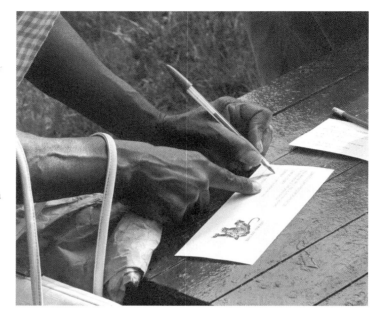

2.4. Maria Varela, woman marks a Black Panther ballot in primary election. Rather than join the segregationist Alabama Democratic Party, Lowndes County Black voters formed their own party and voted in their own primary on May 3, 1963. The party symbol was a black panther, later adopted by Black militants in California. © Maria Varela / Take Stock / The Image Works.

As a result of her involvement with civil rights work in the Deep South, Varela met Reies Lopez Tijerina, leader of the Indio-Hispano land rights movement in New Mexico. In 1968 Varela began working with his organization, the Alianza Federal Mercedes. Aiming to use the skills she had gained with the SNCC, Varela went on to work with the Chicanx civil rights movement, documenting the first National Chicano Youth Liberation Conference in Denver in 1969, protests and other political actions through her work with *La Raza*, and traditional Hispano life in New Mexico, where she continues to live. Varela saw photography as an important tool of the civil rights movement, particularly among the Black and Brown people who rarely saw positive media portrayals of their communities. Photographs that she and others made became posters and calendars; during the early years of these struggles, they encouraged pride and fueled the actions necessary to enact social change.[9]

George Rodriguez (b. 1937, Los Angeles, California; based in Los Angeles), another photographer closely associated with the civil rights movement, pursued much of his early work close to home. He became attracted to photography as a high school student in South Central Los Angeles, where he learned to shoot on a large-format Speed Graphic camera. Growing up in the 1950s,

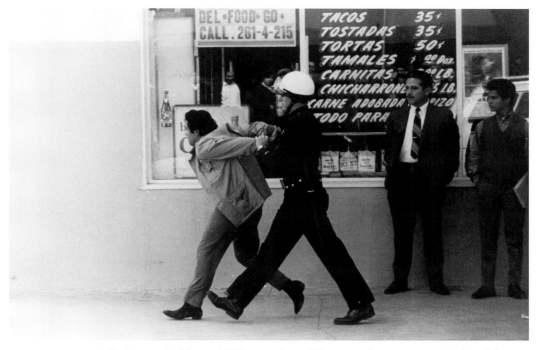

2.5. George Rodriguez, LAPD arresting a Chicano student protestor, Boyle Heights, 1970. Courtesy of the artist.

he idolized *Life* magazine photographers and won second prize in a national photography competition hosted by Kodak.[10] Following high school, Rodriguez managed the color photography lab on the lot of Columbia Pictures while photographing rock concerts and celebrity events in the evenings. As he became increasingly successful at photographing celebrities and musicians, he began to travel across town to East Los Angeles, galvanized by the activities of the Chicano civil rights movement. He documented the 1968 blowouts (student walkouts) at Roosevelt and other high schools, as well as the 1970 Chicano Moratorium protesting the Vietnam War and other demonstrations held in the late 1960s and early 1970s. Rodriguez frequently captured scenes of violence, demonstrating the level of risk young people took as they pressed for a better education and for social justice. Rodriguez also captured everyday life around East Los Angeles and the downtown neighborhood in which he was

raised, focusing on the conditions of poverty that motivated the civil rights movement. During the same years, Rodriguez continued to photograph red-carpet events, pop stars for fan magazines like *Tiger Beat*, and rock-and-roll icons like Jim Morrison and Jimi Hendrix performing at clubs like the Whisky a Go Go. With such disparate bodies of work, Rodriguez captured an unusually inclusive view of the character of a city that was more typically represented in the mass media by manufactured images of glamour.

Perhaps the first Chicanx individual to envision photography as an art form is **Louis Carlos Bernal** (b. 1941, Douglas, Arizona; d. 1993, Tucson, Arizona), who may be rightly called the father of Chicanx photography. Bernal came of age as during the early years of the Chicano civil rights movement. He shared the commitment to social expression visible in the work of photographers associated with the UFW and with *La Raza*, but Bernal's imagery went well beyond documentation. He consciously endowed his images with a deep sense of artistry, a kind of poetic lyricism that could express the tenor of quotidian moments as well as grace and resilience amid hardship. Among the very first photographers to consciously approach his work as a Chicano and as an artist, Bernal aimed to represent the people he knew best and communities that were his own. Through his lens, Mexican Americans are seen not as ethnographic subject but as equal; his approach melded incisive documentation with evocations of the rhythms of everyday life. Bernal's first exhibitions date to the mid-1960s, and he went on to become a beloved teacher in Tucson as well as an active participant in both the local and Mexican photography communities. He participated in the Primer Coloquio Latinoamericano de Fotografía held in Mexico City in 1978, a landmark event that brought photographers from throughout the Americas together for the first time, to expose their work to one another and to participate in exhibitions and meetings.[11]

Bernal worked in his home state of Arizona as well as in New Mexico, Texas, and California, where he photographed everyday scenes in both color and black and white. He pictured people at home, in their most intimate surroundings, as well as at bars, corner barbershops, or other places where people gather in small communities. Clearly, he saw beauty and dignity in humble surroundings. Bernal's subjects acted both as expressions of individuality and as emblems of a culture and way of life he held dear. In the 1978 photograph *Dos Mujeres, Familia Lopez* (Two Women, Lopez Family; figure 2.6), he depicts a child and a

woman—the relationship is not made clear—each inhabiting her own distinct sphere inside a modest home. In the foreground, the girl sits in a chair and works on some sewing, gazing shyly but directly at the camera. Visible through a door, the woman sits on a bed, looking complacently outward as she brushes a strand of hair. The narrative is ambiguous, but Bernal often photographed his subjects inside their homes, capturing moments of quietude and framing their personal spaces as deeply intimate spheres, as symbols of interiority. Here, he created a composition that recalls Vermeer's portrayals of the female subject, framed by architectural space and defined by soft contrasts of light and shadow. In contrast, for the classic Benitez Suite of 1977, Bernal poetically documented the home and belongings of a woman who had gone to live in a nursing home, showing spaces absent of people and yet suffused with the echoes of a life.

Bernal was keenly aware of his role in bringing forth a new kind of image of Chicanx people. "My images speak of the religious and family ties I have experienced as a Chicano," he wrote. "I have concerned myself with the mysticism of the Southwest, and the strength of the spiritual and cultural values of the Barrio. These images are made *for* the people I have photographed."[12]

Oscar Castillo (b. 1945, El Paso, Texas; based in Los Angeles, California) is another key member of the initial generation of consciously Chicanx artist photographers. He became interested in photography while stationed in Japan as a Marine during the Vietnam War, but he credits the artfully composed photos he discovered as a child in the early 1950s in his mother's family album as his earliest inspiration. Beginning as a student involved in activist groups, Castillo began to use the camera to document the rising political ferment taking place around him in Los Angeles. He photographed the 1970 Chicano Moratorium, United Farm Worker rallies, and local civic and cultural leaders. Castillo was also a ubiquitous chronicler of community cultural events and of everyday life; in fact, his archive comprises some three hundred thousand photographs. Working in both black and white and color, Castillo documented family holiday gatherings, concerts and theatrical performances, exhibition openings, rallies and political conventions, and street scenes. Long before his work was seen in museums, it appeared in the pages of *Con Safos*, a literary journal published by activists in East Los Angeles from 1968 to 1972 that responded to and documented *el movimiento*, as the Chicano civil rights movement was also called.

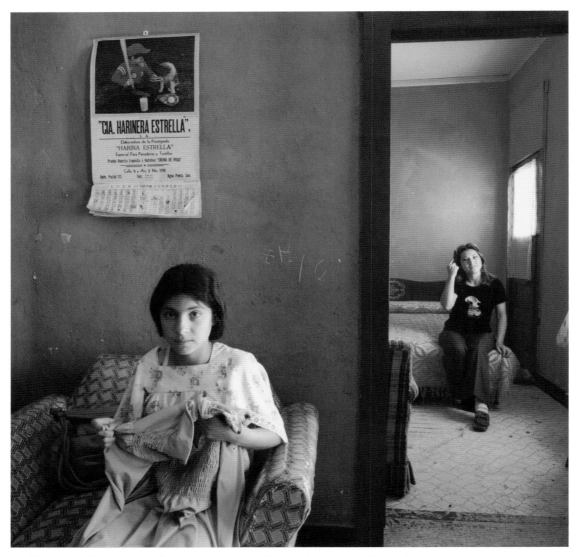

2.6. (*above*) Louis Carlos Bernal, *Dos Mujeres, Familia Lopez (Two Women, Lopez Family), Douglas, Arizona,* 1979. © 2019 Lisa Bernal Brethour and Katrina Bernal.

2.7 (*right*) Oscar R. Castillo, *Shrine of the Virgin of Guadalupe at Maravilla Housing Project,* Mednik Avenue and Brooklyn Avenue, East LA, 1970s. Inkjet print, 14 × 20 in. © 2012 Oscar R. Castillo Archives, UCLA/CSRC.

Castillo also photographed the murals that young artists were painting in East Los Angeles and surrounding neighborhoods, not only the larger, better-known ones but also the many modest paintings that appeared on the walls of humble corner markets and liquor stores in the 1960s and 1970s. The murals—some painted by individuals, others by artist collectives—were emblazoned with political slogans and figures, depictions of pre-Hispanic deities and the Virgin of Guadalupe, and portraits of everyday people. They became a cultural cornerstone for young Chicanx individuals, embodying a true people's art and a form of artistic expression available to communities hardly served by mainstream cultural institutions. Many no longer survive, and Castillo's photos provide a valuable record of their ubiquity in the early years of the Chicanx art movement.

Unusual in this era, Castillo also documented graffiti. What others defined as a sign of urban decay and gang activity, Castillo represented as a self-defining marker of Chicanx identity and an expressive form of cultural resistance adopted by young men and women with limited creative outlets. He

captured young graffiti writers in action and large walls covered with dense fields of language and symbol that were illegible to the uninitiated. Castillo's photographs portray a vernacular, if controversial, cultural practice while recognizing the ways in which marginalized young people in his community appropriated social and physical space. Some images depict people walking beside walls with immense tags in compositions that recall the urban scenes of Mexican photographer Manuel Alvarez Bravo, who often pictured people walking along the high walls of Mexico City. In documenting the production and presence of both murals and graffiti in the urban landscape, Castillo asserted images of creativity, resistance, collaboration, and cultural autonomy. "I had a personal need to do it," Castillo stated. "I never thought I was going to be well known for this. I never really thought I would be creating a legacy."[13]

Castillo produced an image of a Chicanx culture in formation, contributing emphatically to the American visual record. His thousands of negatives have been digitized and are now in the collection of the UCLA Chicano Studies Research Center Library. As artist and photographer Harry Gamboa Jr. noted, "this immense body of images act as a corrective; they play a significant role in updating Chicanx history and defies the people who would erase that history." Castillo himself noted the absence of positive images in mass media about Mexican Americans in the 1960s, and earlier as he was growing up in Texas. "I wanted to present my side of the story, which wasn't being shown."[14]

Chicago

Chicago is typically overlooked as a center of Latinx artistic activity during the civil rights era, but the city played a critical role in the formation of a politicized voice, especially among the Puerto Ricans who had settled there. Puerto Ricans began migrating to Chicago, primarily from New York, in the 1930s and in greater numbers in the 1940s. Although their relative numbers are small (Puerto Ricans currently comprise less than 4 percent of Chicago's population), the city maintains the third largest concentration of Puerto Ricans in the continental United States. It was in Chicago that the Puerto Rican nationalist group the Young Lords was founded, in 1968. Following the Division Street Riots of 1966, a series of demonstrations against police violence, housing discrimination, and a range of other issues facing Puerto Ricans living in the city,

many members of the community, especially young people, became politically engaged. Among the most strident voices in those years were those of the Young Lords, which evolved from an urban turf gang into a group dedicated to pressing for civil rights for Puerto Ricans in Chicago and later in other cities.

Amid this activity **Carlos Flores** (b. 1949, Guayama, Puerto Rico; based in Chicago) began working with the camera in the late 1960s, thanks to "divine intervention," as he says, particularly given that there were no role models for him to follow as a photographer in these years.[15] He was introduced to photography when he was accepted into a training program for inner-city youth held at the Argonne National Laboratory and sponsored by the University of Chicago and the Atomic Energy Commission. He worked in the lab's photography department and used the Yashica camera lent to him to photograph in and around Lincoln Park, a neighborhood where Puerto Ricans were being displaced at a rapid rate—a flashpoint for protestors. Flores took pictures of his family, of children playing outdoors, and of everyday street scenes, now valuable, he says, "because in some of the neighborhoods you will not find any evidence that thousands of Puerto Ricans inhabited these same streets a few decades ago."[16]

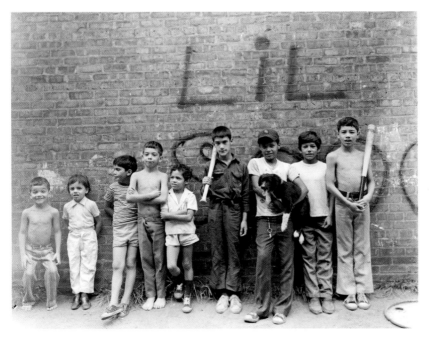

2.8. Carlos Flores, *Boys from Armitage and Clinton*, 1969. Courtesy of the artist.

As Flores became increasingly involved in community activism, he became a member of the Young Lords and was involved in the battle against gentrification in the Lincoln Park neighborhood. He often captured scenes of leisure and music making—children cooling off with the spray of open fire hydrants, jam sessions in Humboldt Park, people gathered for the annual Puerto Rican Day parades on Paseo Boricua (as a section of Division Street was named after the civil unrest). The activities he recorded can be seen as expressions of "Chirican" culture—a rich mix of English and Spanish language, jazz and salsa, theater and poetry. Flores chronicled organizing and political activities among Latinx youths in Chicago, including Young Lords rallies, Latinx student movement activities at the University of Illinois (where he earned his degrees), and the lives of Puerto Rican children in Lincoln Park long before it became a gentrified, "upscale" community. Flores has spoken of the frustration he felt witnessing the story of Puerto Ricans in this period being told by others. As a member of the community, he was trusted by his subjects, and he in turn provided prolific, vivid documentation of a community that was uprooted time and again but that has survived in this city.

East Coast

On the East Coast of the United States, a distinct set of factors gave rise to civil rights efforts among Puerto Ricans, primarily in New York. Puerto Ricans emigrated to New York as early as the mid-nineteenth century, with significant numbers arriving in the 1950s. Limited economic opportunities on the island and the availability of industrial jobs stateside in the post–World War II years led to what has become known as the Great Migration, when large numbers of Puerto Ricans settled in Spanish Harlem as well as in parts of Brooklyn and the Bronx. Historically, Puerto Ricans have concentrated most heavily in New York and New Jersey, but over time they have also settled in other parts of the Northeast and in Pennsylvania and Florida. According to 2017 estimates, 5.5 million Puerto Ricans reside stateside, compared to some 3.2 million on the island. Puerto Rican migration to the Northeast, a longtime trend, was compounded by the devastation Hurricane Maria caused in 2017, destroying the homes of many thousands and leaving essentially the entire population without power, in some regions for many months. In January 2020, a series of

earthquakes, resulting in extensive property damage and more power outages, further weakened the island's infrastructure. Given Puerto Rico's ongoing economic crisis and high levels of unemployment, it is safe to say that emigration from the island will continue for years to come.

By the mid-1960s the kinds of employment that had attracted Puerto Ricans to New York, in manufacturing and shipping, began to wane. White middle-class residents were abandoning the city in favor of newly developed suburbs, and with a decreasing tax base, the city cut services, particularly in the poor and working-class neighborhoods that were home to Puerto Ricans and African Americans. As these communities fell into decay, crime rose, and their residents confronted racial discrimination, job and education inequality, inferior housing, police injustice, and lack of access to health care. An early generation of Puerto Rican and African American activists arose in the early 1960s, uniting around the dire need for better public schools in New York. Schools were segregated, classrooms in inner-city neighborhoods were crumbling, dropout rates were sky high, and a growing population of Spanish-speaking children performed poorly because of a lack of bilingual education. In an early show of force, a group of African Americans and Puerto Ricans took over the Great Hall of the New York City Board of Education for three days in 1966, ultimately leading to various reforms, including a form of decentralized authority that gave local communities greater control over their schools.

The Black Panthers (founded in Oakland, California, in 1966 and reaching New York in 1968) and the Young Lords (which reached New York in 1969) were responsible for more overtly militant social justice efforts. The Young Lords advocated for independence for Puerto Rico while also working to alleviate needs in their communities. They organized a free breakfast program for children, a free health clinic, cultural events, street cleaning in neighborhoods ignored by the city's sanitation department, and classes in Puerto Rican history, a subject excluded from the public school curriculum. The Young Lords also deployed radical tactics to press for change—for example, a 1969 week-long sit-in at Chicago's McCormick Theological Seminary to protest its planned expansion in the Lincoln Park neighborhood. Their demand for resources for low-income housing was met only once the activists threatened to burn down the seminary's library. Similarly, in New York the Young Lords took over the First Spanish Methodist Church in East Harlem for eleven days

in order to gain space for a free breakfast program.[17] As a result of these activities, and particularly because of their pro-independence stance, the group was surveilled by the FBI, and members were ultimately arrested and imprisoned on a variety of charges.

By the late 1960s, artists working in varied disciplines began to assert their voices in a similarly strident tone. The term *Nuyorican* came into use by Puerto Ricans based in New York who sought to interpret the Puerto Rican experience from a diasporic, urban, and politicized perspective. Organizations like the Puerto Rican Traveling Theater (founded 1967), El Museo del Barrio (1969), and the Nuyorican Poets Café (1973) were founded by Nuyoricans to provide cultural resources and venues for artists in their communities and for a public ignored by mainstream institutions. These organizations maintained both cultural and political mandates, seeking to address the lack of access to cultural programming in barrio communities, to educate, and to instill cultural pride. In 1971, in explaining the founding of El Museo del Barrio, artist Raphael Montañez Ortiz (b. 1934) stated, "The cultural disenfranchisement I experience as a Puerto Rican has prompted me to seek a practical alternative to the orthodox museum, which fails to meet my needs for an authentic ethnic experience. To afford me and others the opportunity to establish living connections with our own culture, I founded El Museo del Barrio."[18]

Another significant figure to emerge in this era was Pedro Pietri (1944–2004), a poet and playwright who was a member of the Young Lords and a founder of the Nuyorican Poets Café, still based in the Lower East Side of Manhattan. Pietri's work could be deeply affecting, as in his iconic 1969 poem "Puerto Rican Obituary," an homage to struggling Puerto Ricans migrants in New York. At other times he used irreverence to make pointed social statements. His play *El Puerto Rico Embassy* framed Puerto Rico as an island that was neither independent nor a state of the United States, and that should thus have its own embassy, passports, and ministries led by cultural figures. In addition, visual artists like Pepón Osorio, Juan Sánchez, and Adál Maldonado emerged in the 1970s and 1980s, creating work with varied, sometimes unconventional media that incorporated political statements, elements of popular culture, and spiritual and traditional cultural symbols that spoke to the Puerto Rican diasporic experience.

It was amid this environment of political activism and cultural ferment that a generation of Nuyorican documentary photographers emerged in New York.

Among the earliest was **Frank Espada** (b. 1930, Utuado, Puerto Rico; d. 2014, Pacifica, California), who arrived in New York at the age of nine. Espada grew up in poverty in Brooklyn and joined the US Air Force during the Korean War. On leave from basic training in 1949, he was arrested in Mississippi for not moving to the back of a bus he was traveling in; during the one-week jail sentence he served, he decided to dedicate his life to political activism.[19] Espada became active in civil rights struggles in New York in the early 1960s, years before the Young Lords and the Black Panthers combined political activism with efforts to better their communities. As a community organizer, Espada took part in voter registration drives, organized rent strikes, and marched in demonstrations for causes important to people of color. Although he devoted most of his time in the 1960s and 1970s to his organizing activities, thanks to the GI Bill he had studied first at the New York Institute of Photography, and then privately with W. Eugene Smith. His earliest photographs, dating to the 1960s, reflect his activism: he documented conditions of poverty in his Brooklyn neighborhood, demonstrations demanding school integration, the rent strikes he helped organize, the March on Washington and other civil rights protests, and the activities of the Young Lords. Espada also taught photography and gained a reputation as a master printer.

In 1979, when he was fifty years old, Espada received funding that allowed him to finally devote himself to photography full time, a National Endowment for the Humanities grant for the Puerto Rican Diaspora Documentary Project. For the next three years Espada traveled around the United States to pursue this sprawling and ambitious project, making photographs and recording some 140 oral histories of members of Puerto Rico's diasporic communities from New York to Chicago to Hawaii.[20] His aim was to record the cultural richness, diversity, and vitality of a community that had little presence in the American cultural consciousness, especially outside of New York and a handful of other eastern cities.[21] The project—which became a traveling exhibition and a book and which was ultimately acquired by the Smithsonian National Museum of American History—demonstrated the vitality of Puerto Rican communities throughout the United States. "I was not preprogrammed by some know-nothing editor to bring back more proof as to the miserable lives we were living," he once stated. "It was to be as loving a document as I could produce."[22]

2.9. Frank Espada, *Man with Flag in Washington, D.C.*, 1981. © Frank Espada Photography. Courtesy of the Estate of Frank Espada.

Another pioneering figure, **Hiram Maristany** (b. 1945, New York; based in New York), was born and raised in East Harlem and created much of his work in that neighborhood. He came to photography through an unlikely encounter with Magnum photographer Bob Henriques on an East Harlem street. Henriques offered his camera to the then fifteen-year-old boy. This led to a career in photography, informed by the political and cultural consciousness that he developed growing up in El Barrio, as Spanish Harlem had come to be known, as well as traveling to Mexico and to the 1963 March on Washington. While leading photography workshops in the late 1960s, Maristany became a founding member and the official photographer of the New York branch of the Young Lords. He documented their demonstrations, rallies, and public events as well as the workaday meetings and activities they carried out in an

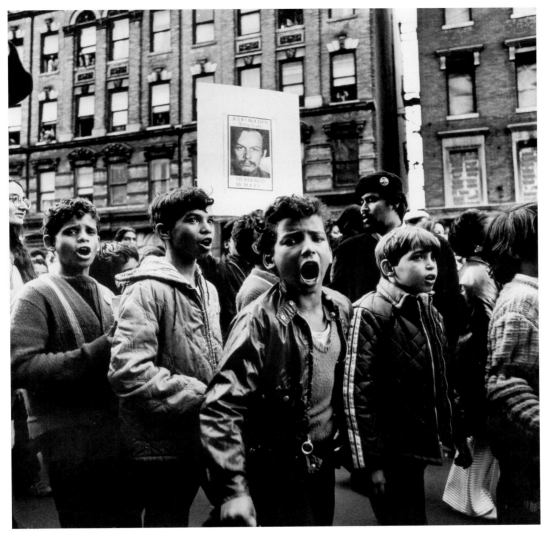

2.10. Hiram Maristany, *Procession*, undated. Courtesy of the artist.

East Harlem storefront to improve access to education, health care, and better housing in the neighborhood. Maristany frequently contributed photographs to the Young Lords' newspaper, *Pa'lante*, a bilingual publication that promoted independence for Puerto Rico while also reporting on news of Young Lords

events and on global struggles for liberation.[23] Maristany was also associated with key Puerto Rican cultural institutions in East Harlem. He was active with the community arts organization Taller Boricua, and he was acting director of El Museo del Barrio from 1975 to 1977, a tumultuous period in the museum's history.[24]

Maristany's work with the Young Lords is highly nuanced, even when composed quickly, in the moment. His photographs of the group's demonstrations depict political actions carried out with fervor and discipline. They often highlighted the presence of women and young people at those demonstrations, evincing the group's appeal to a broad constituency.[25] Maristany has spoken of the kind of challenges he experienced in pursuing this work, both as a member of the Young Lords and as their photographer, in a period when "internal racism," as he has stated, encouraged some in the Puerto Rican community to embrace cultural assimilation.[26] In addition to his work with the Young Lords, he felt a sense of responsibility to photograph people no one saw, and he captured life in a neighborhood that he loved and knew intimately. Unlike the photojournalists who came to East Harlem on assignment in the 1960s and 1970s, intent on presenting the extremes of poverty or urban decay that could be found, Maristany photographed the texture of the everyday—families watching life go by from the fire escapes that provided relief from crowded apartments, or a boy flying his kite not from an expansive green space but from a tenement rooftop. For Maristany, El Barrio was a vibrant neighborhood, one that he loved and that represented the aspirations of a growing Puerto Rican population in New York.

In 2019, a leading Puerto Rican artist in New York, Miguel Luciano (b. 1972), brought Maristany's deep connections to this neighborhood full circle through a public art project in association with El Museo del Barrio, "Mapping Resistance: The Young Lords in El Barrio." Working with Maristany, Luciano made billboard-size photo murals documenting key moments in the Young Lords history and installed these images in the same East Harlem locations where events had taken place half a century earlier. In 1969, for example, Maristany had documented the Garbage Offensive, a Young Lords protest against the lack of regular service by the city's sanitation department. Displayed in large scale, photographs of members cleaning the streets themselves, and at the barricades they created out of uncollected garbage that the city could not ignore,

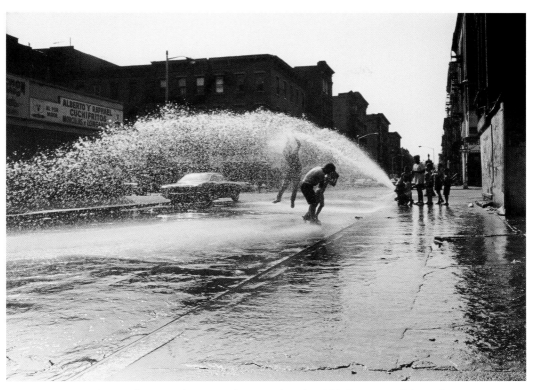

2.11. Hiram Maristany, *Hydrant: In the Air*, 1963. Courtesy of the artist.

act as a compelling history lesson in a revolutionary form of civic activism, preserved by one man's camera.

Máximo Rafael Colón (b. 1950, Arecibo, Puerto Rico; based in New York) came to New York from Puerto Rico as a child and became interested in photography when his father gave him his first camera, a plastic Miranda. Like others photographers of his generation, he was largely self-taught and combined his photography with work as a community activist. The camera became his constant companion as he documented the activities of the Young Lords and Puerto Rican life in New York in the 1960s and 1970s. Colón chronicled myriad aspects of Puerto Rican life and culture, especially in the Lower East Side. Like other Puerto Rican photographers in New York of this generation, the desire to visualize his own community and to use the camera to reverse stereotypes

2.12. Máximo Rafael Colón, *Protest with Sign That Reads "Fuera Yanki" (Get Out Yankee)*, anti–Vietnam War demonstration, 1972. © Máximo Rafael Colón.

endowed his work with a sense of urgency. "We were not all stickup artists or dealers," he stated. "That is the most important thing for the generation I belong to. We are now able to state our own story and picture it through our own eyes."[27] Colón expressed himself most powerfully when depicting public gatherings and street demonstrations by the Young Lords and anti–Vietnam War groups. Many photographers documented protest demonstrations in this era, but Colón's work evinces a special talent for capturing both group dynamics and how culture is expressed and celebrated through music and the collective body.

While photojournalism is largely outside the scope of this study, it provided one of the few outlets available to Latinx individuals working with the camera prior to the civil rights era. With this in mind, two pioneering figures are noted here. **Bolivar Arellano** (b. 1944, Ecuador; based in New York) migrated

to New York in 1971 and was a freelance photographer for *El Diario*, the city's largest Spanish-language newspaper, from 1974 to 1993. He arrived in the city when its social and economic problems were at their peak, especially in economically disadvantaged Latinx and African American neighborhoods that became the focus of much of his work. During this period the Young Lords and others were agitating for equality and civil rights for Puerto Rican people, whose quality of life was among the lowest in the city. Arellano developed a lifelong bond with this community, in great part thanks to his early encounters with the Young Lords and the passion he witnessed in the group's struggles for social justice. Arellano, who called himself an activist-photojournalist, documented the rise of a more politically and culturally conscious Nuyorican identity among this community. He took on countless assignments covering wars in Latin America, crime scenes in New York, popular culture, politicians, celebrities, and everyday street life. At great risk to himself, he also covered civil wars in Ecuador and Colombia, as well as the September 11 terrorist attack in Lower Manhattan. Above all, Arellano relished his assignments capturing the stories of Latinx people—the poor condition of inner-city neighborhoods in which they lived, the activities of militant activists and politicians, and the cultural life of their neighborhoods.[28]

Similarly, **Librado "Lee" Romero** (b. 1942, Los Angeles, California; based in Yonkers, New York) was among the first Latinx photographers on the staff of the *New York Times*. A first-generation Mexican American from California, Romero was given the job of regimental photographer while stationed with the US Army in West Germany in the 1960s. After a brief stint as photographer for a newspaper in Providence, Rhode Island, he joined the staff of the *Times* in 1969. He worked there for much of his career, for some years as its chief photographer. Through his myriad assignments with the newspaper, Romero came to know New York better than most, and to relish it. In the 1960s and 1970s he covered a range of topics—life on the subway, prisoners, the homeless, feminist demonstrations down Fifth Avenue, the Young Lords, and the day-to-day activities of Mayor John Lindsay and other city leaders. One of his most memorable later bodies of work captures the city late at night, in images of Times Square, nightclubs, street vendors, and lone walkers, all pictured with a kind of gentle melancholy that counters clichéd views about the city in this era.

2.13. Librado Romero, members of the Young Lords marching in the Puerto Rican Parade, June 1970. Courtesy of Librado Romero / The New York Times / Redux.

On the West Coast, **José Galvez** (b. 1949, Tucson Arizona; based in Durham, North Carolina) began his career at the *Arizona Daily Star* after graduating from the University of Arizona. The first Mexican American photographer hired by the *Los Angeles Times*, where he worked from 1980 to 1992, he is best known for his contributions to a major 1984 series on Mexican American life in Los Angeles, "Latinos," which earned the newspaper a Pulitzer Prize. In more recent years, working independently, Galvez has worked to document the presence of Latinx communities in the southeastern United States.

The first significant generation of Latinx photographers arose in the late 1960s and early 1970s out of a sense of political urgency—to document a civil rights struggle taking hold across the nation that would radically alter what it meant to be Mexican American or Chicano, Puerto Rican or Boricua. These photogra-

phers were keenly aware that the protests and community organizing activities taking place in California's Central Valley, in East Los Angeles, in the Lincoln Park neighborhood of Chicago, and in Spanish Harlem signaled a tidal change in the United States; Latinx people could no longer be an ignored or invisible element in America's social landscape. In California, numerous photographers came to Delano, Fresno, and Sacramento to follow Cesar Chavez and members of the United Farm Workers, understanding their role in witnessing history. Through tireless participation in boycotts, strikes, massive demonstrations, and campaigns to create public awareness, everyday people fomented a truly populist grassroots movement that ultimately prevailed. Similarly, in Chicago and on the East Coast, concepts of self-determination were foundational to the Young Lords, who staged numerous gatherings calling for equality in their decaying urban neighborhoods and protesting US imperialism. As with the Black civil rights movement, what became clear amid these challenges to the status quo was that change was possible and that voices would be heard. In tandem with these movements, photographers recognized the crucial need to witness and record these struggles, as well as to give visibility to those pressing for change. As a result of their work, for the first time Latinx people were presented not as victims but as instigators of change and as individuals worthy of documentation and of being remembered.

3

Documents,
1970s–Present

B Y THE 1970S AND INTO THE 1980S, THE COMMUNITY
of Latinx photographers had grown, in parallel with
the flourishing of the photographic medium and the surge of interest in the
medium by museums, collectors, and a broader public. Photography was no
longer questioned as a serious art form, and universities were adding studio
and history of photography courses to their curricula. Museums dedicated to
the medium were being established, including the Center for Creative Photog-
raphy at the University of Arizona, Tucson, in 1975, the International Center
of Photography in New York in 1974, and Lightwork in Syracuse, New York, in
1973. Moreover, commercial galleries that opened in this period, like the Wit-
kin Gallery in New York and the Fraenkel Gallery in San Francisco, would play
a key role in advancing the medium's status as fine art as well as the commercial
value of both vintage and contemporary photographic prints. Photography's
popularity also spread to the mass media. In October 1974, *Newsweek* mag-
azine dedicated a cover story to photography, calling the 1970s the "Golden
Age" for the medium and noting that the contemporary generation of photog-
raphers was acutely aware of their work as "an instrument of culture."[1]

Amid the rise in photography's popularity, much was changing in the early 1970s. A generation of female photographers with a new feminist consciousness emerged on the scene, including figures like Judy Dater, Judith Golden, and Bea Nettles. In addition, photographers pursuing conceptual approaches became more visible, most notably Robert Heinecken, who took few actual photographs himself but made his works by appropriating images and texts from newspapers, magazines, and pornographic publications to critically examine consumerism and other aspects of the contemporary social and cultural landscape. Heinecken's approach anticipated the rise of the so-called Pictures Generation of the later 1970s and 1980s, and of such artists as Barbara Kruger, Louise Lawler, Cindy Sherman, Richard Prince, and Laurie Simmons, who similarly scavenged images from the mass media and popular culture to reflect an image-saturated society and the manufacture of desire. Nevertheless, documentary photography retained its privileged position, with a rising generation of photographers like Mary Ellen Mark, Larry Clark, and Nan Goldin using their cameras to frankly and intimately picture youthful alienation, drug culture, and radically changing social norms in the United States. In 1973 a large, posthumous traveling exhibition of photographs by Diane Arbus, organized by the Museum of Modern Art, was seen by over seven million people, clear indication that photography had become part of the broader cultural discussion. Images by Arbus as well as by photographers like Bruce Davidson, Lee Friedlander, and Robert Adams were shaping the way people viewed the social landscape. Their work suggested not only that the mundane, the marginal, and the incidental were worthy photography subjects but also that even "documentary" images could be subjective—expressions of cynicism, ambiguity, and dissent.

As discussed in the preface, one of the chief efforts undertaken in countering the negative portrayals of Latinx communities was the 1974 founding of En Foco in New York by Charles Biasiny-Rivera, Phil Dante, Roger Cabán, Benedict Fernández, Adál Maldonado, and Geno Rodriguez. They came together as a collective of Nuyorican photographers dedicated to illuminating the life and times of their communities. Particularly in the early years of its history, En Foco's photographers were united by their dedication to a form of hyperlocal social documentation. **Charles Biasiny-Rivera** (b. 1930, New York), En Foco's executive director from 1974 to 2005, became a photographer while serving

in the Korean War and later studied with Sir Cecil Beaton. Inspired by figures like Robert Frank, Roy DeCarava, and W. Eugene Smith, Biasiny Rivera photographed in the tradition of the humanist photographer, working in Upper Manhattan as well as in Puerto Rico and other parts of the world. In the 1990s, he hand-colored his gelatin silver prints, adding texts and elaborate frames, transforming everyday scenes into images of grace and reverence. Phil Dante (1934–2004) similarly photographed in El Barrio, capturing street concerts, storefronts, and small religious shrines inside homes. He also photographed scenes of work, of manual laborers in the city as well itinerant farmworkers in upstate New York, underscoring Puerto Ricans as hardworking people and countering negative stereotypes common in the 1970s. **Roger Cabán** (b. 1942, Puerto Rico; d. 2017, New York) made one of his most important bodies of work, the 1974 *IRT Prayer Book*, while traveling in New York subway cars. His original idea was to document the graffiti that then covered the cars, inside and out. "Once I started to go down there with my camera," he stated, "I started to see that something else was going on."[2] Cabán captured such a range of activities in the cars—praying, sleeping, socializing—that he expressed the subway as an extension of home, especially for the poor and working-class New Yorkers who had long commutes and no other option for transport. Geno Rodriguez (b. 1940, New York), an early member of En Foco who took up photography in the late 1960s after studying in London, stated that he was motivated "to right the wrong that Bruce Davidson did in his book *East 100th Street*, with his excellent photographs, but bad exploitation of the neighborhood I grew up in. My images were an attempt to show that not everyone from the barrio was a drug addict or a hooker."[3]

Outside of the orbit of En Foco, the Brooklyn-based **René Gelpi** (1946–2018), active in the 1960s and 1970s, endeavored to create a historical record of his time and place, portraying prostitutes, pimps, gang members, workers, wrestlers, circus performers, and others. The son of a Cuban father and a Puerto Rican mother, the self-taught Gelpi photographed often around the Bedford-Stuyvesant neighborhood where he grew up in poverty. Bedford-Stuyvesant was then largely an African American neighborhood where racial tensions and poverty rates remained high, following a 1964 race riot that had begun in Harlem after an NYPD lieutenant shot and killed an African American teenager. As a portraitist, Gelpi aimed to illuminate life's hard realities in this neighborhood

3.1. Charles Biasiny-Rivera, *Child God*, 2006. Digital print with gold acrylic and mixed media. Courtesy of the artist.

where he "spent a lot of time on the streets," as he once said, and where he once belonged to a gang.[4] He worked hard to build a rapport with those he photographed, displaying his street cred with young gang members, hanging out with prostitutes, and sharing his portfolio with strangers before approaching them with his camera and explaining his goal of capturing a moment for history. Gelpi typically used a wide-angle lens, and at times artificial light, to create tightly composed and closely seen studies of people, whether of a young boy gently cradling a pigeon—a rare outlet for tenderness amid the harshness of city life— or of a gang member displaying not only his brazen machismo but his allegiance

 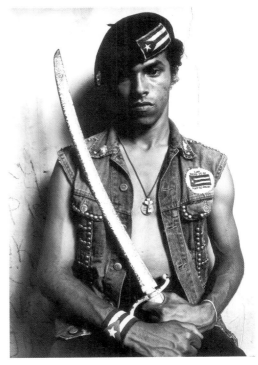

3.2. (*left*) Roger Cabán, *Woman on the Subway Platform*, 1970. Courtesy of the Center for Puerto Rican Studies Library & Archives, Hunter College, CUNY.

3.3. (*right*) René Gelpi, *The Gang Member—Black Pearl*, 1971. Gelatin silver print. Courtesy of Ryoko Gelpi.

to his Puerto Rican heritage. Illness prematurely ended Gelpi's career, but his body of work was revered by those who knew him.

Representing a subsequent generation, **Ricky Flores** (b. 1961, New York; based in New York), the son of a merchant seaman and a garment worker, initially photographed his friends and family in his South Bronx neighborhood. Photography evolved into a serious pursuit for Flores, who was motivated to record positive aspects of life in a neighborhood that was becoming known for the negative depictions made by outsiders. In the early 1980s he photographed a range of experiences in the Bronx—subway cars covered with graffiti tags, a phenomenon some saw as a creative expression and others saw as a

manifestation of a city out of control; the all-too-common spectacle of build-ings burning at night after being torched by arsonists; destroyed city blocks seen through the windows of subway cars on elevated tracks; and people he encountered along the way. These years also witnessed a burgeoning urban youth culture focused on hip-hop, emceeing, rapping, and break dancing. The Bronx is widely acknowledged as the birthplace of hip-hop music and culture, developed by young DJs and rappers at block and house parties. Flores immersed himself in this world, photographing hip-hop shows and dance crews performing in subway cars. Despite the urban devastation that provides the backdrop for much of his work, Flores's imagery projects a vibrancy, the sense that these new artistic forms represented a sense of optimism and were to be embraced.

In 2009 Flores, along with David Gonzalez, Ángel Franco, Joe Conzo Jr., Francisco Molina Reyes II, and Edwin Pagán, formed Seis del Sur (Six from the South), a collective with the shared goal of exposing their early social

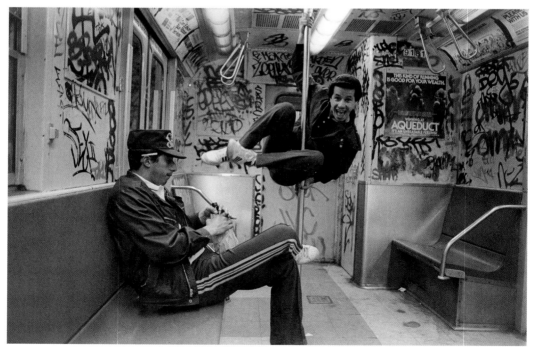

3.4. Ricky Flores, *Carlos and Boogie on the 6 Train*, 1984. Courtesy of the artist.

documentary work made in Upper Manhattan and the South Bronx, areas that were then being threatened by the forces of gentrification. These young street photographers, all born and raised in the Bronx, had captured the variety of what they saw—urban decay and the trauma of block after block of abandoned buildings, to be sure, but also the everyday street life that is a hallmark of New York. Although the photographers were still learning their craft when they took the photos, they were motivated by a sense of responsibility to represent their own communities and neighbors from the position of insiders. As Ángel Franco stated, "We are in charge of our community and more importantly, we are in charge of the image portrayed by our communities. And when you empower a community that way, you can't take away the good stuff coming out of it."[5] Looking back years later and sharing this work through exhibitions became a means for these photographers to reassess work that had never reached a broad audience, work that documented parts of the city that had radically changed over the intervening decades.

Joe Conzo Jr. (b. 1963, South Bronx, New York; based in New York) took up photography as an adolescent, capturing the world around him in the South Bronx as well as photographing political activities for the Committee Against Fort Apache—a grassroots community organization formed to protest the 1981 film *Fort Apache, the Bronx* and the negative racial stereotypes it propagated about a South Bronx neighborhood. In the late 1970s, Conzo began to chronicle luminaries of the Latin music world as well as of the nascent hip-hop scene in his neighborhood—performers like the Cold Crush Brothers, school parties, B-boys, rap battles, and now legendary DJs and emcees.[6] His large body of work is now seen as key source material in understanding the birth of the hip-hop movement.

David Gonzalez (b. 1957, Bronx, New York; based in New York) discovered photography while a student at Yale College. When he returned to his South Bronx home in 1979, he was dismayed by the level of deterioration he witnessed in his neighborhood. Gonzalez found work with En Foco, teaching photography to adults as well as to teenagers in public schools around Charlotte Street in the Bronx, infamous in the 1970s as the location of the single most blighted block in the city. Gonzalez also documented life in the neighborhood—kids playing, street life, storefronts, and portraits of locals, as well as rubble-strewn lots and abandoned, burned-out shells of buildings. He

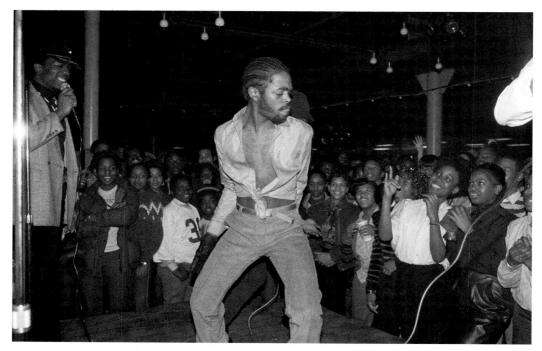

3.5. (*above*) Joe Conzo Jr., *JDL at Skatin' Palace*, 1981. Courtesy of the artist.

3.6. (*right*) David Gonzalez, *Dancers, Mott Haven*, August 1979. Courtesy of the artist.

had witnessed a history of outsiders coming into Bronx neighborhoods "documenting poverty and dysfunction," as he has stated. Like for other photographers affiliated with En Foco, wielding the camera made it possible for local residents to define their communities from the inside.[7] Photography also laid the foundation for Gonzalez's future work as a photographer and journalist for the *New York Times*.[8] At the *Times*, he has remained committed to examining change in the Bronx as it emerged from years of neglect, as well as to writing about the humanitarian crisis in Haiti and the role of Latinx immigrants in reshaping the United States, among numerous other topics.

The work of female Puerto Rican documentarians in New York in the 1970s and 1980s has received much less attention than that of male photographers of this period. Nevertheless, many were active photographing around El Barrio,

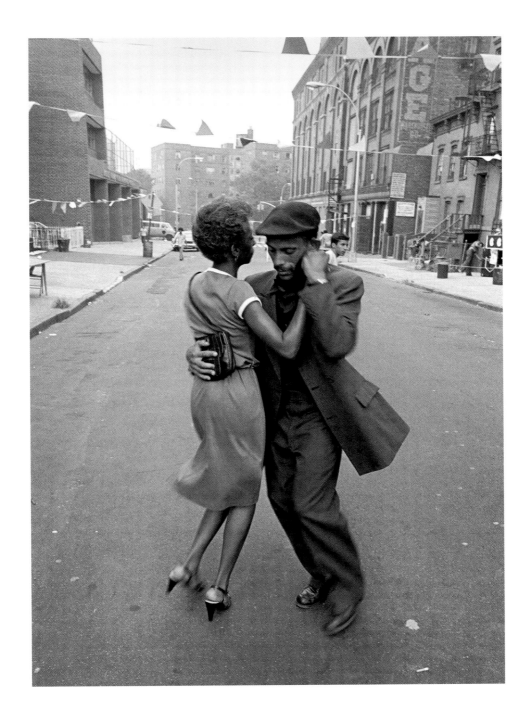

as well as exhibiting their work. One such exhibition, the 1979 *Mujeres 9*, was organized by Evelyn Collazo and shown at El Museo del Barrio's F-Stop Gallery, a space that mounted photography exhibitions into the 1980s, frequently highlighting the work of women. *Mujeres 9* included work by Collazo, Nydza Bajandas, Sylvia Arlene Calzada, Marili Forastieri, Perla de León, Carmen Mojica, Sophie Rivera, Josefa Vázquez, and Ivonne Villaquiran. Two major exhibitions presented in 2017, *Down These Mean Streets: Community and Place in Urban Photography*, curated by E. Carmen Ramos of the Smithsonian American Art Museum, and *Home—So Different, So Appealing: Art from the Americas since 1957*, curated by Chon Noriega and Mari Carmen Ramírez for the Los Angeles County Museum of Art, both contained significant bodies of work by Perla de León. Clearly, much more work needs to be undertaken to bring to light the oeuvres of female photographers of this era.

Perla de León (b. 1952, New York; based in New York) initially developed her skills as a result of her association with En Foco. Raised in Harlem, she first came to the South Bronx under En Foco's auspices to teach photography to young people in two local high schools. Lacking funds and cameras, she taught her young students pinhole photography, a technique of capturing an image by making a small aperture in a cardboard box. De León later taught in public schools in the South Bronx, carrying her camera on her walk from the subway station to the school. The devastation to be found in the South Bronx in the 1970s and early 1980s was overwhelming; entire blocks had been torched by arsonists, who often were absent property owners seeking insurance payouts. When she arrived there, she was shocked to see a neighborhood that had been "completely burned down." De León photographed what she saw: almost surreal landscapes of rubble-strewn lots; building after building, once homes, now burned, hollow shells; and long stretches of empty streets. But this was also home to de León's young students, whom she captured playing, exploring, posing. There is poignancy to much of this work—this is where young children were growing up; it was the only world they knew. She often portrayed youthful glee, children playing hopscotch and touch football or using large, empty lots as their playgrounds. "Everyone would capture the fires," stated de León, "but I wanted to capture the life that was there, the spirit of the kids . . . the resilience."[9] De León's achievements are significant; she was active as a street photographer in the South Bronx when few other women ventured

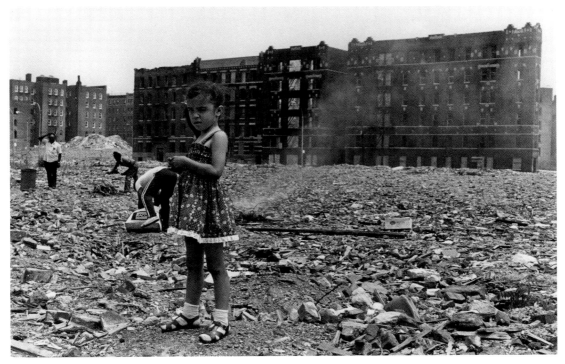

3.7. Perla de León, *My Playground*, 1980. Gelatin silver print. © Perla de León.

out into the neighborhood, and when the few Latina photographers who were active received little recognition for the work they produced.

In the same period, another photographer associated with En Foco, **Sophie Rivera** (b. 1938, New York; based in New York), boldly photographed the everyday life she knew in Upper Manhattan. To make one large series of portraits in the late 1970s, she stopped passersby outside her building, asking them if they were Puerto Rican and if they'd like to sit for her camera. Upstairs in her studio, she made a series of starkly lit, uncompromising portraits of these people—anonymous people, but for her, life-affirming symbols of a persevering community. Rivera printed the photos in large scale (45 by 36 inches) as a means of monumentalizing otherwise anonymous subjects and of compelling the viewer to confront and engage with their humanity. In 1989, under the auspices of En Foco and New York's Public Art Fund, Rivera

3.8. Sophie Rivera, *Portrait of Man in a Hooded Jacket*, from the Latino Portfolio, 1978. © Sophie Rivera.

installed selections from this series in a passageway of the Yankee Stadium subway station, where they would be seen by thousands of people.

Of a later generation, **Luis Carle** (b. 1962, San Juan, Puerto Rico; based in New York) focused on a subject that is often overlooked in the Latinx community, creating an expansive record of queer Latinx life in New York and beyond. His work has spanned a broad arc of gay culture and history in New York and other cities, from the years of the AIDs crisis to ongoing activities pressing for LGBT rights. "My generation," he has stated, "was the one between oppression and freedom."[10] Carle has photographed demonstrations and gatherings

3.9. Luis Carle, *Amanda Lepore*, Wigstock 2018, New York City. Courtesy of the artist.

in New York and Washington, DC, the club scene, transgender activists, and gay pride parades. Above all, his imagery demonstrates the power of a large community passionately dedicated to asserting its rights and presence. Photographs of a gay rights march in the nation's capital and the infamous black parties are impressive for the massive, energetic crowds they capture. This community, Carle announces with his work, lives life on its own terms and is a force to be reckoned with. He has also made portraits of members of his community—friends, activists, drag performers, and DJs. At the same time, Carle is responsible for other varied bodies of work, including moody figure studies, abstracted studies of light and shadow, and the Santos in Bags series, photographs of statues of saints placed in plastic bags that playfully repurpose a particularly Puerto Rican form of Catholic spirituality.

While New York was home to numerous street photographers in the 1970s and 1980s, Latinx photographers were similarly active in other parts of the United States. One singular, little-known figure is **Luis Medina** (b. 1942, Havana, Cuba; d. 1985, Chicago, Illinois), who arrived in Miami in 1961 as a young adult with the early wave of Cuban political exiles. He was one of the first Cuban Americans of his generation to dedicate himself to the photographic medium. Unfulfilled by a string of unchallenging jobs in Miami, he left for Chicago to study sculpture at the School of the Art Institute. But by the early 1970s he was immersed in the world of photography. In and around Chicago, he worked with his partner, José López, photographing architecture and Americana, looking at places and things as fascinated outsiders. Storefronts and everyday street scenes, carnivals and parades, were all of interest to the young photographer. By 1977, working on his own, Medina began to study and photograph graffiti, wandering streets to document tags before they had been sprayed or written over by others, and seeking out what he saw as the finest examples of graffiti writing. As curator David Travis has stated, Medina understood graffiti as a defiant expression of self, and he approached his documentation "not from the perspective of an archivist as much as a connoisseur."[11] He also portrayed their makers, young members of the Latin Kings or the Puerto Rico Stones, who would convey their trust in him by posing for photographs before their walls. In addition, Medina depicted expressions of local Latinx culture, both traditional and contemporary, that he discovered in Chicago, such as a Puerto Rican motorcycle gang and Santería rituals, all of which Medina photographed in vibrant color, always projecting a sense of boldness and intellectual curiosity.

Max Aguilera-Hellweg (b. 1955, Fresno, California; based in Stamford, Connecticut) has also had a long and evolving career in photography, a medium to which he was drawn as a child when he discovered his father's World War II photo albums. His unconventional biography includes a period as Annie Leibovitz's assistant at the age of seventeen, work for *Rolling Stone* magazine, hitchhiking around the world, filmmaking, a degree in medicine, and extensive work in both commercial and artistic photography. His early 1990s series La Frontera sin Sonrisa (The Border without Smiles) was inspired in great part by a long and drawn-out search for his cultural and racial identity, as well as by his memories traveling with his family to border towns as a child. For this

3.10. Luis Medina, *Gang Member, Sons of the Devil*, 1978. Silver dye-bleach print, 13¼ × 8¾ in. Courtesy of the Art Institute of Chicago / Art Resource, New York.

series he made portraits in East Los Angeles, Mexico City, the border town of Piedras Negras, and other locales, working in the manner of a latter-day *ambulante*, inspired by itinerant Mexican photographers of the early decades of the twentieth century who traveled from town to town to make portraits for those who could not afford studio portraits. Using a 4 × 5 field camera and working in black and white, Aguilera-Hellweg documented common people in public places, conscious of the deep importance that having one's picture taken once had in Mexico, when it was still an uncommon event. *Sin sonrisa*—without smiles—refers to the solemnity that many Mexicans have often projected before the camera, a quality that can suggest a sense of stoicism or a reverent revelation of self. Along the border at the Rio Grande, Aguilera-Hellweg photographed *The Lovers* (figure 3.11), a couple whose tight embrace suggests that they have little to depend on beyond each other. In *VNE*, three young women display hand signals to mark their affiliation to Varrio Nuevo Estrada, a gang that originated in an East Los Angeles housing project. Two of the figures stare forthrightly at the camera while the third closes her eyes as if rejecting the camera's insistent gaze.

In the late 1980s Aguilera-Hellweg took a magazine assignment to photograph the work of a neurosurgeon, and his time in the operating room became an epiphany for him. Aguilera-Hellweg not only based much of his future work on topics related to medicine and the body, but also went on to attend medical school and became a physician, a direct if radical means for an artist to understand the human condition. He has made photographs of doctors, patients, medical conditions, and surgeries, portraying a frank intimacy that

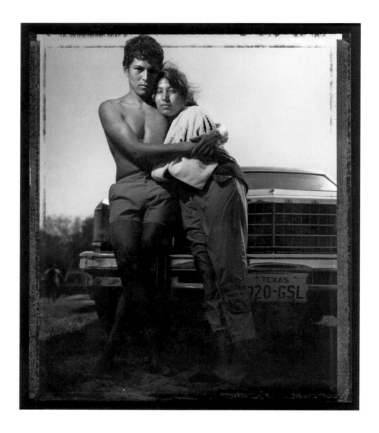

3.11. Max Aguilera-Hellweg, *The Lovers*, 1989. Courtesy of the artist.

is rare in medical photography. Aguilera-Hellweg has also used his preoccupation with the human body as a springboard for constructed compositions, noirish scenes of body specimens or of the tools and equipment of hospitals seen from nightmarish perspectives.

In varied ways, Latinx photographers have also examined aspects of the American justice system. **Joseph Rodriguez** (b. 1951, Brooklyn, New York; based in Brooklyn) dedicated his first extended series to life in El Barrio in the 1980s. Working there a decade after figures like Hiram Maristany and Máximo Rafael Colón became active as photographers, Rodriguez portrayed a neighborhood where poverty had endured, at a time when new social issues—the crack cocaine epidemic, drug dealing, and attendant gang violence—made life increasingly burdensome for East Harlem residents. Rodriguez was well acquainted with living with these kinds of challenges; growing up as a

working-class Puerto Rican in Brooklyn, he struggled with drug addiction and spent time in prison.[12] Since that time, he has dedicated much of his career to documenting violence, whether from the point of view of youth gangs, the prison system, or gun violence. "My aim is to get to the core of violence in America," said Rodriguez. "Not just the physical violence against one another but the quiet violence of letting families fall apart, the violence of unemployment, the violence of our educational system, and the violence of segregation and isolation."[13] He has also discussed his process as one of "working slowly," a means of aiming to diminish distance and to develop a deeper understanding between people.[14] Rodriguez's photographs, whether of men or women reentering society after serving prison time or of young Latinx gang members in Los Angeles, express a deeply nuanced view of a flawed social system that allows prisons to be a predictable destination for young people of color. Throughout his work, he has consistently demonstrated that photography can function as a social and ethical tool, one that can teach lessons, reflect hope, and express the humanity of people enduring struggle.

In the same period, **Ángel Franco** (b. 1951, Bronx, New York; based in New York), a long-time Pulitzer Prize–winning photojournalist with the *New York Times*,[15] was traveling internationally as a freelance journalist, working in war-torn El Salvador in the late 1970s, when he realized that the kind of violence

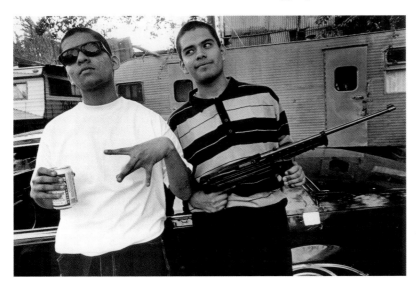

3.12. Joseph Rodriguez, *Porky and Pony from the Maravilla Mariana Gang*, East LA, undated. Courtesy of the artist / Gallery Stock.

he encountered in Latin America had a parallel much closer to home. More-over, as he saw it, civil violence and street crime, despite their differences, were rooted in social injustices. New York in this era was experiencing record levels of crime, and the South Bronx, where Franco grew up, had become an area devastated by high levels of arson, crime, and drug use. From 1979 to 1984, drawn by an impulse to document the struggles for survival and everyday life, he followed police offers and detectives of the Bronx's 46th Precinct. In an area known for its homicide rate (at that time, a murder was committed on average once every five days), Franco photographed gunshot victims, arrests, crime scenes, and abandoned children, creating a stark record of a struggling neighborhood that he understood intimately. About this period he has stated, "I saw a beaten folk. I saw a people desperate. I saw myself—where I came from and where I am still at, in many ways. I wasn't experiencing it as an outsider."[16] Franco also pursued this work to make a political statement. "The whole thing with 'the 46th' is that there is no resolve. I would see children who witnessed murders of family, corpses on the street. If there is no help for a community like this, it doesn't stand a chance."[17]

In contrast, **Camilo Cruz** (b. 1971, Los Angeles, California; based in Los Angeles) has photographed the criminal justice system from within the courts in Los Angeles. The child of parents who were active in the Chicano civil rights movement in Los Angeles in the 1960s (his father was a legendary civil rights attorney), Cruz refers to himself as a "bureaucracy artist," one who has found ways to merge his work as a community relations officer for the Los Angeles Superior Court with his work as an artist. About his practice he states, "I have witnessed and played a part in government from the standpoint of an artist and criminal justice administrator. My conflicting experience inside the legal system has inspired me to assemble scenes of justice into visual art about humanity, its survival, and its evolution/devolution inside the institution."[18] In one series of work, Cruz paired portraits of a judge and the accused, often assuming similar poses and becoming so closely aligned by means of the photograph that a striking level of tension is achieved. In other compositions, faces turn away from the camera, or are partially masked by means of double exposures with images of the courtrooms themselves. He has also led workshops in a detention facility for women, guiding participants in activities aimed at introspection and then photographing them as a way to memorialize

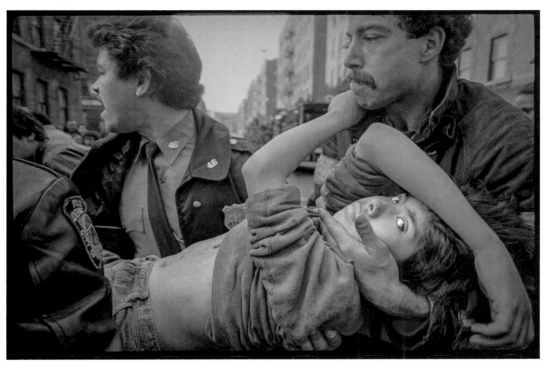

3.13. Ángel Franco, *46th Precinct, The Bronx*, 1982. Police and firefighters respond to a boy who was shot while riding his bike in front of the building where he lived, as a result of a shootout over a territorial dispute between drug dealers. Black-and-white silver gelatin print, 16 × 20 in. Courtesy of Ángel Franco and Estate © 2019.

the ethos of an inmate's life purpose, as it was discovered within the confines of a prison. This form of portraiture underscores how these kinds of institutions affect the body and the human psyche. "By exposing the justice system, my place of employment, as a massive 'theater' of souls," he states, "I strive to capture the imagination of justice leaders and governmental institutions and ask them to consider the relationships between institutions and the public they serve on a more profound basis."[19]

The 1970s and 1980s represented a coming-of-age for Latinx photographers. Although some discussed here were self-taught, many who emerged in the

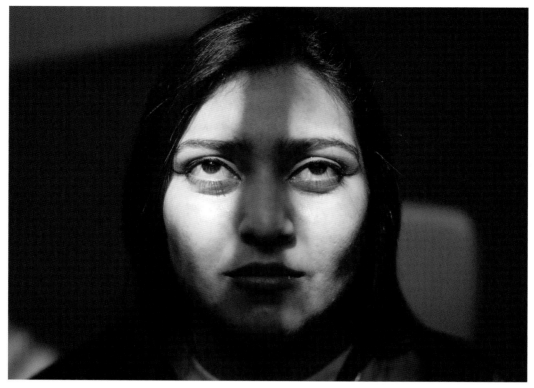

3.14. Camilo Cruz, *Untitled*, from the series Portraits of Purpose, 2015. Courtesy of the artist.

years after the civil rights era were the first in their families to have the advantage of higher education; they also represent the first generation of Latinx individuals to attend art school in any number. They tended to work in neighborhoods close to home and primarily in large cities, at a time when older American cities, especially the so-called inner-city neighborhoods that were home to people of color, were in the throes of decline. Photographer David Gonzalez stated that when, after attending Yale, he returned to the South Bronx neighborhood where he was raised, he was shocked by the conditions he saw all around him. Working with the camera became a way to make sense

of the devastation. "It was important to not forget what happened," he has said, in speaking of that period.[20] Similarly, Ricky Flores stated, "Photographing my community, coupled with the turbulent and violent transformation of the landscape around us, galvanized me to document what was taking place around me. It wasn't an atypical experience to photograph a fire taking place on our block on any given day, just like it wasn't atypical to take photos of kids playing in the park or on the street or in some abandoned building. It was a commonplace experience for us."[21] The fact that these photographers were turning their gaze on what was commonplace meant that they were portraying what they knew, what they felt needed remembering. Children playing in lots reduced to rubble, the strangers who agreed to sit for Sophie Rivera, the gang members who came before René Gelpi's camera, people caught up in the criminal justice system—all projected a humanity that needed to be seen and understood as part of the broader American experience.

4

LA Chicanx

B Y THE 1980S, LOS ANGELES WAS THE LOCUS FOR A
maturing community of Chicanx artists, one still deeply
committed to the ethos of the Chicano civil rights movement but whose work
also manifested a broader set of interests and visual approaches. Thanks to
new tides of immigration, the Mexican population in the city was increasing
rapidly, more than any other ethnic group. In fact, by the end of the 1980s, the
number of people of Mexican origin in LA was second only to the number in
Mexico City. The east side of the city—long home to a large and established
Mexican American population—experienced the arrival of increasing num-
bers of Mexican immigrants, now joined by Central American immigrants.
Moreover, Latinx people were moving to other parts of the city, especially to
South Los Angeles, traditionally home to African American communities, and
nearby suburbs.

For Chicanx artists in Los Angeles, an art movement that had begun in
the late 1960s as an outgrowth of civil rights struggles—once characterized
by such formats as muralism and printmaking—had grown into a vibrant art
scene. A younger generation of artists was working with video, installation,
and conceptual approaches to art making. Others had turned to easel paint-
ing and were finding success exhibiting in commercial galleries. Significantly,

especially by the end of the 1980s, Chicanx artists were receiving greater public and critical recognition, even international attention. *Le Démon des Anges* (The Devil of the Angels), a major 1989 exhibition organized by the Centre de Recherche pour le Développement Culturel (Research Center for Cultural Development) in Nantes, France, traveled to several European venues, introducing Chicanx artists to audiences abroad.[1]

A major exhibition organized by UCLA's Wight Gallery, *Chicano Art: Resistance and Affirmation* (CARA), represented a true coming-of-age for Chicanx art. Inaugurated in 1990 after years of research and planning by a team of Chicanx scholars and curators, *CARA* featured artwork by some ninety individual artists and collectives from the earliest years of the movement through the 1980s. The traveling exhibition was seen by more people than any previous exhibition of Chicanx art, appearing at ten venues across the United States including the Denver Museum of Art, the National Museum of American Art of the Smithsonian Institution, the San Francisco Museum of Modern Art, and the Bronx Museum of the Arts. With such a large audience and presentation at major institutions, *CARA* represented a watershed event for Chicanx artists and for the art world, then beginning to take steps toward a more inclusive embrace of contemporary art. Contextualizing Chicanx art through the lens of history and politics, it challenged art audiences and institutions to look beyond Eurocentric narratives and to understand Chicanx art as a dynamic aspect of modern and contemporary American art.

CARA received extensive critical coverage, both positive and negative. Its detractors, especially art critics who wrote for mainstream publications, faulted the social and political framework of the exhibition or, more simply, the quality of the art itself. Eric Gibson, writing in the *Washington Times*, suggested that the exhibition represented a visual form of affirmative action, writing, "it is simply another attempt to cater to and/or pacify some political interest group at the expense (as always) of any real aesthetic standards."[2] Nevertheless, *CARA*, along with other shows, played a crucial role in broadening the playing field and in prompting broad reexaminations of the power structures at work in the art world. *CARA* and other exhibitions also illuminated growth and change among Chicanx artists in the 1980s. Expanding beyond the roots of populist art closely aligned with community activism, members of a new generation of

Chicanx artists were increasingly working with new media and approaches and tackling new subject matter.[3]

This move to mainstream acceptance, however, was not without controversy. An influential article by artists Malaquias Montoya and Lezlie Salkowitz-Montoya took Chicanx artists to task for seeking validation from mainstream institutions and for moving away from the community focus and identity as a "people's art" that drove the early years of the movement. "Art that is produced in conscious opposition to the art of the ruling class and those who control it has, in most cases, been co-opted," they wrote. "It has lost its effectiveness as visual education working in resistance to cultural imperialism and the capitalist use of art for its market value." And moreover, "Chicanos cannot claim to be oppressed by a system and yet want validation by its critics as well as by the communities. . . . It will be a victory when Chicano communities find Chicano artists a success because they are viewed as spokespersons [and] citizens of humanity, and their visual expressions viewed as an extension of themselves."[4] Shifra Goldman, a pioneering historian of Chicanx art, responded to these arguments, labeling them separatist and stating, "By 1980 the Chicano movement had attained many of [its] objectives, and can confront the mainstream from a position of strength and self-awareness. Its vanguard—political militants, artists, intellectuals, self-education workers, students—now have the twin obligation of disseminating and testing constantly evolving new ideas within the U.S. Mexican community, and potential allies outside that community."[5]

Amid this evolving and highly active art scene, Chicanx *photographers* remained much less visible. Many remained devoted to documentary modes and to chronicling the local scene, but by the 1980s, Chicanx photographers were working with a multiplicity of approaches to communicate concerns both political and personal.

John Valadez (b. 1951, Los Angeles, California; based in Los Angeles), best known as a painter, was photographing around East Los Angeles during the same years as Oscar Castillo, concentrating on street portraiture of Chicanx youths. He came of age during a period of political ferment, when protests were raging against the Vietnam War (and the disproportionate number of young Mexican American men sent to fight in it), police violence, and the lack

of opportunity in communities of color. As Valadez stated about his early years as an artist, "I was a Mexican American kid embracing and trying to become a Chicano, trying to consciously make Chicano Art."[6] Through the subject matter, he aimed to create a cultural iconography relevant to his own community and to claim Chicanismo (political consciousness and pride of one's Chicanx identity) as positive and self-affirming. Valadez came to photography through painting; from his early days as an artist he was drawn to realism and to creating large-format images of barrio life. His dedication to a hyperrealist mode of depiction and his highly disciplined approach to his craft led to an interest in the camera as an aid in composition. Valadez's photographs depicting

4.1. John Valadez, *Couple Balam*, 1978–80. Courtesy of the artist.

the realities of life for Chicanx youths also provided direct inspiration for his paintings, and he would assemble several into one composition to produce dramatic allegories of the contemporary urban condition. Belatedly, these photographs have received exposure and critical attention in their own right.

Valadez's Urban Portfolio Project comprises full-length color portraits of adolescents Valadez encountered along the streets of East Los Angeles where he grew up and in nearby downtown Los Angeles. He produced these photographs early in his career, in the late 1970s, when he would walk the streets of Los Angeles and look for interesting people willing to pose for him. He has stated that he hoped to capture people who weren't being seen, who were marginalized.[7] The cholos and cholas in their highly stylized dress and the other young people who stood before his camera would

have been doubly marginalized—not only by the dominant culture for being Mexican Americans, but by the more mainstream Mexican American community, who would deride them as gang members. But standing before Valadez's camera, they assert themselves with little regard for mainstream convention or approval; they sought not to fit in but to live for themselves.

A groundbreaking figure in the history of Chicanx art, **Harry Gamboa Jr.** (b. 1951, Los Angeles, California; based in Los Angeles), was an activist before he became an artist; he was among the leaders of the series of walkouts from East Los Angeles public high schools in 1968, events that laid the groundwork for a broader mobilization of Chicanx activism in that city. A protest largely against unequal educational opportunity in schools populated by Mexican Americans, the walkouts (or blowouts as they are also known) gained national attention and were formative to Gamboa's career as an artist, one that links art making with a politicized sense of his Chicanx identity. With three of his classmates from Garfield High School, Gronk (Glugio Nicandro), Patssi Valdez, and Willie Herrón, Gamboa later formed ASCO ("nausea" in Spanish; active 1972–87), an art collective that became known for its interventions and performative work in the burgeoning Chicanx art period. The group staged absurdist theater pieces, "no movies" (essentially, staged photographs recording a single moment of an imaginary, nonexistent film, an ingenious if satirical strategy for artists of limited economic means),[8] and street actions (most infamously, spray-painting their names on an exterior wall of the Los Angeles County Museum of Art in 1972, an artistic intervention and public protest against the museum's then exclusion of Chicanx artists from its exhibitions and permanent collection).[9]

Gamboa initially pursued photography to document ASCO's performative actions, but the medium has played multiple roles in his vast oeuvre. In an era when Chicanx artists were still largely known for murals and canvases with representations of traditional elements and symbols of Mexican identity, ASCO staged public performances that acted as protests against the Vietnam War and the marginalized status of Chicanx people. At the same time, such works sardonically critiqued the kinds of conventional artistic formats, like murals and canvas paintings, that many of their peers were pursuing. Their 1972 *Walking Mural*, a "live" mural, parodied and upstaged the numerous murals then being painted around East Los Angeles through a procession

4.2. (*left*) Harry Gamboa Jr., *Salomon Huerta, Artist*, from Chicano Male Unbonded series, 2008. Gelatin silver print, 11 × 14 in. © 2008 Harry Gamboa Jr.

4.3. (*right*) Harry Gamboa Jr., *Father Richard Estrada, Priest, Church of the Epiphany (Episcopal Church)*, from Chicano Male Unbonded series, 2017. Gelatin silver print, 11 × 14 in. © 2017 Harry Gamboa Jr.

down Whittier Boulevard—a long thoroughfare running through East Los Angeles—with members of the group dressed in gaudy clothes. In the 1974 *First Supper (After a Major Riot)*, the group staged a grotesque banquet on a median strip of Whittier Boulevard in the midst of rush hour as a commemoration of the Chicano Moratorium, a major political demonstration that had taken place along that street four years earlier. Gamboa took part in and pho-

tographically documented these and other performances by the group that were either largely ignored (like *Spray Paint LACMA*) or received only a modicum of attention. He was also the member of ASCO behind the camera for its collectively produced *No Movie* images. Through Gamboa's photos, we witness how the group moved—sometimes furtively and at other times assertively—into public and institutional space in transitory events whose significance has been appreciated only decades after their original performance.

Gamboa has also had a significant career as a solo artist; his work, spanning over four decades, encompasses literature, video, installation, performance art, and photography. All of this work, he has stated, has been motivated by a desire to interpret the Chicanx urban experience, a theme that is central to his seminal series, Chicano Male Unbonded. Gamboa began the project in 1991, inspired to create the body of work after hearing an announcement on his car radio to be on the lookout for a dangerous Chicano male. His aim, he has stated, was "to counter the issue of negative stereotypes by introducing a B&W photographic documentary project that would be based on my interpersonal encounters with the Chicano men who have impact on my life."[10] The series is made up of over one hundred full-length portraits of men of varied ages and professions. They are pictured alone, in isolated urban settings, and at night, with assertive if seemingly confrontational gazes. Gamboa repeatedly challenges racial and ethnic stereotyping with the series—each portrait is titled with his subject's name and occupation, including lawyer, artist, actor, editor, chemist, and film director. He also expands the possibility of the portrait genre, transforming it into a mode of social and political engagement, particularly through the serial nature of this work and through the active participation of the men who act as Gamboa's subjects.

Ricardo Valverde (b. 1946, Phoenix, Arizona; d. 1998, Los Angeles, California) found the life of the street an inspiration for a deeply creative body of work—photography, video, and sculpture. The city was a key player in his oeuvre, especially Chicanx culture in East Los Angeles (lowrider cars, Day of the Dead processions), as were members of his family and social circle. Valverde initially became involved with photography in the late 1960s while serving in the military, assigned to work as a journalist for a US Air Force newspaper. Later, while attending college and then graduate school, he always carried his camera with him, including when he traveled around the city as a meter reader

for the Department of Water and Power. As a result, street photography was an ongoing and fluid part of his life, and he constantly captured the realities, both banal and strange, that characterized his sprawling city. Valverde lived in East Los Angeles during the heyday of the Chicanx art movement and established close ties with many of the artists and organizations that were developing an alternative art scene in this largely Mexican American community. He took part in the founding of Self Help Graphics & Art, a community art center that began in East Los Angeles, and was a cofounder of Ojos, the Council of Latino Photography, and Chicano Art Collectors Anonymous. Valverde documented some of the first Día de los Muertos (Day of the Dead) events staged in East Los Angeles, a tradition begun in 1972 by Self Help Graphics and local artists as a means of reclaiming (and reimagining) an indigenous Mexican tradition. He photographed costumed and masked participants, performances by ASCO, and the large public processions that took place as part of the event. Día de los Muertos was a perfect theme for Valverde—as interpreted by ASCO and other local artists, it evoked life as vulnerable and erratic but also brimming with creative potential. Although inspired by traditions in Mexico (which can range from somber to celebratory in different regions of the country), the processions in East Los Angeles were raucous, transgressive, and spontaneous—manifestations of a Chicanx community that embraced difference, collective action, and cultural autonomy. Valverde also photographed lowrider car culture, people he encountered in his travels, and often members of his own family.

Later in his career, restless to push his work in new directions, Valverde began manipulating and altering his prints. He solarized his prints, created double exposures, painted over photographs, abraded prints, and scratched

4.4. (top) Ricardo Valverde, *Portrait of the Artist as a Young(er) Man*, 1991. Gelatin silver print with acrylic and hand-applied pigment, 6½ × 10 in. Courtesy of Esperanza Valverde; Ramon Garcia, author of "Ricardo Valverde," 2013; Cecilia Fajardo-Hill, art historian and curator; and Chon Noriega, director of the Chicano Studies Research Center at UCLA.

4.5. (bottom) Ricardo Valverde, *Boulevard Night*, 1979/1991. Hand-painted gelatin silver print, 8 × 10 in. Courtesy of Esperanza Valverde; Ramon Garcia, author of "Ricardo Valverde," 2013; Cecilia Fajardo-Hill, art historian and curator, and Chon Noriega, director of the Chicano Studies Research Center at UCLA.

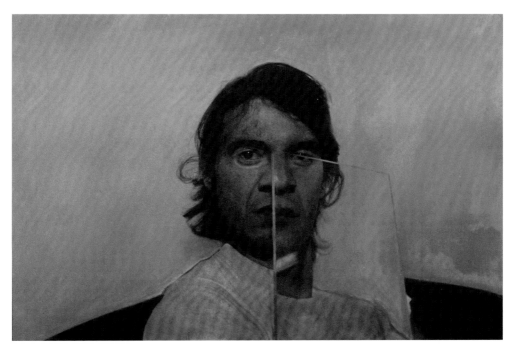

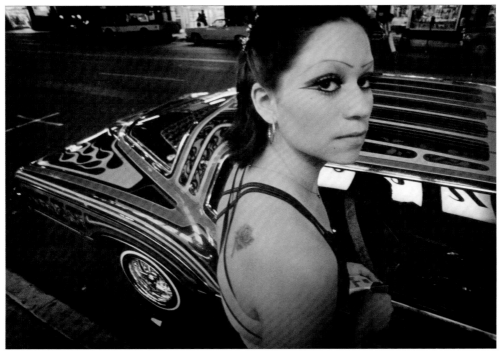

or burned 35mm slides before printing, often appropriating his older photographs for this experimentation. In doing so, he charged his images with a sense of the surreal and transformed his practice into a conceptual exploration of the limits and potential of the photographic medium. Now broadly seen as among the most innovative work in the corpus of Chicanx photography, at the time these creations were not well received among his contemporaries, who saw him principally as a street photographer and did not understand why he would destroy or deface his prints. Nevertheless, as Valverde's widow, Esperanza Valverde, has stated, "There was no turning back. Even though he was going back to his old images from the 1970s or early 1980s, he was creating a whole new piece, sometimes working it so much that the image beneath essentially disappeared."[11] For his 1991 *Portrait of the Artist as a Young(er) Man* (figure 4.4), Valverde applied acrylic paint over the entire print except around his eyes, accentuating his intent outward gaze. The sheet of glass that Valverde holds before him, precisely positioned to cover the lower half of one eye, distorts the angle by which we view his upper body and acts like a kind of shield. The photographer reminds us that despite his freewheeling creative evolution and unwillingness to conform to photographic convention, he was keenly aware of the medium's capacity to influence how we view the world. Here, he shows us how he viewed it—as messy, tinged with eroticism, and sometimes hallucinatory.[12]

The flourishing of the Chicanx art scene in Los Angeles in the 1980s also saw the rise of female photographers whose work has often received much less recognition than that of their male counterparts. They include figures like Diane Gamboa (b. 1957), a painter and fashion designer who also actively documented the underground punk music scene in East Los Angeles in the late 1970s and 1980s, and **Elsa Flores** (b. 1955, Las Vegas, Nevada; based in Hawaii), a photographer and painter. Both are emblematic of female artists within the Chicanx art scene in Los Angeles, who had little visibility. In the early 1980s Flores began to exhibit her photography locally, in Mexico City, and in exhibitions in New York organized by En Foco. She participated in the first exhibition of Chicanx photography ever organized, *Con Cariño: Photos of Another America*, held at the University of Erlangen–Nuremberg, West Germany, in 1983. Flores has termed her photographic work autobiographical; she documented the people around her, including artists, members of the band

Los Lobos, and family members, whom she would stage with unusual perspectives and lighting. Among her photographs are creative documentation of performance works by ASCO and of Chicanx bands like The Plugz, among the first Latinx punk bands, and others who performed at Los Angeles clubs. Early in her career, Flores experimented with painting on her photographs, in a thick impasto that obliterated parts of the image. She also experimented with Polaroids, manipulating the prints as they developed so that they would look like paintings. Working with photography in this way—and the lack of income she derived from the medium—encouraged her to move to painting.[13]

Flores also undertook her own performance work. In 1980, with Louie Pérez, a member of Los Lobos, she staged *Let's Put an End to This Nightmare* (figure 4.6), with Pérez carrying a large cross, embellished with a hubcap, photos of family members, and plaster casts of hands, in downtown Los Angeles

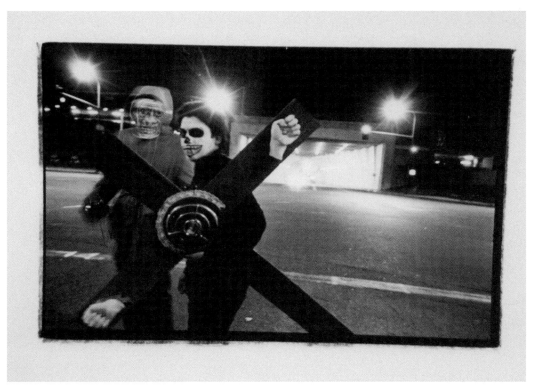

4.6. Elsa Flores, *Let's Put an End to This Nightmare*, 1980. Courtesy of the artist.

and through a traffic tunnel. Photographed by Flores, the action takes on the appearance of an absurdist evocation of the Crucifixion, the lone figure silhouetted against the harsh lights of an otherwise empty street.

Flores has been outspoken about the sexism and "boys' club" mentality of the early Chicanx art scene in Los Angeles, an outlook that contributed to the documentation of the scene's history—at least until recently—from a predominantly male perspective. She has stated that the attitudes toward female artists within the community at the time led her to make art that was more individual than group-oriented, while the challenge of making a living with photography compelled her to eventually return to painting.[14] Among her other projects, Flores collaborated with her husband, the noted Chicanx painter Carlos Almaraz (1941–89), and codirected the 2019 documentary film, *Carlos Almaraz: Playing with Fire*, about his life and work.

Isabel Castro (b. 1954, Mexico City; based in Los Angeles, California) focused on the female body, with images that frankly addressed issues related to feminism, women's rights, and the exploitation of women's bodies. She worked with photography in an experimental manner, including scratching and dyeing slides, printing on Xerox copiers, and hand-painting prints, all to heighten the emotive power of her images. Her 1980 series X Rated Bondage features shadowy images of women seemingly in the throes of sexual pleasure. Castro's subjects are seen in shadowy environments and are often placed off-center, as if the photographer caught these private glimpses in a rapid voyeuristic instant. The photographs, however, were taken from porn magazines. By rephotographing them, Castro compels her viewers to uncomfortably gaze at these figures, forcing a harsh recognition of the way women's bodies are exploited.

Castro's portraits of young Chicana women in her 1980 Women Under Fire series are forthright and tender—she gazed at these subjects directly, as equals, and also to call attention to a human rights issue. She made the series in response to learning about the sterilization of women, without their consent, at a major Los Angeles medical center in the 1960s and 1970s. Castro photographed female relatives of women who had been victims of forced sterilization and hand-colored the images with gestures meant to symbolize "the body under attack."[15] She presented these portraits as emblematic of women

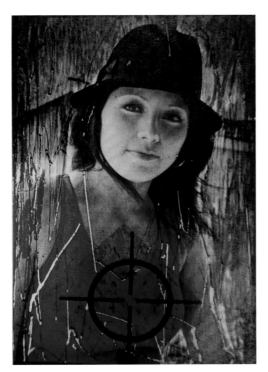

4.7. Isabel Castro, *Image #4*, Women Under Fire (coerced sterilization series), June 1980. Color Xerox, mixed media, hand painted, 8½ × 11 in. Courtesy of the artist.

vulnerable to the threat of violence, both obvious and less visible. In one photograph, Castro places over the chest of one woman the crosshairs of a rifle to create an image that is uncannily prescient when seen in the present day, in the context of the Me Too movement.

Laura Aguilar (b. 1959, San Gabriel, California; d. 2018, Long Beach, California) had a long career in photography, focusing primarily on figures of women and of her own body to forthrightly examine issues of gender and her multiple identities as Brown, queer, Mexican American, and female. In an early body of work, Latina Lesbian, Aguilar combined photographic portraits with texts to make powerful statements about women who, at the time, were a little-seen, marginalized community within the city's large Mexican American population. Her stark black-and-white photos convey a performative element; her subjects took an active, self-affirming role in the construction of their image and in authoring brief declaratory statements that accompany the images. The caption beneath the portrait *Carla Barboza* (figure 4.8) reads, "My mother encouraged me to be a court reporter . . . I became a lawyer."

"What I am trying to do with the series," Aguilar stated in 1993, "is to provide a better understanding of what it's like to be a Latina and Lesbian by showing images which allow us the opportunity to share ourselves openly, and to provide role models that break negative stereotypes and help develop a better bridge of understanding. . . . Within the Lesbian and Gay community of Los Angeles, people of color are yet another hidden subculture; we are present, but remain unseen. Through the work of this series, I have found this subculture to be a caring and diverse community of women who are quite proud and connected to their heritage."[16] With these works Aguilar presented the resilience

*My mother encouraged me to be a
court reporter...
I became a lawyer*

Carla Barboza Esq.

of subjects who are dually marginalized and whose outlooks were guided by a refusal to assimilate mainstream values and ways of life. In a subsequent series, the 1990 How Mexican Is Mexican, Aguilar's portraits of women are accompanied by the subjects' handwritten texts and by illustrations of thermometers indicating the women's level of consciousness of their ethnic identity.

Aguilar turned to her own body for later series. Her 1990 *Three Eagles Flying* (figure 4.9), among the most powerful images in the corpus of Chicanx photography, is a triptych depicting the artist seen against a stark black background, flanked by the flags of the United States and Mexico. Her partially

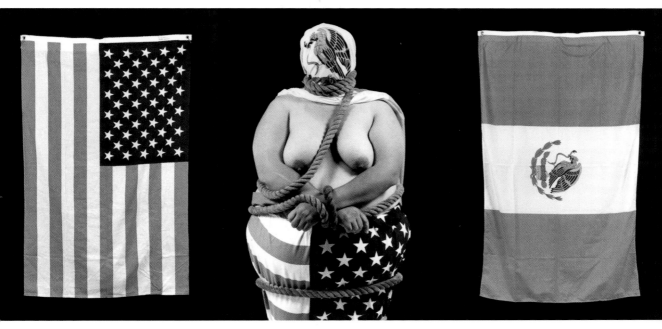

4.9. Laura Aguilar, *Three Eagles Flying*, 1990. Three gelatin silver prints, 20 × 20 in. each. Courtesy of Christopher Anthony Velasco, owner trustee of the Laura Aguilar Trust of 2016.

nude body is covered and bound by the flags of the two nations and by thick rope, giving literal expression to a dual cultural heritage that has overwhelmed her sense of individual identity. The ropes trap her, binding her hands and neck, while a Mexican flag covers her head. Aguilar's face is masked by the coat of arms in the flag's center, an eagle holding a snake in its mouth, a symbol of the Mexican nation, of strength, and here, of the artist herself (the surname Aguilar is derived from *águila*, Spanish for eagle).

In the 1999 Stillness series, Aguilar photographed herself with other women, using the stark desert landscape of southwest Texas as backdrop. Photographing in black and white, Aguilar depicted herself and other women nude, their bodies arranged as if primal elements of nature, forces to be reckoned with. She sometimes has her back to the camera, emphasizing the body's form in relation to the large boulders in the landscape. Less a statement on the artist's

identity as a lesbian, at their core these images are laden with emotional and spiritual meaning for the artist, particularly in their depictions of women who defy conventional notions of ideal beauty and sexual identity, yet who present their bodies with seeming ease. They also act as a political response to the tradition of modernist nude photography, dominated by the objectifying male gaze. Aguilar's work provides a feminist response to such forms of photography while also paying homage to a pioneering feminist photographer, Judy Dater, whose 1982 *Self Portrait with Stone* presents the body as sculptural and in communion with the earth.[17]

Chicanx photographers active in the 1980s and 1990s focused above all on the individual, affirming that Chicanx identity could not be understood in monolithic (or stereotypical) terms. John Valadez's portrayals of urban youth, Harry Gamboa Jr.'s project Chicano Male Unbonded, and Laura Aguilar's forthright depictions of Latina lesbians, to name a few, demonstrate that there is no one way of being Chicanx. As the scholar Chon Noriega stated when discussing Chicano Male Unbonded, "I think that what the series achieves is not to give you the correct definition of Chicano male, but to give you nearly 100 answers to that, to really push for the individuality and diversity of people who identify as part of a group, in the same way we all identify as Americans."[18]

By extension, the photographers discussed in this chapter contributed to that idea; the people who came before their cameras represented both collective and individual ways of being. And, as Noriega suggests, they are Chicanx *and* American, coalescing not around a shared mindset but around desires for self-determination and the freedom to define oneself autonomously. By 1990, the Latinx population of Los Angeles was nearing 40 percent, almost equal to that of whites who were not "persons of Spanish/Hispanic origin or descent," in the parlance of the US census categories of that year. And while the civil rights struggles that began in earlier decades had resulted in important gains—for example, the unionization of agricultural workers, broader access to education, and expanded voter rights—poverty persisted and discrimination against Latinx people remained pervasive. The 1994 ballot initiative California Proposition 187 (also known as SOS, or Save Our State) enacted stringent new policies against undocumented immigrants, reflecting the racially divisive climate

that endured in the state a generation after students and farmworkers rallied for equality.[19] What *had* changed in the intervening years was the emergence of an emphatic sense of self-affirmation and ethnic pride captured by photographers who exemplified a similar desire—to create art on their own terms.

5

Staging Self, Narrating Culture

THE EMERGENCE OF A NEW GENERATION OF ARTISTS and photographers at the end of the 1980s and into the 1990s signaled a new phase in the history of Latinx photography. Members of this generation brought new aesthetic sensibilities to their work, devising an array of unconventional photographic modes to pursue a largely identity-based discourse. The exploration of identity in all its guises, in fact, was a broader tendency in American visual art in these years. Women artists, artists of color, queer artists, and others pushed against the mainstream and status quo values while innovating new approaches to art making. Photography proved to be a potent tool for imagining a complex sense of self, one that was layered, hybrid, or in conflict with conventional social norms. As a new generation of photographers took on issues of race and racial politics, gender and sexuality, and cultural heritage and hybridity, they freely deployed new ways of approaching the photographic medium. The privileged position of "straight" or street photography gave way to numerous forms of experimentation, in essence acting to liberate photography from the purist dicta of previous decades. While forms of photographic manipulation had existed throughout the twentieth century,

such techniques as altering negatives or prints, photomontage, combining images with text, and integrating photographs into installations and other artistic media were becoming common, no longer at the margins of photographic practice. Such approaches offered artists potent means of examining the complex intersections of race, ethnicity, and gender.

Many Latinx photographers also turned to staged or constructed photography to create emblematic images of culture. Such techniques as layering or collaging images, combining disparate objects or subject matter, overlaying cultural symbols, and other forms of manipulation became means of expressing the complexity of Latinx culture. Acts of layering took on literal meaning among artists who sought to give visual form to the distinct historic phases of the Spanish-speaking Americas—broadly speaking, the ancient, colonial, and modern eras. Moreover, the layering of disparate symbols drawn from indigenous spiritual beliefs and Catholicism, from Spanish and English, from north and south of the border, and so on point not only to cultural hybridity's potential to become a generative source of new visual forms but also to photography's capacity to convey meaning well beyond physical realities.

Photographers who articulated new approaches in the 1980s—figures like Don Gregorio Antón, Kathy Vargas, and Juan Sánchez—did so well before the era of digital photography and Photoshop techniques. Through elaborate forms of manipulation and staging, as well as through meticulous craft, these photographers created fabricated or staged images that anticipated the digital realm. Relying on the artist's hand and on techniques improvised in the studio or in the darkroom, their approaches underscore how the adaption of new visual languages could define cultural identity on one's own terms.

While not strictly a photographer, **Juan Sánchez** (b. 1954, Brooklyn, New York; based in Brooklyn) has long drawn on photography as the basis for mixed-media works charged with symbolic meaning. Among the most significant Latinx artists of his generation, Sánchez has directed his oeuvre toward an exploration of his Nuyorican identity and the disparate influences that contribute to it—African, Taíno (indigenous Caribbean), and Spanish cultures; Catholicism and Afro-Caribbean spiritual practices; contemporary pop culture; and his own family. As an adolescent growing up in a working-class migrant family in Brooklyn, Sánchez became politicized in great part as a result of his encounters with the Young Lords, the activist group that worked to foster cultural

pride among Puerto Ricans while also engaging in social action and political protest. Ideas espoused by the Young Lords, especially political independence and self-determination for the Puerto Rican people, became the impulse for artworks that portray political activists—Puerto Rican and others—as heroes and martyrs who have been imprisoned or murdered for their cause. Sánchez's deep exploration of his identity, cultural and political, is the fundamental theme of his work.

The background of many of his compositions is composed of the repeated photographic image of a face shrouded in a Puerto Rican flag, laid down in

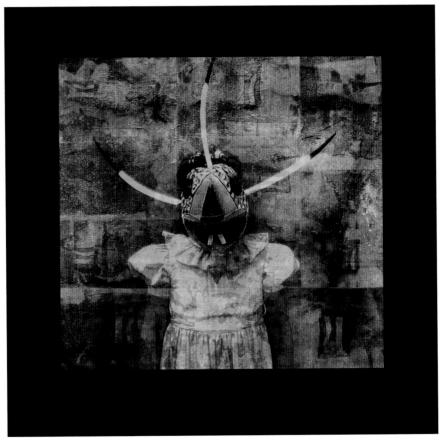

5.1. Juan Sánchez, *Niña Vejiganta*, 2010. Archival pigment print on watercolor paper, 21 × 20 in. Courtesy of the artist.

grid-like fashion on paper or canvas. This symbol of personal and political repression acts as a literal framework and foundation; it is a starting point and unifying statement whether his principal subject matter is family, politics, or the survival of popular Puerto Rican traditions, as in *Niña Vejiganta* (figure 5.1) from the series Unknown Boricuas. Sánchez titled this series with intention, conscious that *Boricua*, a self-defining term many Puerto Ricans use as a sign of cultural pride, is derived from *Boriken*, the indigenous name of the island of Puerto Rico. For Sánchez, the image of a young girl wearing the mask of a *vejigante*—a Medieval symbol of the Moors defeated by St. James the Apostle, and in modern practice a symbol of resistance to colonialism and imperialism—acts as a layered statement about human struggle and perseverance, expressing the survival of popular culture and the African and indigenous roots of the Puerto Rican people against a backdrop evoking the island's current political status. In discussing his approach to constructing imagery, Sánchez has explained, "I think I have to start with the essential reality of why I started making this work to begin with, and part of it has to do with the amnesia of history. . . . memory is something that is maintained in the minds of people once it manifests itself in writing or some other form of documentation such as drawings or recordings. To give it physicality, to create an object that is referential to that memory (or to history), has always been a struggle through colonialism."[1]

Kathy Vargas (b. 1950, San Antonio, Texas; based in San Antonio) began her career in the early 1970s as a rock-and-roll photographer. Her freelance gigs shooting concerts and portraits provided some income, but early on she found greater satisfaction in documenting the life and environment of her east San Antonio neighborhood. While attending the University of Texas at San Antonio in the 1970s, Vargas took courses with painter Mel Casas, leader of Con Safo, a pioneering organization of Chicanx artists active from 1968 to 1976. Like other artist groups in the early Chicanx era, Con Safo aimed to create work relevant to its community and to encourage greater recognition for artists who then had little visibility. Vargas was a member for only a brief period, but the group's politicized stance and their sense of urgency in defining a Chicanx sensibility through visual art had a deep impact on the young artist.[2] Among her earliest personal projects was documenting the yard shrines common in her largely Mexican American neighborhood. By 1980 she

began to define a distinct visual language, working with a 4 × 5 view camera and experimenting with such techniques as double exposures, constructing scenes for the camera, and toning or hand-coloring prints to produce images that spoke to memory, emotion, and personal forms of spirituality. She was also influenced by an imaginary that included her grandmother's ghost stories and her father's retelling of pre-Columbian myths.

Vargas's form of image making also became corollary for the expression of identity. She has written (with photographer and curator Robert Buitrón) about how Chicanx individuals live *layered* lives, a quality that stems from the mix of languages spoken at home, the multiple historic and cultural influences that shape identity, and the need to negotiate between disparate spheres, from family and local community to society at large, and from borders north to south.[3] Her work of the early 1980s, still lifes arranged from organic elements (plants and flowers, bones, dead birds) juxtaposed with objects (tin *milagros*, pieces of fabric and paper, gold and silver leaf, strips of photographic film, human X-rays) and set in tightly framed spaces act as visual meditations on this layering. Vargas photographed these assemblages and then hand-painted portions of the photographic print, sometimes including objects as elements of the work.

Vargas dedicated much of her work in the 1990s to friends who had died during the AIDS crisis as well as to departed members of her family. Traditional Mexican attitudes toward death, Day of the Dead rituals, and memories of a grandmother's discussions with her as a child led her to elaborate images that express death as both physical and

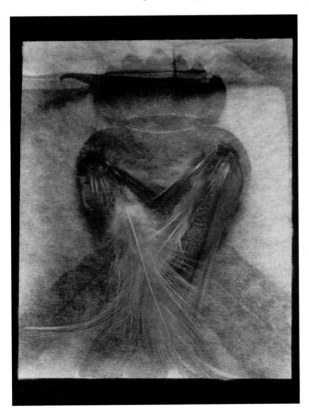

5.2. Kathy Vargas, *"A" Series #1*, ca. 1992–94. Courtesy of the artist.

spiritual. Works in the series Oración: Valentine's Day / Day of the Dead are hand-colored gelatin silver prints with double exposures of human skulls as well as of milagros, thorns, and hearts. Other series contained portraits and texts dedicated to friends who had died of AIDS-related illnesses; these images act as elegiac tableaux, a form of visual prayer in which absence, desire, memory, and loss are made palpable. "I don't use a *lot* of 'reality' in my work, but I refer a lot to events in the world," she stated. "I'm not taking pictures on the front line of the Persian Gulf, but I am talking about it, and about AIDS and apartheid. I'd like to think that I'm fighting death that way."[4] These images also take her full circle, evoking the street altars and shrines common in the San Antonio neighborhood in which she has long lived, which she documented as a young photographer.

Explorations of spirituality and mortality also preoccupied **Don Gregorio Antón** (b. 1956, Los Angeles, California; based in San Miguel de Allende, Guanajuato, Mexico). Over the course of decades, Antón pursued idiosyncratic technical modes with the aim of visualizing the unseeable, motivated by his own lifelong spiritual quest, by visions he has experienced, and by stories told to him by elders in his family. Early in his career, in the late 1970s, he photographed nude figures, composing with light and shadows and obscuring elements to produce intimate scenes with a heightened sense of mystery. In the early 1990s Antón began to move toward his mature style, which reveals the influence of his grandmother, a *curandera* (healer). In one series he depicted supine human bodies, some illuminated by intimations of fire and evoking a return to a primal, mystical experience of life. His images of this era conjure dream states and the realm of myth.

In the first decade of the twenty-first century Antón began his Retablos series, inspired by his childhood experiences as an altar boy. He was moved by Catholic ritual and its teachings of hope and faith, but the church was also the place where he would see remarkable visions of the Virgin Mary and other saints coming to life. The photographs in the series, dramatic staged narratives accompanied by handwritten texts, draw from the Mexican popular tradition of *retablos*, small devotional scenes typically painted on tin to offer thanks to the Virgin Mary or other saints for healing or for answered prayers. Often photographing himself in these scenes along with others, Antón created enigmatic, otherworldly visions, as if conjuring arcane revelations or alternate realities. In

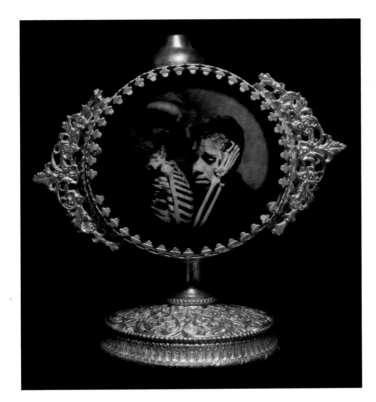

5.3. Don Gregorio Antón, *Estoy Aquí*, 2008. Translucent image, transferred on scratched, burned, and painted copper. Courtesy of the artist.

one work, he depicts a scene glowing with a mysterious light, of a man seated at a table who appears to receive knowledge from a half-earthly being. In another, from 2007, two figures—a man and a skeleton—are seated in a large wooden boat being pushed out to sea by another figure. Shrouded in darkness, they seem about to embark to points unknown, unfettered by earthly concerns.

Antón printed these images on translucent membranes adhered to copper plates that he flame-treated, etched, sanded, and then hand-painted. With pencil, he inscribed prayerful texts, or "lessons" as he has called them, to the works' surfaces, underscoring the revelatory nature of his artistic practice. In one series, he framed small photographs and personal relics sealed in wax within elaborate gold monstrances, the kind used in Catholic masses and processions to display the communion host or holy relics. In these ways, he conflates his own Catholic upbringing with a mystical form of spirituality. The artist, also a legendary teacher of photography, sees these images as a way of

meditating upon metaphysical aspects of human existence; he explores the arc of life and the universality of human emotions—fear, desire, love, pain, grief, and above all, the quest to comprehend the unknown. Antón also pays homage to the oldest and most fundamental concept of art's purpose, as a form of sacred rite. Printing these images on copper, he distills photography to its essential form, as a medium that illuminates or inscribes with light.[5]

Examining varied themes and employing a range of innovative photographic approaches, **Delilah Montoya** (b. 1955, Fort Worth, Texas; based in Houston, Texas) has long been dedicated to expressing issues of identity through the lens of Chicana ideology. Through numerous bodies of work, she has reached back to symbols and concepts related to Aztlán, the spiritual homeland of Chicanx (and Mexican) people, understanding the US Southwest as occupied territory. Montoya has also created works that reveal contemporary manifestations of the syncretic culture of Latinx people in this region, one rooted in both indigenous American and Spanish traditions.

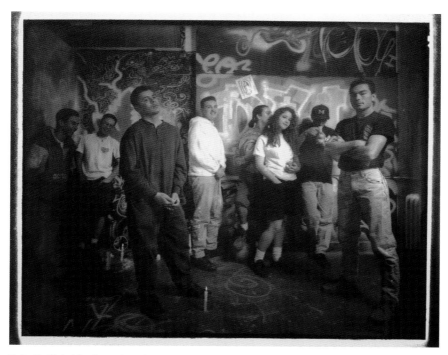

5.4. Delilah Montoya, *Los Jovenes*, 1993. Collotype. © Delilah Montoya.

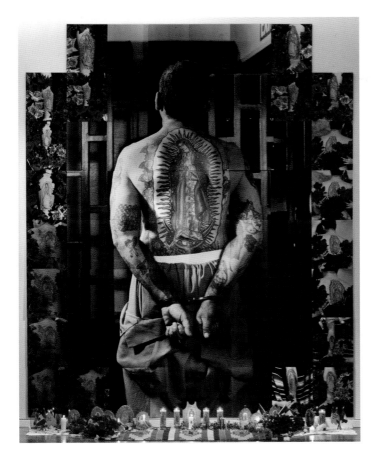

5.5. Delilah Montoya, *La Guadalupana*, 1998. Sepia-toned gelatin silver print and C-prints, 15 x 10 ft. © Delilah Montoya.

For the mid-1990s series El Corazón Sagrado / The Sacred Heart (figure 5.4), she elaborately staged portraits with members of Albuquerque's young Chicanx community as well as with noted artists and intellectuals to examine the influence of intersecting rituals—New Mexican Hispanic, Roman Catholic, and indigenous—on contemporary urban life. The ideological center of this work is the Sacred Heart, a symbol of Roman Catholicism representing Christ's suffering and compassion through the Crucifixion, as well as one connected to the Aztec practice of human sacrifice. When indigenous artists in Mexico were made to create imagery in service of the Church following the Spanish conquest, they stylized symbols and scenes in ways that reveal their preservation of indigenous belief systems within the very tools of colonization.

As Montoya has stated, "Basing my research on my own *Mestizo* perspective, I have concluded that this Baroque religious symbol expressed shared cultural religious patterns that connote a syncretic relationship between European Catholicism and Aztec philosophy."[6]

Montoya conceived this series as a collective portrait of the Chicanx community, one in which both the photographers and the participants share agency and creative power. She photographed with an 8 × 10 view camera and worked with a group of young people who spray-painted murals in the space that acted as backdrops for the portraits. Montoya invited each sitter to illustrate a facet of the Sacred Heart, an iconic symbol of Christ's suffering in popular Catholic tradition, by posing with artworks or objects of personal significance. The photographer's mechanic, Apolinar "Polo" García, posed with a carburetor, which he referred to as "the heart of an engine," while a young woman, Elena Avila, wearing traditional dress, enacted her real-life role as a *curandera*, or native healer. She also made portraits of such noted Chicanx figures as poet and activist Cecilio García-Camarillo, flamenco dancer Eva Encinias-Sandoval, and author Rudolfo Anaya, among others. With the youths, she depicted such figures and concepts as *la genizara* (a person of mixed ancestry), *la muerte y infinity* (death and infinity), and *teyolia* (an Aztec term roughly meaning one's soul or inner energy), thus representing the layered and evolving nature of Chicanx identity and expressing the resonance of ancient symbols in contemporary visual forms and perspectives. Uncannily, the graffiti backdrops created by the young people recall the exuberant baroque decoration of historic Catholic churches that survive in New Mexico.[7]

Throughout her work Montoya underscores dualities in Latinx culture—the sacred and the profane, indigenous and Spanish, public and private—themes that embody the complexity of a culture with ancient roots. For the 1999 series Guadalupe en Piel (Guadalupe on Skin; figure 5.5), she photographed male prison inmates whose backs are emblazoned with large tattoos of the Virgin of Guadalupe, the patron saint of Mexico. Montoya notes that these portrayals of the Virgin express the syncretism that is at the heart of Latinx culture. The tattoos are a vernacular form of Catholic devotion, evoking the Virgin of Guadalupe's first appearance in 1531 to the native Mexican Juan Diego, and the miraculous imprint of her image left on his *tilma* (outer garment) as proof of his apparition. But the significance of skin as symbol has

an even older source: the flayed skin worn by the pre-Hispanic Nahuatl fertility deity Xipe Totec as a symbol of fertility and rebirth. As Montoya notes, "the contemporary tattooing of the Guadalupe onto the back of the Hispanic inmate is not an odd coincidence—that is, if one trusts the collective consciousness. In many ways this practice suggests a ritual act meant to provide protection against harm and also empowers the inmate during the conflict by wearing 'Our Lady.' In following the myth, the tattooed inmate can be thought of as a symbolic Xipe Totec."[8] Montoya is also responsible for a 2006 documentary series on women boxers, a body of work that counters traditional Mexican attitudes toward women and femininity. In these black-and-white images, women defy stereotypical gender roles and present their bodies with forthright ease, in spite of their participation in a realm so closely related to the masculine and machismo.

María Magdalena Campos-Pons (b. 1959, Matanzas, Cuba; based in Nashville, Tennessee), who first arrived in the United States from Cuba in 1988, has worked with photography, performance, and installation to explore autobiography and family heritage, gender, spirituality, and the condition of exile. Campos-Pons traces her ancestry to Nigeria and China. Her Nigerian (Yoruba) ancestors came to Cuba as slaves and worked in sugar plantations, while her Chinese ancestors worked in sugar mills as indentured servants; the artist herself grew up on a former sugar plantation. "Exile has been our experience, our bloodline," she has stated. "When my ancestors moved to America, they brought their heritage with them. Home for us has been a history of displacement and relocation."[9]

A member of the generation of Cuban artists that emerged in the 1980s and that gained much critical recognition for the powerful manner in which their work spoke to Cuban social and political issues, Campos-Pons initially worked with painted relief sculptures. She came to the United States in 1988 for graduate study, and she soon turned to photography, often working with large-format Polaroid cameras to create staged, color-saturated portraits that she combined with other media. These works imagined the body as a site of symbolic display. Frequently using herself as model, she wore elaborate hair ornaments, covered her body in painted patterns, or held objects of ritual significance. Campos-Pons infused every element in the photographs with meaning, sometimes referencing the Yoruba traditions of her ancestors and

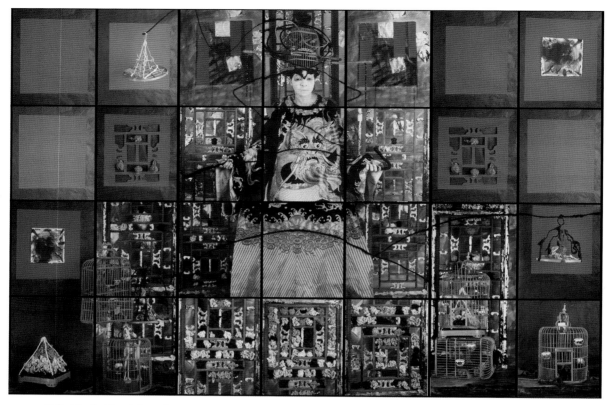

5.6. María Magdalena Campos Pons, *Finding Balance*, 2015. Composition of 28 Polaroid Polacolor Pro 24 × 20 photographs, 96 × 140 in. Courtesy of the artist and Gallery Wendi Norris, San Francisco.

sometimes using objects and symbols to evoke the memory of Afro-Cuban people and their traditions while also expressing absence, loss, and displacement. Many of these compositions are visually complex, made of multiple prints arranged in a grid.

The monumentally scaled *Finding Balance* (figure 5.6) is composed of twenty-eight large-format Polaroid photographs. It acts as a visually complex exploration of an aspect of Caribbean identity that is often overlooked—the significant Asian presence and the legacy of Chinese labor and trade in the region. The polyptych depicts a regal female figure (the artist herself) dressed in a theatrical, gold-hued operatic dragon robe, the attire of emperors. The

figure's head is crowned with an elaborate birdcage, and she is surrounded by other birdcages as well as by an array of ornamental forms. The headdress possesses multiple meaning; the birdcage signals confinement and oppression but also the Chinese tradition of keeping birds, once seen as an activity of leisure and sophistication. Campos-Pons also references Yoruba headdresses, thus visualizing a literal intertwinement of her Asian and African roots. Lengths of hair crisscrossing the image represent balance and justice, while the pompoms arrayed throughout the composition serve as counters for the miles traveled—by the artist and by generations of ancestors—between Africa, China, Europe, Cuba, and the United States. With such symbolic means, Campos-Pons constructs an image of female empowerment and enlightenment while also conjuring the difficult histories of migration and oppression that are part of her familial and cultural heritage. *Finding Balance* is part of a larger project, a performative and theatrical staging centering on a matriarchal figure the artist invented, FeFa, an abbreviation for *familiares en el estranjero* (Fe) and "family abroad" (Fa). As the artist states, "FeFa is both [my] artistic persona and a metaphor for the immigration, exile, family and community separation experienced by numerous Cuban families."[10] In an installation and performance at the 2013 Venice Biennial, Campos-Pons, in collaboration with her partner, sound artist and musician Neil Leonard, staged a guerrilla performance through the Piazza San Marco, a historical center of trade and cultural crossroads. The accompanying installation included numerous birdcages placed in a gallery of Venice's Museum of Archeology amid ancient Roman sculptures. By combining a photographic practice with installation, performance, and other media, Campos-Pons creates layered experiences that express her Cuban identity as inextricably connected—by trade, exile, and slavery—to diverse regions and cultures.

Christina Fernandez (b. 1965, Los Angeles, California; based in Los Angeles), who began her career in the early 1990s, has worked with diverse photographic approaches to critically examine issues related to gender, identity, and cultural history. In the 1995–96 series Maria's Great Expedition (figures 5.7 and 5.8), she combined staged narrative scenes with texts to construct a deeply personal, alternative history of Mexican migration, one seen from the point of view of a female protagonist. Fernandez presents this work as an installation meant to mimic an interpretive display in a history museum, with a map

tracing Maria's migrations and with six photographs, each accompanied by a text. In each image Fernandez plays the role of her great-grandmother María González, the first member of her family to migrate from Mexico to the United States as an adolescent in 1910, charting a family history and an evolving sense of Latina identity that spans geographic borders, generations, and evolving economic circumstances. In evoking different moments of social and cultural history, Fernandez also reflects the technical and aesthetic evolution of the photographic medium. She used the camera and darkroom as a conceptual tool by reflecting the photographic styles of the time periods she represents. Most of the images in the series focus on the domestic roles long played by Latina women, but in the final image, the only one in color, Fernandez shows a young woman tied to the kitchen looking outward, dressed in modern clothes and seeming to warily confront the future.

With the 1999–2000 series Ruin, Fernandez looked back to the Mexico of distant ancestors. The series juxtaposes images of disparate subject matter: large-format selenium-toned silver-gelatin prints of archaeological sites in Oaxaca, Mexico, and multiple exposures of herself and of indigenous women appropriated from the work of iconic Mexican male photographers like Manuel Álvarez Bravo and Nacho López. In photographing the mounds of ancient temples at sites like Monte Albán and Mitla, Fernandez portrayed the vestiges of ancient Mexico from the vantage of someone both connected to and removed from this heritage. She also evokes (and contributes to) the long tradition of foreign explorers and travelers in this region, beginning with nineteenth-century European archaeologists and photographers who made the earliest documentation of pre-Hispanic sites and continuing to contemporary tourists. By depicting unexcavated mounds and piles of stone, Fernandez exposes a history that was ruptured, literally ruined, and that is now only partially understood. The inclusion of her own portraits overlaid onto those of historic Mexican women acts to question history and the absence of female voices. "The work in Ruin," Fernandez stated, ". . . is self-reflexive; it questions my own sort of colonialist desires and flaws, as well as idyllic notions of homeland."[11]

The concept of constructing culture takes a wholly different aesthetic shift when culture is defined as mass culture and when the mass media, consum-

5.7. (*left*) Christina Fernandez, *#2, 1919, Portland, Colorado*, from Maria's Great Expedition, 1995–96. Portfolio of 6 prints, 5 gelatin silver prints, and 1 chromogenic print, 6 text panels, and 1 inkjet print map, each 20 × 24 in. Courtesy of the artist and Gallery Luisotti.

5.8. (*right*) Christina Fernandez, *#6, 1950, San Diego, California*, from Maria's Great Expedition, 1995–96. Courtesy of the artist and Gallery Luisotti.

erism, and brand fetishism are pervasive. If many Latinx photographers were absorbed with interpreting more traditional aspects of Latinx culture in the 1970s and 1980s, by the 1990s many aimed to reflect contemporary realities and the way new influences—television and other manifestations of popular culture—were playing a role in evolving concepts of Latinx identity.

Robert Buitrón (b. 1953, East Chicago, Indiana; based in Chicago, Illinois) began working as a photographer in the late 1970s, producing a series

of classically posed black-and-white portraits of family members that traced his lineage from Mexico to the United States. He later turned to the creation of staged narratives, deploying trenchant humor to expose both racism and the changing realities of contemporary Chicanx life. His 1990–92 series The Legend of Ixtaccihuatl and Popocatépetl is a modern-day reenvisioning of the tragic, legendary romance story of an Aztec princess and a warrior from a competing tribe. Reflecting an era when second- and third-generation Mexican Americans were increasingly entering the middle class and confronting the conflicting pressures of tradition and assimilation, Buitrón recounted episodes in the lives of a more contemporary Ixta and Popo—Ixta, made "Aztec" by donning feather headdresses, attending a meeting in a corporate boardroom (figure 5.9), or the two figures as south-of-the-border tourists posing on the stationary cart of a Tijuana burro. Buitrón initially presented the images in the form of a wall calendar inspired by Mexican chromo calendars of the 1940s and 1950s that featured gaudy, color-saturated illustrations of pre-Hispanic myths as their themes and that are still distributed by Mexican restaurants and bakeries to patrons at year's end.[12]

In the mid-1990s series El Corrido de Happy Trails, Buitrón critically responded to the stereotypical representations of Mexicans (and Native Americans) in early television westerns, the kinds of programs he watched as a child. As Buitrón stated, "Hollywood and history textbooks relegated Mexicans to the margins of frontier myth, portraying them as untrustworthy half breeds."[13] In theatrically staged photographs, Buitrón depicts Pancho and Tonto (sidekicks for the Cisco Kid and the Lone Ranger) in a variety of incongruously modern situations—for example, in a café, where a modern-day Malinche and Pocahontas, over a cup of coffee, discuss the characters standing in the background. In Identity Surfing (figure 5.10), Pancho and Tonto sit in a middle-class living room, each holding remote controls. The array of televisions sets before them suggests mass media's increasing role in influencing changing notions of self, especially among younger members of the Chicanx community.

Chuck Ramirez (b. 1962, San Antonio, Texas; d. 2010, San Antonio) came to photography relatively late, in his thirties, after a corporate career in graphic design. His corporate work, most notably designing product packaging for a major Texas supermarket chain, had a crucial influence on his artistic career. Mass-produced objects, bright colors, glossy surfaces, and slick style indebted

5.9. (*top*) Robert Buitrón, *Ixta Ponders Leveraged Buyout*, 1989. Courtesy of the artist.

5.10. (*left*) Robert Buitrón, *Identity Surfing*, 1995. Courtesy of the artist.

to studio and commercial photography all played a formative role in his work. Ramirez was drawn to banal items that he typically photographed in series, such as images in his early Santos series, produced in 1996, depicting the bases of religious statues common in traditional Mexican American homes. Ramirez arranged the color photos in a grid that pays homage to the opening credits of a late 1960s television series he watched as a child, *The Brady Bunch*, and titled each after a character on the show—Santa Marcia, San Gregorio, Santa Alicia, and so on. Such a work announced his conflicted relationship with Catholicism, a faith that he questioned in adulthood but that eventually engendered nostalgia for the kind of popular religious devotion practiced by his beloved grandmother. Contradictions and irony, in fact, were fundamental to Ramirez's oeuvre. He was a Mexican American who grew up in the 1960s but felt only a minimal connection to this heritage. "I am queer, a[n] HIV+ designer, and a Mexican-American [who is] not considered a Chicano because of my white bread upbringing," he stated. "I was raised as a white boy, with television, not art. I never learned Spanish, and though I was brought up Catholic, I wasn't raised with the mysticism of Latinx religious culture."[14] Nevertheless, he chose to depict santos—even if ironically—in one of his first significant bodies of work. This series also demonstrated Ramirez's preoccupation with giving value and new meaning to objects that others would overlook or toss aside. He also slickly photographed, often in large scale, plastic shopping bags, cuts of raw meat, broken piñatas, and plastic candy trays, all in color, set in isolation against white studio backgrounds. In this way, Ramirez called attention to the decadence of consumerism while coaxing an odd beauty out of quotidian forms. In 1997 he produced the series Coconut, depicting the fruit whole as well as split open to reveal the inner white meat. Visualizing a racial slur, "brown on the outside, white on the inside," these images were as much a critique of racial discrimination as a frank commentary on the contradictions of his own identity.

Although nearly the entirety of Ramirez's oeuvre was guided by a minimalist sensibility, he offered a more baroque vision of the material world in his 2004 series Seven Days (figure 5.11). Here, he recorded the aftermaths of large, celebratory feasts—a birthday party, Super Bowl celebration, or special meal for Día de los Muertos. If other bodies of his work focused on consumer culture, these photos concentrated on the literal act of consuming—KFC fried

5.11. Chuck Ramirez, *Día de los Muertos*, from the Seven Days series, 2003. Pigment ink print, 48 × 60 in.; 24 × 30 in. editions of 6. Courtesy of the Estate of Chuck Ramirez.

chicken, heaping platters of barbecue, breakfast tacos, and an abundance of liquor. Photographing from overhead once the feasting had ended, Ramirez captured messy, unappetizing scenes of dirty plates smeared with food, half-empty bags of chips, and ashtrays filled with cigarette butts. Part affectionate remembrances of social gatherings and part contemporary vanitas compositions, the Seven Days series is ultimately a meditation on overconsumption and human mortality.

Representing a more recent generation, **Martine Gutierrez** (b. 1989, Berkeley, California; based in Brooklyn, New York) uses photography to contest

norms and social constructs surrounding gender and ethnic identity. As Gutierrez notes, binary constructs such as male/female, gay/straight, Brown (and Black)/white, and so on are rigid and manipulated by social constructs that resist ambiguity and fluidity. Through photographs and videos, Gutierrez, a trans woman, acts to convey identity as mutable, fluid, and creative while also asking viewers to question their own perceptions of self and other. In the 2013 series Real Dolls, Gutierrez (then Martín) enacted the roles of four life-size female sex dolls. Rigid and staring blankly into space, the figures are posed in varied interior spaces—on a kitchen floor, with a dishwasher door open in the background; at a dining table set for a meal; and on a bed, legs wide open. Scenes that might infer forms of sexual kinkiness played out in the domestic sphere become complicated both by the seeming artificiality of the female figures and by the fact that they are performed by the artist. In the subsequent Line Up series of large color photographs (figure 5.12), Gutierrez created elaborately staged scenes of females (six mannequins and the artist) portraying various characters such as uniformed schoolgirls, luau performers, models and erotic show-girls, and lingerie-clad women relaxing around a sumptuous bed. In sets created by the artist out of humble materials, these characters become representations of exaggerated, and ultimately absurd, notions of female identity. In fact, in this series Gutierrez embraces the realm of the fictive through references to such films as *Showgirls* and *The Fifth Element* and the actresses Milla Jovovich and Brigitte

5.12. Martine Gutierrez, *Line Up 1*, 2014. Archival inkjet print on Arches Baryta mounted on Sintra, 43¼ × 27¼ in., edition of 10. Courtesy of the artist and Ryan Lee Gallery, New York.

Bardot. Layering fiction upon fiction, Gutierrez points to such realms as glamour, desire, and luxury as social constructions necessitating a turn away from reality and acceptance by the spectator.

Gutierrez has continued to explore identity as fluid and nonbinary, more recently with full-length portraits of women, both indigenous Mexican and Chicana, who draw equally from youthful fashion trends and from traditional indigenous culture. The women assert themselves boldly, their dress becoming extensions of a confident sense of identity. "I think of each work as a documentation of a transformative performance," says Gutierrez. "I am interested in every facet of what it means to be 'genuine', especially when performing in a role society would never cast me in. I stage the scene and emote, but the viewer sees what they want to see; they can actively engage with the work or passively make assumptions. While gender is inherently a theme in my work, I don't see it as a boundary. The only profound boundaries are those we impose upon ourselves."[15]

In the essay "Choosing the Margin as a Space of Radical Openness," the feminist cultural theorist bell hooks explored the concept of the marginal space—spaces in which persons of color often exist, create, and develop a sense of identity. It can be, she stated, a "site of radical possibility, a space of resistance." Speaking of her own lived experience, hooks wrote, "It was this marginality that I was naming as a central location for the production of a counter-hegemonic discourse. . . . I was not speaking of a marginality one wishes to lose—to give up or surrender as part of moving into the center—but rather of a site one stays in, clings to even, because it nourishes one's capacity to resist. It offers to one the possibility of radical perspectives from which to see and create, to imagine alternatives, new worlds."[16] For the artists discussed here, photography has acted as an ideal medium to visualize ideas around identity, precisely for those on both sides of the camera who understand marginal space (and indeed, marginalization) as discursive space, as space from which meaning can be probed and presented. Their modes of constructing imagery by drawing on varied photographic process, layering forms, staging narratives, and merging fiction with reality became incisive means of conveying weighty histories, and identity, as multifaceted, fluid, and evolving.

6

Family

FAMILY IS AN ENDURING CORNERSTONE OF LATINX culture. The closeness of families even when they span geographic borders and the deep pride felt for family histories across generations are indeed sources of strength and resiliency, especially in the face of increasing hostility toward Latinx people. Connection to family also sustains cultural traditions, language, and a belief that knowledge of the past nurtures our present lives. For immigrants and the children of immigrants, remembrances of homeland, often tinged with nostalgia, and stories of border crossings, exile, and migrations become means of preserving the family narratives that bind one generation to another. They have also become rich source material for artists, a unique archive and source for reaching into the past as a means of better understanding the present.

Family, in fact, was integral to the foundational ideologies articulated in the early years of the Chicano civil rights movement, when an anticolonialist sense of nationalism (*la raza*) and political and spiritual values tied to ancient heritage (Aztlán, the mythical ancestral home of the Aztec people) were linked with cultural values based in family and community. A key Chicano manifesto, the 1969 Plan Espiritual de Aztlán, states in part, "Our culture unites and educates the family of La Raza towards one heart and one mind. . . . Our cultural

values of life, family, and home will serve as powerful weapon to defeat the gringo dollar value systems and encourage the process of love and brother-hood."[1]

In a very different way, family was central to the cultural consciousness of early generations of Cuban Americans for whom migration to the United States typically represented a traumatic rupture between those who stayed and those who left. Castro called the exiles *gusanos* (worms or maggots), while members of the generation that left in exile shortly after his ascendancy typi-cally saw the act of visiting Cuba as lending legitimacy to a repressive regime. With communications between geographically separated families sporadic at best in the decades immediately following the Revolution, younger Cuban Americans knew their extended families largely through photographs and par-ents' stories and recollections.

It must be recognized, nevertheless, that for Latinx photographers devel-oping their artistic voice, the push and pull between a family's traditional val-ues and expectations and the appeal of alternative ways of life and cultural norms could give rise to tension and conflict—especially for those who did not aspire to a middle-class lifestyle. Family could also engender dysfunction and alienation for those who grew up in difficult domestic circumstances, amid poverty and struggle (expressed, for example, in the 1993 video *L.A. Familia* by Harry Gamboa Jr., one of the artists discussed in this book). Moreover, tra-ditional narratives about the Latinx family—*la familia*—that privileged the heteronormative nuclear family unit (in its most stereotyped version, led by a hypermasculine, macho male) left little space for those who embraced ris-ing feminist ideals in the late 1960s and 1970s, and even less for those whose gender identity fell outside the accepted norms—queer people, lesbians, and other gender-nonconforming people. Particularly before broader acceptance of LGBTQ rights in the latter decades of the twentieth century, such indi-viduals either largely existed on the margins of Latinx communities or were essentially treated as outcasts.

Numerous artists discussed elsewhere in this book have evoked family his-tory in their work. Juan Sánchez has frequently included images of his mother in his photo collages; Christina Fernandez staged a series of images recounting her great-grandmother's migration; and María Magdalena Campos-Pons pro-duced large-format Polaroid imagery that often references ancestors' strug-

gles and resilience. The photographers discussed below are responsible for extended meditations on family.

Tony Mendoza (b. 1941, Havana, Cuba; based in Columbus, Ohio) left Cuba with his family in 1960 at the age of eighteen and became a photographer in 1973 after an initial career as an architect. Among his first bodies of work were black-and-white documentary images made during travels to Colombia. Thereafter he worked closer to home, early in his career photographing animals with humor and a sense of stark realism. A 1979 series was dedicated to Leela, a girlfriend's pet dog, and another from the early 1980s to Ernie, his roommate's cat, about which he produced over ten thousand negatives. Mendoza also pursued biographical themes, particularly with the series Stories, begun in 1987. Through portraits and staged images he described his life as an affluent Cuban in the United States who attended Ivy League schools, became a hippie in San Francisco and a commune member in Boston, and came of age as a photographer while living in Lower Manhattan in the 1980s. Mendoza accompanied the images with droll, often self-deprecating texts that became a hallmark of his practice (figure 6.1). These works speak of the conflicts and contradictions embodied by his life as both a member of a traditional Cuban family and an American artist searching for an independent identity. In 1996, as travel restrictions between the United States and Cuba were easing, Mendoza returned to his birthplace, where he photographed the kinds of scenes that other exiles have captured—the malecón, colonial buildings in a state of decrepitude, and street scenes—but less with a sense of nostalgia than with a frank realism and a denunciatory stance toward the Castro regime. His photograph of a scruffy dog in a shabby living room reflects the reality of a society whose citizens were then subsisting on an average of eight dollars per month, their physical environments deteriorating by the day. Most poignantly, he pictured a man sitting alone along the seawall, looking north toward Florida, capturing an emblematic scene of separation and longing. Most recently, Mendoza has turned to images of animals and nature, working in color and focusing overtly on the theme of beauty as well as on purely formal issues.

Martina Lopez (b. 1952, Seattle, Washington; based in South Bend, Indiana) works with found imagery to create dreamlike narratives that act as a meditation on family as well as a collective history of human experience. She composes digital collages with elements taken from nineteenth-century studio

6.1. Tony Mendoza, *Untitled (My Grandmother . . .)*, from the Stories series, 1983.
© 1987 Tony Mendoza .

portraits and landscape scenes. Lopez, a young photographer when her father died in 1986, turned to software tools as a means of reconstructing history and exploring themes of loss and change. In doing so, she became a pioneering figure in the development of digital approaches to photography, if an unrecognized one. Lopez originally used photos from her own family albums but eventually moved to found photo albums and images from the nineteenth century. Computer technology allowed her to seamlessly bring together in a single frame figures from disparate moments in time and to create fabrications that nevertheless evoke the lived experience of her subjects. Lopez's compositions, especially those of the 1990s, have a surreal air—groups of figures do not engage with each other, and the backgrounds might include such unlikely subjects as an early flying machine, monumental statues, and often cemeteries. For Lopez, such juxtapositions of forms and topographies and of black-and-white

6.2. Martina Lopez, *Questioning Nature's Way 2*, from the series Memory Reference, 1990–98. © Martina Lopez.

and color in a single image were deliberate means of breaking down hierarchies between fact and fiction. These images also suggest that such realms as dream, myth, and nostalgia matter greatly in the construction of one's identity. While Lopez's imagined spaces are rooted in the private, domestic sphere, they also speak to a preoccupation with the collective family and with cultural history, formed by remembrances, fictions, and reality.

Nereida García Ferraz (b. 1954, Havana, Cuba; based in Miami, Florida) has worked across varied visual media, including painting, works on paper, sculpture, and video; in 1987 she coproduced *Ana: Fuego de Tierra*, an important documentary film about the artist Ana Mendieta, who had been her close friend. García Ferraz has also worked with various forms of photography. Departing Cuba as an adolescent in 1971, she came to the United States with few possessions. When she returned to the island for the first time in the 1980s,

she spent time with relatives and began to accumulate old family photographs and documents. Eventually she decided to use these materials as the subject matter for photographic works. For García Ferraz, the creative reuse of personal artifacts became a way not only to memorialize emotionally burdened family histories but to symbolically link people separated over time and space. In one series from 2005, she photographed poetically evocative objects, such as rose petals or a seashell, placed upon old photographs or over the pages of a passport (figure 6.5). Such constructions were meant to visualize the often divergent threads that contribute to identity, particularly for a person who has experienced exile. "These photographs," she wrote, "helped me rebuild my life, to place pieces of the puzzle, searching always for that bigger image that will help me understand what paths everyone took to get to the places they are today."[2] She has also presented old family photographs and street scenes made in Havana in sepia tones and partially out of focus, transforming such photographs from an index of reality into the site of pure memory.

6.3. Nereida García Ferraz, *Pasaporte*, 2005. Courtesy of the artist.

Eduardo Muñoz-Ordoqui (b. 1964, Havana, Cuba; based in Austin, Texas) represents a later generation of Cuban American artists. He arrived in the United States in 1994, decades after the first generation of exiles, and is based not in Miami but in Austin, Texas. But his work, like that of many members of the preceding generation of Cuban American artists and photographers, is centered on issues of place and family. Early in his career, in the 1990s, Muñoz-Ordoqui devised a disjunctive visual language to evoke the psychological dimensions of exile and migration and to metaphorically close the gap between time and geography. Extreme shifts between foregrounds and backgrounds and the seamless juxtapositions of imagery endow these analog photographs with the appearance of digital manipulations. To create them, he typically photographed in domestic interiors that he transformed into stark spaces of memory. He would project old family photos onto the walls of these rooms, or show scenes from historic Cuban films on televisions. These photographs also contained other elements that symbolized the repressive political state that was no longer his home but that shaped his outlook toward life.

6.4. Eduardo Muñoz-Ordoqui, untitled from the series *Sabina's Letters*, 1999–2001. Courtesy of the artist.

In the 1998–2001 series Sabina's Letters (figure 6.4), Muñoz-Ordoqui employed stills from video correspondence he received from his sister to compose enigmatic, deeply personal images that suggest time retrieved and upended. They included black-and-white images from their childhood, juxtaposed family photos, and pixelated close-ups of a woman's face, all projected onto walls of the photographer's own home. Projecting such images in large scale on the walls or furniture of domestic interiors, Muñoz-Ordoqui underscored the way changing physical contexts can distort, manipulate, and even heighten memory.

Muñoz-Ordoqui returned to Cuba for the first time in 2001 upon the death of his father. There, he began work on a new series, Marea Baja (Low Tide). He photographed in locales remembered from his childhood, typically juxtaposing projections of the old photographs onto interior or outdoor settings. One composition centers on an adolescent Muñoz-Ordoqui (a photo originally taken by his stepfather, also a photographer) standing along a wave-swept Havana coast, his arms stretched outward in carefree exuberance. The scene is visible through a car window, and Muñoz-Ordoqui added a recent photo of the sea, made in the same locale, visible in the auto's rearview mirror. By reproducing a depiction of youthful freedom situated at the very geographic limit of a repressive homeland, Muñoz-Ordoqui crafted an image that is as much emotional as analytical. Rendered in grainy black and white, the image is awash in nostalgia for both a time and a place left behind.

Groana Melendez (b. 1984, Brooklyn, New York; based in the Bronx) looks at issues of migration and separation from the perspective of someone raised between Santo Domingo, Dominican Republic, and Washington Heights, a center for Dominican life in New York. Her parents came to New York in the late 1970s in search of a better life for their family; in contrast to Cubans, they are able to maintain relatively close relationships with family members in the Dominican Republic, although these relationships can be marked by long periods of absence. In various bodies of work Melendez explores the dynamics of a family fractured by migration. In the series Aquí y Allá: Closing the Gap, she reproduces images of family members from old photo albums and passports to document a family history that she can only trace back to her grandparents. A more recent series of color portraits made with a medium-format camera, Ni Aquí, Ni Allá (Neither Here nor There), depicts members of an extended

6.5. Groana Melendez, *Laura Daydreaming*, Gazcue, Santo Domingo, R.D., from the Family Work series, 2006. Courtesy of the artist.

family living on both the island and in New York with whom she has an easy familiarity. She depicts them in the intimate space of home, in bedrooms, bathrooms, or kitchens, sometimes indifferent to her presence and sometimes carefully posing, mindful of the significance of the photographer (figure 6.5). Melendez states that she acts as both observer and participant, an insider and an outsider in the creation of this work—meant to close the gap between a family separated not only by geography but by differences in class and cultural values.[3] She also seeks to evoke broader issues of the immigrant experience. As she states, "What began as a personal archive, in which I sought to immortalize my family and forge a stronger connection to my Dominican identity, soon became a much larger exploration of the internal process many bicultural and bilingual individuals face as they struggle to construct hybrid identities across cultures."[4]

Karen Miranda-Rivadeneira (b. 1983, New York, New York; based in Queens, New York, and Ecuador) was raised in both the United States and Ecuador and has used a range of photographic approaches in bodies of work that examine her Latin American cultural roots. Miranda-Rivadeneira's 2010–13 series of color photographs, Other Stories / Historias Bravas, re-created incidents from her youth and family history that had never been documented but that shaped her identity and outlook. Family members participated in the staging of these images, which the photographer elaborated with handwritten texts (figure 6.6). About the series, Miranda-Rivadeneira wrote, "According to my research, the act of remembering is an unstable and profoundly unreliable process. The more we recall an event the more we are likely to change it with time. Departing from this thought, I began questioning the role of photography and its relationship to memory, specifically what it intends to preserve."[5] Many of the works are deeply intimate, such as one where an adult Miranda-Rivadeneira cuddles with her mother in bed, reenacting her infancy and breastfeeding. With family members, she also reconstructed such youthful moments as learning to make bread with an aunt, having her hair braided by her mother, and her mother placing an egg on her head to cure her of the evil eye. "The contexts in which these reenactments are staged are not meant to convey a romanticized vision of my experiences," she stated. "Rather they provide a means for reflection and a search for truthfulness."[6]

Rachelle Mozman Solano (b. 1972, New York; based in Brooklyn, New York) also photographs staged narrative images, in her case to create fictive dramas that evoke her Panamanian family's history of immigration and cultural assimilation. Mozman Solano, who has noted that her art is deeply informed by psychoanalysis, creates complex scenes that examine family dynamics, unstable social hierarchies, and inner strife. In the series Casa de Mujeres (House of Women; figure 6.7), the artist's mother plays the role of three women in an upper-class Latin American household, twin sisters and a darker-skinned maid. The women are depicted enacting common domestic rituals—preparing for bed or getting dressed in the morning—displaying undertones of both contempt and familiarity. Mozman Solano states, "These images can be *read* as portraits of my mother as her various selves—like a nested doll, and as pictures that reveal the conflict of vanity, race, class and rivalry."[7] For a related series, La Negra, Mozman Solano constructed a narrative of a dark-skinned woman

6.6. Karen Miranda-Rivadeneira, *Mom healing me from my fear of iguanas, by taking me to the park and feeding them every weekend*, ca. 1994, 2012. Digital C-print scanned from 6 × 6 in. negative. Courtesy of the artist.

6.7. Rachelle Mozman Solano, *En el Cuarto de la Niña*, from the series Casa de Mujeres, 2010. C-print, 23 × 26 in. Courtesy of the artist.

who has migrated to the United States with a young, light-skinned daughter, Pequeña (the younger figure is a digital blending of the artist's face with her mother's). Across this series, mother and daughter struggle with assimilation and acceptance, despite their seemingly comfortable domestic surroundings.

Delilah Montoya worked with families based in New Mexico and Texas to produce the 2016 series Contemporary Casta Portraiture: Nuestra Calidad (figure 6.8). She created portraits of sixteen families from varied socioeconomic backgrounds, Latinx families and others whose ancestry emerges from New World ethnoracial mixtures. Montoya recruited families who willingly participated in the process and exercised agency over their representation.

6.8. Delilah Montoya, *Casta 13*, 2017. Infused dyes on aluminum, 24 × 36 in. © Delilah Montoya.

The process of making this work became a form of collaboration; the families chose the settings in which to be photographed and revealed what they chose to reveal about their family life, and Montoya employed digital manipulation techniques to stitch together a multiplicity of activities within a single frame. The familiarity and trust she experienced in these encounters resulted in images that intimately evoke varied ways of life within a range of family units. There are portraits of an extended family group sitting down for a meal; of members of a middle-class family in their living room, each engaged in separate pastimes; and of other families attending to mundane domestic chores.

Contemporary Casta Portraiture draws not only from documentary and constructed modes of photography but also from research, sociology, and science. As part of the project, Montoya ordered DNA tests of members of each family. Her intention was to construct a contemporary form of Spanish

colonial *casta* paintings, hierarchically ordered scenes of couples and their off-spring meant to exemplify the family combinations and racial mixtures that came from miscegenation in the Spanish colonies. Created largely in the eighteenth century and meant to describe ways of life in the New World while demonstrating the supremacy of the Spanish colonizers, these paintings now act as telling evidence of a rigid social hierarchy in the Americas that privileged light-colored skin and European blood. The paintings also offer fascinating anthropological details of the clothing, possessions, and domestic settings of persons in the Spanish colonies across the full social spectrum. In contrast to traditional *casta* paintings and their depictions of emblematic (and stereotypical) "types," Montoya's project reveals race and ethnicity not as a contrived system of hierarchies but as fluid, complex, and layered. The DNA analysis that Montoya includes with each photograph bears out this reality. Illustrated with world maps delineating the migratory paths of ancient ancestors and bar charts indicating percentages of regional ancestry for the individual tested, the analysis reveals how racial makeup frequently extends well beyond a family's knowledge (or suppositions) of its own heritage; the DNA of a Latinx person, for example, will likely contain genetic markers of Spanish and indigenous American blood, as well as markers linked to Africa, Asia, and other parts of Europe. For Montoya, the portraits combined with DNA data express forms of hybridity that are both biological and cultural. They portray, as she has stated, "the resonance of colonialism as a substructure of our contemporary society that was constructed by an imposition of sovereignty."[8]

Time and again, Latinx photographers have spoken of family photographs as creative catalysts in their decision to become artists. For many, especially those of an older generation, family photographs offered the first point of contact with the medium. Prior to the digital era, faded snapshots found within photo albums or old shoeboxes could conjure ancestors, places, and experiences known only from parents' recollections, and the painful realities of ties ruptured by exile or immigration. Particularly for Cuban American photographers, a treasured family photo album might have provided the only tangible evidence of a connection to family histories ruptured by political circumstances. And when these photographers pursued such deeply personal work,

family and the domestic sphere also provided ideal source material for thinking through broader issues of cultural and national identity: family narratives also point to such issues as race, class, separation, and survival. For many of these artists, probing biography and family narratives becomes not so much an exercise in nostalgia as a means of reckoning, of confronting histories that can be painful or unresolved but also affirming and transformational.

7

The Archive

FOR MANY LATINX ARTISTS WORKING WITH THE CAMera, photography functions as an act against forgetting—against the forms of social and cultural marginalization that diminish or erase communities from the historical record, effecting a kind of historical amnesia. Photographs assert the presence of individuals, communities, and histories that might otherwise be either willfully overlooked or inaccurately portrayed; the medium acts as both a personal and a political form of declaration, an affirmation of being. In *Archive Fever*, the philosopher Jacques Derrida examined archives from a Freudian perspective, framing them as repositories both public and personal. For Derrida, the archive—whether based on personal belongings, institutional records, the library, or the museum collection—is driven by primal urges to forget or omit, on the one hand, and to conserve, on the other. Derrida spoke of a compulsive drive, a burning human passion for the archive—a return to origins. Rather than seeing the archive as the dry receptacle for history, he posited it as an active force; it holds a position of authority because it shapes and controls the way history is read, which in turn shapes our social and political realities. As Derrida noted, "the question of the archive is not . . . a question of the past." Rather, it opens "the very question of the future itself, the question of a response, of a promise and of a responsibility for tomorrow."[1]

In varied ways, figures like Muriel Hasbun, Ken Gonzales-Day, Jaime Permuth, Luis Delgado Qualtrough, and Pablo Delano have drawn on archives to elaborate varied bodies of photographic work. Some have worked with family collections or historic archives (often focusing on little-known sources or subject matter overlooked in mainstream historical records), while others have approached their practice as the creation of new archives, of images and information that had not previously been assembled together.

Muriel Hasbun (b. 1961, San Salvador, El Salvador; based in Washington, DC) has dedicated much of her oeuvre to an in-depth investigation of her family's complicated history. "I come from people in exile," she has written. "My mother was born in Paris to Polish Jewish parents who settled in France just before World War II. My father was born in El Salvador to Palestinian Christian parents who settled in Central America shortly before World War I. I was born and raised in San Salvador and now live in Washington, D.C. So I follow in my family's legacy of exodus."[2] Among Hasbun's earliest bodies of work, made during a return visit to her native country after undergraduate studies in the United States, was documentation of children displaced by the civil war in El Salvador, a theme she understood well thanks to the experiences of her parents and grandparents. "The initial investigation of my own family history was a strategy to reconcile the irreconcilable," she stated. "I began gathering and closely scrutinizing family photographs and documents that had been previously dispersed and unexamined. Little by little, I realized the power of learning the stories and historical events surrounding the archive. This became a method of inquiry and part of my creative process."[3] Hasbun developed a process of taking multiple exposures and layering found and original photographs with letters, documents, and found objects to create melancholic narratives that plumb the half-buried memories of a family scattered to many parts of the world. A series that occupied her for much of the 1990s, Santos y Sombras (Saints and Shadows) was based on years of research into her paternal Palestinian family. The thirty-eight prints constituting the series layer old family photos, handwritten letters, and documents with her own photographs. The images act as an evocative visual diary, revealing Hasbun's own childhood experiences with Catholicism and culminating with (or returning back in time to) the story of her grandfather's cousin Esther, who survived internment in Auschwitz and eventually settled in Palestine. Hasbun

traveled to Haifa to meet Esther, who shared stories and old photographs she had preserved, filling what had long seemed to be an irretrievable gap in the family history. In one image from the series, *Sólo una Sombra? (Familia Łódź) / Only a Shadow? (Łódź Family)* (figure 7.1), the infant Esther, held in her mother's arms, is barely visible; her form seems to inhabit a fragile realm between memory and evanescence. Hasbun used a contemporary photo of a snowy winter in Washington, DC, her present home, to symbolically join an elusive past with her present life. Working through a family narrative shaped by war, exile, and diverse family roots, she demonstrates how the photograph itself can act as a spark of memory, a weapon against silencing and loss.

7.1. Muriel Hasbun, *Sólo una Sombra? (Familia Łódź) / Only a Shadow? (Łódź Family)*, 1994. Selenium gelatin silver print, 16½ × 12 in. © Muriel Hasbun.

Ken Gonzales-Day (b. 1964, Santa Clara, California; based in Claremont, California) pursues a rigorously conceptual, interdisciplinary practice that involves research, photography, and the use of historic images. Reflecting a similar dedication to political commitment that distinguished the pioneering generation of Chicanx artists, he has created bodies of work that powerfully illuminate little-known aspects of Latinx history in the United States. Gonzales-Day has been particularly interested in countering the absence of Latinx people in visual and written histories of the American West. He based his 2006 series, Searching for California's Hang Trees, on extensive research he conducted over the course of a decade to expose the little-known history of the lynching of Mexicans in California in the late nineteenth and early twentieth centuries. He identified the sites of lynchings in California— mostly of Latinx men but also of Native

Americans and migrant Chinese laborers. By searching archives, Gonzales-Day located photographs, written documents, souvenir postcards, and newspaper accounts of lynchings. He traveled to the sites where these crimes took place decades ago and photographed some of the trees where victims were hung. The artist has presented this project as a book, as a detailed walking tour of Los Angeles, and in exhibitions of monumentally scaled photographs that render the trees as massive but mute witnesses, unnerving in our cognizance of their role in heinous crimes.[4]

In the related 2000–2013 series Erased Lynchings, Gonzales-Day altered historical postcards of lynchings, removing the hanging victim from the image

and leaving the setting, onlookers, and perpetrators of these crimes to be seen. "This conceptual gesture," as the artist stated, "was intended to direct the viewers' attention away from the lifeless body of the lynch victim and towards the mechanisms of lynching. The work asks viewers to consider the crowd, the spectacle, the role of the photographer, and even the impact of flash photography, and their various contributions to our understanding of racialized violence. The perpetrators, when present, remain fully visible, jeering, laughing, or pulling at the air in a deadly pantomime. As such, this series strives to make the invisible—visible."[5]

In 2014, **Jaime Permuth** (b. 1968, Guatemala; based in New York) moved from documentary work to a more conceptual approach to produce the series The Street Becomes (figures 7.3a and 7.3b). Under the auspices of a Smithsonian Artist Research Fellowship, he secured permissions to use archival images by other photographers to create a new body of work, a meditation on public space and how it changes during times of war and peace. This theme has personal resonance for the artist, who grew up in Guatemala during that nation's long civil war. For the series, he appropriated images by photographers based in Washington, DC, who had covered the city's annual Latino Festival in the 1970s and 1980s, as well as images drawn from US Marine Corps archives documenting military occupation in Central American and Caribbean countries from the early twentieth century to the modern era. In the images based on the Marine Corps archives, public space is controlled; it becomes the site of fraught tension and violence. In juxtaposition, the photographs taken during the Latino Festival frame public space as a place of community, resistance, and assertions of cultural autonomy. Permuth unites the two themes through his printing technique—the images are grainy, low-contrast representations of varying legibility. They are all clearly historical photographs taken at different times and places, suggesting that neither peace nor war, neither control nor freedom, is a given condition but that they exist in uneasy oscillation.

Luis Delgado Qualtrough (b. 1952, Mexico City; based in San Francisco and Long Beach, California) began his career as a social documentarian and

7.2. Ken Gonzales-Day, *Nightfall I*, 2007–12. LightJet print on aluminum, 36 × 46 in. Courtesy of the artist and Luis De Jesus, Los Angeles, California.

7.3a. Jaime Permuth, *Untitled*, from The Street Becomes series, 2017. Courtesy of the artist.

7.3b. Jaime Permuth, *Untitled*, from The Street Becomes series, 2017. Courtesy of the artist.

is known for a prolific and varied body of photographic work and artist books, often involving unconventional approaches to the medium. In the early years of the twenty-first century, as Delgado Qualtrough moved to digital forms of image making, he produced large-scale photomontages and diptychs that combine multiple images to speak to the complexity of such issues as historical memory, political power, and neocolonialism. His earliest photographs were documentary in nature, portraits he made in Mexico during a return trip to his country of birth in the 1970s. His black-and-white series Ojos Que Ven—Ojos Que No Ven (Eyes That See—Eyes That Do Not See) portrays subjects who were mostly poor and rural and were wholly unfamiliar with the act of posing for the camera. These compositions have an elegant simplicity, and while clearly demonstrating Delgado Qualtrough's talent, they belie the more complex approaches to the medium he would embrace in later decades. In the 2006 series Unfathomable Humanity (figure 7.4), created under the pseudonym Lisdebertus, he created a series of sequential, gridlike compositions populated by historic scenes, some now iconic, of warfare and weapons, of ritual sacrifice depicted on pre-Columbian codices, and of Nazi concentration camps, as well as portraits of Western political and religious leaders. By gathering an iconography of such disparate images in a single composition, Delgado Qualtrough makes connections between politics, power, and violence at numerous points in history. In one, the infamous portrait of the hooded prisoner at Abu Ghraib is reproduced alongside historic scenes of American presidents and warfare, creating a damning collective portrait of Western geopolitics and aggression, particularly in light of the Iraq War.

Delgado Qualtrough has continually experimented with the photographic medium and with printing formats. In 2015 he published a portfolio of ten images, *Stratigraphies*, based on glass-plate negatives he had discovered several years earlier in a flea market in Lima, Peru. The negatives were from the studio of a workaday Peruvian portrait photographer active in the 1940s, Miguel Mestre. Delgado Qualtrough's digital manipulations of the negatives, all of everyday people, accentuate the degradation of the emulsion on the glass plates—a chemical breakdown that appears as spots, blemishes, and cracks. His prints, toned and printed to underscore the negatives' deterioration, show how the photographic print, meant to "freeze" a moment in time, can itself age and undergo its own organic process.[6] Moreover, by working with the archives

7.4. Luis Delgado Qualtrough, *Unfathomable Humanity*, 2006. Courtesy of the artist.

of a mostly forgotten photographer, Delgado Qualtrough revives that photographer's memory, as well as that of the everyday people who once sat before his camera.

Pablo Delano (b. 1954, San Juan, Puerto Rico; based in Hartford, Connecticut) is responsible for significant bodies of documentary work created in Hartford, Connecticut, where he is based, as well as in Trinidad, Honduras, Cambodia, and other locations. He grew up in Puerto Rico, the son of Irene and Jack Delano, who played significant roles in developing the cultural infrastructure of Puerto Rico in the mid-twentieth century (Jack Delano's contributions as a photographer are discussed in chapter 10). Like his father, Pablo Delano is deeply conscious of the role that photography can play in conveying the spirit of people and communities. His documentation in Hartford, of its

aging housing stock, banal strip malls, storefront businesses, abandoned factories, and civic buildings, offers an objective sociological picture of a struggling city and its trajectory. In the 2010s, he turned to a more conceptual approach to the medium, working with the historic photographs and texts he had long collected to examine the legacy of US colonialism in his Puerto Rican homeland. Delano's project, *The Museum of the Old Colony* (figure 7.5), is named after a popular Puerto Rican soft drink brand whose name is emblematic of the island's colonial status. The project takes the form of a historical or anthropological exhibition of ethnographic photographs, employing large-scale digital reproductions of vintage photographs and moving images of Puerto Rico produced mostly by US photographers for dissemination to a US audience. Delano collected material from *National Geographic* magazine articles, old stereographic views and postcards, newspapers, news agency archives, and the 1899 book *Our Islands and Their People.* The latter was a lavishly illustrated edition published by US interests shortly after the conclusion of the Spanish-American War with the aim of encouraging tourism and business investment in the then US territories of Hawaii, the Philippines, Puerto Rico, and Cuba. Delano's archive includes images of peasants, some in ragged clothes, others suggesting Puerto Rico as a tropical paradise; of military operations; and of scenes exemplifying "progress" and modernization. "I purposefully intend to strip away any intrinsic value from the exhibition material so as to make clear that the context of the image is what's at play," Delano has stated, "not any notion of a collectible, sentimental, or precious object."[7] With a display of this material in a manner akin to an imaginary museum exhibition, he evinces histories of exploitation, oppression, and discrimination while also demonstrating how photographs have been used to enact political control and to sway public sentiment. As Delano also notes, Puerto Ricans "have not held claim to their own land from the arrival of Columbus in 1493 through the occupation of that supposedly benevolent benefactor, Uncle Sam. The installation suggests that a careful examination of the colonizer's gaze might shed light on the island's present predicaments: an economy in default with no recourse to bankruptcy laws, exorbitant rates of poverty and unemployment, a mass exodus of population, and the stripping away of any pretense of democracy under the new Federal PROMESA act."[8] Moreover, as this project has evolved, it has gained greater urgency as a result of Hurricane Maria's devastating impact

7.5. Pablo Delano, *The Museum of the Old Colony*, exhibition view, 2018. © Pablo Delano.

on Puerto Rico and the continued political and economic instability on the island. Delano's visual archive offers a stark reminder that the failed colonialist patterns of exploitation and oppression have endured for well over a century; these images of the past also evoke the island's present reality.

The photographers discussed here have turned to the archive to understand complicated family histories, reveal difficult histories, and meditate on the medium of photography itself, its capacity to preserve history and interpret it from varied points of view. For the Latinx artist, the archive itself may be an elusive site. A first task may be not to locate the archive beyond canonical or institutional sites but rather to create it, toward a memorialization of our own histories. The twenty-five thousand film negatives representing the publication *La Raza* (1967–77), now housed at the Chicano Studies Research Cen-

ter at UCLA; the massive Farm Worker Movement Documentation Project, which includes photographs, essays, oral histories, videos, and other materials amassed by LeRoy Chatfield (once a volunteer with Cesar Chavez and the movement), now preserved online by the Library of the University of California San Diego; and Ken Gonzales-Day's painstaking research and documentation of lynching sites in the American West—all represent heroic efforts to gather materials and preserve histories that would otherwise be lost. As curator Renée Mussai has stated in writing about En Foco's permanent (and little-known) collection of photographs, "Part of our mission going forward must be to firmly locate 'the archives' within different discursive sites of engagement, and to extend their reach beyond (at times) insular contextual frameworks of gallery, academy and museum circuits . . . to infiltrate and permeate canons, to resurrect and inject works in unexpected places."[9] This kind of work has been pursued by many, although presumably, much comparable work has also been lost.

In recent years, Latinx curators and activists have created archives on digital platforms, a democratized realm that offers a space to reclaim histories and to chronicle the lived experience of varied communities. The best known, *Veteranas and Rucas*, an Instagram feed founded by Guadalupe Rosales to document Latinx youth culture in Southern California, is discussed in this book's afterword. Other similar Instagram feeds include *Nuevayorkinos* (@Nuevayorkinos), founded by Djalí Brown-Cepeda as a visual archive dedicated to memories of the New York Latinx community, and the *Rock Archivo de LÁ* (@rockarchivola), founded by Jorge N. Leal, which collects and presents photos and video clips, as well as 'zines, flyers, and visual artifacts of the city's Rock en Español movement.[10] For figures like Rosales, Brown-Cepeda, and Leal, such efforts become necessary correctives, making the archive an open, evolving source of knowledge that connects with individuals and communities. As Leal has stated, "If we don't document our stories, there are two dangers: That it doesn't get documented or it gets completely distorted. We [become] a footnote or reference when we were active participants."[11] In this sense, the archive can be framed in both personal and social terms; it becomes the site to fully recognize oneself, to counter amnesia, and to form connective tissues between our past and present.

8

Geographies

ONCEPTS OF CULTURAL IDENTITY AND COMMUNITY
have always been deeply rooted in place—those geographies that act as extensions of ourselves, where communal bonds are held and memories and histories shared. For Latinx people, this fundamental element of identity is also a site of conflict, reaching back to the European conquest of the Americas. The Spaniards and other Europeans who established vast colonial empires in North and South America and in the Caribbean vanquished indigenous populations and transposed European cultural, religious, and political systems only wholly unfamiliar terrains. For the native populations whose spiritual beliefs and ways of life were inextricably bound to nature, the conquest was, in essence, cataclysm—an erasure of cultures, ways of life, and populations. Contemporary concepts of place are further complicated for Latinx people because place functions as a kind of binary proposition—it is both *aquí y allá*, north and south of the border, island and mainland, homeland and adopted home, places of ancestors and of one's current life. And likewise, connection to place, to *places*, is often multidimensional.

For Chicanx people, place is the American Southwest, the land now generally defined as the states of California, Arizona, Nevada, New Mexico, Colorado, and Utah. The modern history of this region is distinguished by

its Spanish influence, now reaching back nearly half a millennium. Spanish exploratory expeditions arrived in Alta California in the 1530s and 1540s, lured by accounts of streets paved with gold and silver. Spanish colonization of this region began in earnest in 1769, when a Spanish presidio was established in San Diego. The same year, Father Junípero Serra arrived in San Diego to establish the first of twenty-one missions that would eventually extend as far north as San Francisco, thus allying Catholic proselytization with political control in dominating local indigenous populations. After Mexico's victory in the War of Independence in 1821, Spanish territories—which had grown to encompass much of what is now the American Southwest—came under Mexican authority. A large swath of the current western United States, including California, Nevada, Utah, most of New Mexico and Arizona, and parts of Colorado and Wyoming, was part of Mexico until 1848, when the United States prevailed in the Mexican-American War and the Treaty of Guadalupe Hidalgo ceded Mexico's northern territories.

Members of the pioneering generation of Chicanx artists and activists were keenly aware of this history—at the root of their culturally and politically driven work was the cognizance that the inequities Mexican Americans had long experienced took place on land that once belonged to their ancestors. Moreover, this generation drew from ancient history, seeing the border region as Aztlán, a sacred land and the mythic place of origin for the Mexica or Aztec people. While archaeologists have posited its locale as encompassing various sites in central Mexico, Chicanx activists in the 1960s and 1970s focused on theories identifying the American Southwest as the true site of Aztlán. For Chicanx people who believed they had a legal right to the lands transferred to the United States at the conclusion of the Mexican-American War, Aztlán became a rallying cry. The Plan Espiritual de Aztlán (Spiritual Plan of Aztlán), adopted at the First National Chicano Liberation Youth Conference—a key early gathering, held in Denver in 1969—advocated for Chicanx nationalism and self-determination. The plan became a call to mobilize, to decolonize and reclaim the Chicanx homeland through political action. These ideas played a significant role during the formative years of the Chicano civil rights movement and also informed the work of artists and photographers who reflected the growing political and cultural consciousness of those associated with the movement.

Concepts of place among Latinx people are also dependent on generation. Chicanx individuals whose families have been in the United States for decades may feel a much greater sense of allegiance to neighborhoods with large Mexican American populations like Boyle Heights in Los Angeles or the Mission District in San Francisco while perceiving Mexico as a distant realm, the place of ancestors. Nevertheless, even places like East Los Angeles and the Mission District are contested spheres. In both neighborhoods—both historic centers for the Mexican American population in their cities—gentrification threatens local residents and small business owners alike.

Place takes on a wholly different meaning for Cuban Americans, a community that only came into being in 1961 after Fidel Castro imposed communist rule on the island, prompting a half million Cubans to leave the island over the next fifteen years. It also differs greatly for Cuban Americans depending on their generation. The initial generation of Cuban exiles in the United States were mostly members of the professional and business classes who had the means to flee and reestablish themselves, primarily in Miami at first. For members of this generation, now in their seventies or older, Cuba maintains a profound emotional hold; an ardent hope to return in the early years of exile was eventually replaced by longing and the realization that the United States would be a permanent home. And thanks to their defiant political opposition to Castro, for many, it was also a place never again visited, even after travel restrictions were eased. South Florida, especially Miami's Little Havana neighborhood, came to act as a surrogate for Cuba, a cultural, political, and social center. Many members of the second generation eventually visited Cuba, some for the first time and others returning after a separation of many years, even decades, and with strictures placed on visas restricting the length of their visits. For such pioneering Cuban American artists and photographers as Ana Mendieta, Tony Mendoza, Abelardo Morell, and Nereida García Ferraz, a journey to Cuba represented a watershed moment in their lives—a coming to terms with ruptured family histories and with a place known only through parents' memories. Their work reflects the centrality of Cuba to their identity; whether it is expressed through nostalgia, familial longing, skepticism, or analytical questioning, these artists have devised creative means to link the gap between political reality and personal desire.

For Puerto Ricans, place is a dual proposition involving families divided between island and mainland, most commonly New York and its environs. Puerto Ricans began arriving in the United States in large numbers after World War II, frustrated by a lack of opportunity on the island and attracted by the availability of jobs in New York during the booming postwar economy. The ease by which Puerto Ricans—US citizens since 1917—can travel between the island and the continental United States is a critical factor in the manner in which Puerto Rican culture and identity has evolved. Fully one-third of Puerto Ricans have, at some point in their lives, resided stateside. As a result, they are a truly bicultural people, able to find a sense of home in both places.

San Juan, Puerto Rico's largest city and its capital, is also its cultural center, with numerous cultural institutions, museums, and commercial art galleries. It is also where the majority of artists reside, although many spend periods in cities like New York or Miami to attend art school or pursue careers. Puerto Ricans who migrated to the continental United States originally settled in East Harlem and on the Lower East Side of Manhattan as well as in Williamsburg, Brooklyn—neighborhoods that continue to have large Latinx populations, though reduced by gentrification. Over time, Puerto Ricans migrated to cities in New Jersey and other parts of the Northeast, as well as to Philadelphia, Chicago, and Orlando. But East Harlem, also known as El Barrio, endures as the spiritual center of Puerto Rican life in the United States. Puerto Ricans have established businesses and founded cultural institutions (for example, El Museo del Barrio and Taller Boricua) and improvised cultural and community spaces in these neighborhoods. Over generations, Puerto Ricans have preserved numerous aspects of island culture in El Barrio, ranging from language, food, music, religious practices, and holiday celebrations, including the large Three Kings Day Parade that has traversed the neighborhood's streets annually for over forty years. Despite ongoing social issues, including high poverty levels, a stubbornly high crime rate, and the area's status as a food desert, the neighborhood is a place of pride for Nuyoricans, who can trace their heritage there over generations.

Puerto Rican population peaked in 2000 at about 3.8 million, but in the last two decades, emigration to the United States has intensified as a result of Puerto Rico's economic crisis and the devastation caused by Hurricane Maria in 2017. As one indication of the economic hardship on the island, 2010 cen-

sus statistics indicate that median income there is $18,862, half that of Mississippi, the poorest US state.[1] As a result, today more Puerto Ricans reside stateside than on the island. Estimates dating prior to Hurricane Maria stated that nearly 5.5 million Puerto Ricans lived in the continental United States compared to 3.1 million in Puerto Rico, and thousands departed the island in the months following the hurricane after enduring dire living conditions, with little water, food shortages, and no electrical power. With these conditions compounded by Puerto Rico's persisting economic crisis, the number of Puerto Ricans remaining on the island will likely continue to decrease.

Latinx photographers have expressed concepts of place in their work in myriad ways. Many, like George Malave and Silvia Lizama, examined a world close at hand, while others found fascination in distant locales—for example, Mario Algaze discovered echoes of a beloved Cuba in the old quarters of Latin American cities. In contrast, **Ana Mendieta** (b. 1948, Havana, Cuba; d. 1985, New York) turned to the land to produce deeply personal, poignant works tied to her personal history. Mendieta left Cuba as age twelve in the early years of the Castro regime and was resettled for a period with a foster family in Iowa through Operation Peter Pan, a program that transported unaccompanied Cuban children to the United States between 1960 and 1962. Drawing on this traumatic removal from her parents and homeland, Mendieta dedicated her oeuvre to a profound exploration of identity and exile. She stated, "I have been carrying out a dialogue between the landscape and the female body (based on my own silhouette). I believe this has been a direct result of my having been torn from my homeland (Cuba) during my adolescence. I am overwhelmed by the feeling of having been cast from the womb (nature). My art is the way I reestablish the bonds that unite me to the universe. It is a return to the maternal source."[2]

Mendieta is best known for her series of Siluetas (Silhouettes; figure 8.1), performative actions she undertook in natural sites in the United States, Mexico, and Cuba by impressing her nude body or a cut-out silhouette of its form upon the earth. She created some one hundred works in this series through much of the 1970s, sometimes leaving her bodily imprint in the raw earth and sometimes filling the body-shaped void with natural elements such as leaves, moss, or even fire. These were private acts performed in isolated locations but meant to be shared with an audience via photographic documentation.

8.1. Ana Mendieta, *Untitled*, Siluetas series, August 1978. Gelatin silver print, 6¾ × 9¾ in. © 2019 Estate of Ana Mendieta Collection, LLC. Courtesy of Galerie Lelong & Co. / Licensed by Artists Rights Society (ARS), New York, and courtesy of the Solomon R. Guggenheim Foundation / Art Resource, New York.

Mendieta conferred significance on these images beyond mere documentation, noting, "In galleries and museums the earth-body sculptures come to the viewers by way of photos, because the work necessarily always stays *in situ*. Because of this and due to the impermanence of the sculptures the photographs become a very vital part of my work."[3] In this series of both black-and-white and color photographs Mendieta presented images at varying scales, offering evidence of the deliberate manner in which she presented photographs as a central facet of her oeuvre.[4]

Such complex relationships to place, whether place of origin or adopted home, have been central to numerous Latinx photographers. In New Mexico, **Miguel Gandert** (b. 1956, Española, New Mexico; based in Albuquerque, New

8.2. Miguel Gandert, *Matachines de Nochebuena, Picuris Pueblo*, 1993. Courtesy of the artist.

8.3. Miguel Gandert, *Melissa Armijo, Eloy Montoya, and Richard "el Wino" Madrid, Albuquerque*, 1983. Archival digital print, 17 × 22 in. Courtesy of the artist.

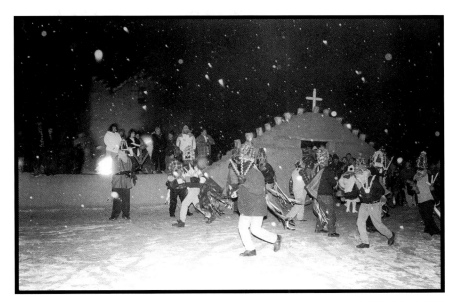

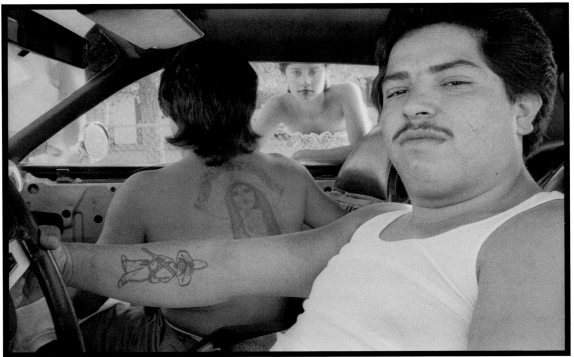

Mexico), a descendant of Spanish settlers in the southwestern United States, has worked for over four decades to document traditional and contemporary life in northern New Mexico. He has studied the persistence of Indo-Hispano rituals unique to this region that date to Spanish colonization of the Americas, symbolizing a syncretism of indigenous and European traditions and the influence of Native American, European, and Mexican people. Gandert traces practices and rituals that ignore political borders and that have evolved slowly across centuries. He is known for an extensive study of the annual Holy Week pilgrimages to the Santuario de Chimayó, a Catholic shrine north of Santa Fe dating to the early 1800s and known for the healing properties of the soil found in a well within the church. Gandert's photographs evoke Chimayó as a site that links historical tradition with a kind of religiosity rarely seen in a secular America. They depict pilgrims—young men bearing crosses, families with small children, and lone hikers—all making their way on foot toward the holy site. Another body of work studies the Matachines, ritual dances originating in Medieval Spain to recount the battles between Christians and Moors (figure 8.2). In the Americas, the tradition evolved into a drama about the Spanish conquest; it has long been performed (in some cases, for hundreds of years) in such northern New Mexico communities as Picuris Pueblo, Rancho de Taos, and Bernalillo.

In addition to memorializing the persistence of tradition, Gandert has also photographed contemporary life in this region—cholos, bikers, and lowriders of his hometown of Española, teenage mothers, and recent Mexican immigrants. These portrayals underscore the geographical isolation and poverty in northern New Mexico outside the tourist centers of Santa Fe and Taos, aiming to give voice to those who remain on society's fringes (figure 8.3).

George Malave (b. 1946, Aguadilla, Puerto Rico; based in New York), in contrast, interprets place from his perspective as a member of an immigrant family that settled in Brooklyn in the 1960s. He began his work as a photographer by focusing on a single block, the one he called home while growing up in the Williamsburg neighborhood of Brooklyn. In the late 1960s, when he created the Varet Street Kids series, the neighborhood's population was predominantly poor and Puerto Rican. This was many years before the onset of gentrification that largely transformed Williamsburg first into a neighborhood where young artists could find cheap living and studio space and eventually into an enclave

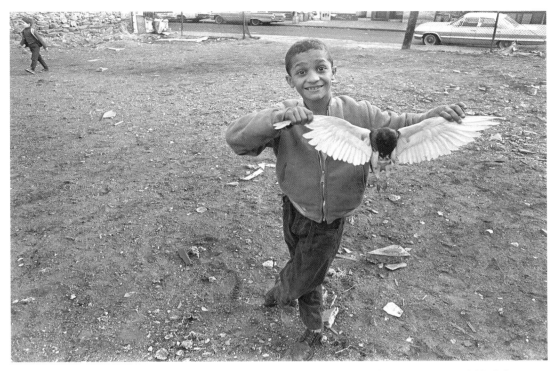

8.4. George Malave, *Boy with Dead Bird,* from the series Varet Street, 1969. © George Malave.

of luxury condos and boutiques. Malave arrived in New York as a small child with his mother, representing an early wave of Puerto Rican immigrants who came to the city in search of work. She earned a living as a seamstress. Between 1967 and 1969, while in his early twenties, Malave photographed children on Varet Street, capturing expressions of playful joy that contrast starkly with their surroundings. In his black-and-white images, the children play atop piles of garbage in abandoned lots or on mattresses left on sidewalks. If some see in these scenes crumbling tenements and grim poverty, for Malave they represent the place where he grew up, a place many other struggling families called home—their first in a city where they persevered to find a better life. This series also launched his long career as a photographer, one that has frequently been dedicated to documenting aspects of public life in the city.

A member of Cuba's first generation of exiles, **Mario Algaze** (b. 1947, Cuba; based in Miami, Florida) arrived in Miami as a young adolescent in 1960 and became a photographer in the early 1970s. His earliest photographic work was for *Zoo World*, a Fort Lauderdale–based, tabloid-style counterculture newspaper. He covered rock concerts, photographing the likes of Mick Jagger, Carlos Santana, and Frank Zappa in their youthful heyday. Exhausted by the live music scene and trying to find his place in a new world, Algaze began traveling through Latin America, initially prompted by an invitation to visit Mexico. "It was on that trip in 1974," he states, "that I regained the identity all exiles lose. . . . Even though I was not in Cuba, I understood the simplicity of that moment: I am Latin, this is my identity."[5] After spending time in Mexico City he traveled to Lima, Cartagena, Buenos Aires, and other cities and towns with central districts seemingly little touched by modernity, and these offered some reminders of a then inaccessible Cuba. It was these places that gave purpose and passion to his photography. Working in black and white, Algaze developed a virtuoso skill for composing with light and shadow to render often melancholic evocations of place. He relied on the early morning light to create images that are cinematic in quality; light not only illuminates form but also calls forth a sense of slowly moving time. Once he found a place to capture, he waited for passersby. "I need to fill the space," he stated. "I need to include the human presence. It takes a lot of patience, but you want to fill that moment."[6] The 1981 photograph *Cotton Candy*, for example, depicts a woman all but hidden behind the tall stack of cotton candy bundles she carries as she walks along a Mexico City street. Composed with simplicity and restraint, this photograph not only evoked the realities of making a living for members of Latin America's underclass but also presented the city as a site of poetic possibility.

After a separation of nearly forty years, Algaze returned to Cuba in 1999 and photographed there for twenty-one days, the length of his visa. Much of his time was spent studying the tropical light, experimenting with the best film to use, and journeying to places at certain times of day to catch the light of the rising or setting sun. The resulting photographs—spare scenes of people inhabiting spaces and interiors that had changed little in the last century—represent the recovery of memory, an emotional yet keenly observed reflection of a place that felt both distant and close.

8.5. Mario Algaze, *Encuentro, Cuzco, Peru*, 2002. Silver gelatin print. Courtesy of the artist.

Silvia Lizama (b. 1957, Havana, Cuba; based in Hollywood, Florida) has worked as a photographer for some forty years, focusing on notions of home from the perspective of someone who has personally experienced exile. In her Construction series of the early 1990s Lizama photographed construction of the I-95 highway in South Florida, envisioning it more as a ruin than as a symbol of urban progress, a monumental emblem of human mobility and alienation, of anywhere and nowhere. Her most enduring bodies of work have been hand-colored images of the interiors and exteriors of home—those she has lived in, and those she has encountered around Hollywood and Miami. Referring to her early years in the United States, Lizama wrote, "The feeling at first was that our situation was temporary and that my family would soon return to the life they once knew. . . . We did not set roots in any one place for a long time. We stayed in hotels for months, then lived in sparsely furnished rented rooms. I often wonder if my attraction to stark moody interiors comes from this time when, as a young refugee, I experienced them firsthand."[7] One photograph, of

a modest living room, was made from a negative she found among the boxes of belongings she inherited after her mother's death. Although absent of people, the stark image of an assortment of chairs surrounding a television set is meant to denote the subconscious if seemingly unimportant experiences that we all share and that contribute to our present sense of self. Lizama has also devoted series of works to the front-yard statuary (fountains, lions, and classical figures) that embellishes single-family homes in South Florida neighborhoods. Across this work, Lizama evinces a charged emotional connection to the concept of home as a place of stability and individuality. These compositions are circular, an homage to George Eastman and the first Kodak camera, which produced prints masked as round images (figure 8.6).[8]

8.6. Silvia Lizama, *Statue 3322*, from the Statue series, 2014. Hand-colored gelatin silver print, 13½ in. diameter. Courtesy of the artist.

Hand-coloring has been key to Lizama's process. Early on, she printed her photographs on silver gelatin paper and then painted them with oils. She eventually focused on digital photography and software, shooting images with a digital camera and turning them into black-and-white photographs printed in a traditional darkroom. She continues to hand-color, endowing her scenes with a muted, expressive color. "Besides making each image one of a kind," she says, "the carefully applied coloring adds to the fictional quality of the image and hopefully makes real the world I witness."[9]

Over a long career, **Abelardo Morell** (b. 1948, Havana, Cuba; based in Boston, Massachusetts) has pursued varied bodies of constructed photographic compositions that demonstrate a deep interest in optics and in the ways that the camera can transform our perception of places and mundane things. He is best known for the camera obscura images that he began to produce in the early 1990s. Morell experimented with this ancient photographic technique[10] by using sheets of black plastic to cover a room's windows and then creating a pinhole-size opening in the plastic. The hole acts like a camera aperture, allow-

8.7. Abelardo Morell, *Camera Obscura Image of La Giraldilla de la Habana in Room in Broken Wall*, 2002. Gelatin silver print. © Abelardo Morell. Courtesy of the artist and Edwynn Houk Gallery, New York.

ing a narrow stream of light into the room and creating an inverted image of the outside world on the walls and other inside surfaces. To photograph this phenomenon, Morell would position a large-format camera facing the wall onto which the image was projected, then make a long (five to ten hour) exposure on film. Beginning with classic images made at home, where he recorded the trees and houses of a suburban Boston street merging with the toys and furniture of his child's bedroom, Morell later made more ambitious camera obscura photographs in many parts of the world. "One of the satisfactions I get from making this imagery," he stated, "comes from my seeing the weird and yet natural marriage of the inside and outside."[11] He has reproduced the monumental span of the Brooklyn Bridge as seen inside a derelict bedroom that faced the bridge, and the hilly Umbrian countryside viewed inside an

empty room. These images evoke the way we hold the places of our past inside us, phantom-like, altered over time and by imperfect memory.

Morell returned to Cuba for the first time in 2002; he had not been there since his family fled the country four decades earlier, shortly after the Castro regime assumed power. One photograph he made in Havana depicts a sixteenth-century fortress tower projected onto the wall of a decrepit room. The tower is crowned by La Giraldilla, a weather vane in the form of a woman that acts as a symbol for the city. In a single camera obscura image, Morell could envision the dichotomy of Cuba in that era, as a place that is insular but that looks outward, and that possesses great beauty even in its state of physical decay (figure 8.7).

More recently, Morell endowed his camera obscura practice with greater portability by designing a light-proof tent that uses periscope-type optics. He projects views of the surrounding landscape onto the ground inside the tent, resulting in images that not only merge views of the spaces inside and outside but also, projected on a variety of surfaces, offer varied effects that can suggest painting, drawing, and even collage. Employing digital technology with his tent-camera works, Morell could record images in a relatively short time frame and thus could make visible the presence of people, whose traces disappear in his earlier, long-exposure camera obscura photographs.

Representing a younger generation of Cuban Americans, **Luis Mallo** (b. 1962, Havana, Cuba; based in Brooklyn, New York) moved with his family to Spain when he was eight and to New York when he was twelve. His photographs have concentrated on the urban environment, beginning with his mid-1990s Passenger series—portraits made in New York City subway cars (figures 8.8 and 8.9). These black-and-white images pay homage to Walker Evans's Depression-era subway portraits, photos made with a hidden camera of people sitting, waiting, and peering outward. Mallo's subjects similarly assume the quality of grim, Depression-era subjects with their dark winter clothing. Mallo, however, depicts his riders from the chest down, focusing on hands that are endlessly expressive. Many simply cup one hand in another as they await their destination. Another knits, one reads a book, and another silently prays.

Mallo made the photographs of his 2001–5 In Camera series (figure 8.10) at industrial sites in Brooklyn and Queens. He photographed through construction fences, screens, or small openings in walls, veiling or distorting views

8.8. (*left*) Luis Mallo, *Untitled (no. 34)*, from the Passenger series, 1994–95. Courtesy of the artist.

8.9. (*right*) Luis Mallo, *Untitled (no. 20)*, from the Passenger series, 1994–95. Courtesy of the artist.

of spaces meant to be inaccessible, and often overlooked by passersby. Mallo used a 4 × 5 view camera and a painstakingly slow process to reveal images possessing a kind of obstinate beauty that could be found in the city's marginal, empty spaces. He offered a nuanced view of the city, where the geometry of screens and fences interacts with the forms of the industrial buildings they enclose, and where accidental gaps and openings frame views that attain a surprising sense of intimacy. These photographs also capture transitional moments in the city, especially in Brooklyn, where old industrial districts and once neglected marginal areas along the waterfront became increasingly vulnerable to luxury real estate development and gentrification not long after Mallo realized this series.

8.10. Luis Mallo, *Untitled (no. 56)*, from the In Camera series, 2003–5. Courtesy of the artist.

Jaime Permuth has worked with both documentary and staged photography. As a documentarian, he has focused on little-known subjects ranging from the makeshift locales where Jewish men recite the Mincha (a daily afternoon prayer) to traveling circuses and a program of free classical music education for young people in his native Guatemala—a country with one of the highest rates of violence in the world. Permuth is best known for the 2010 series Yonkeros (figure 8.11), titled after the Spanglish term for businesses that deal in junked cars, stripping them and selling them as scrap metal or for parts. Such businesses have long dominated the streetscape of Willets Point, an industrial area in Queens bounded by highways and a polluted creek. Willets Point is populated with shantytown-like corrugated tin structures and, unlike elsewhere in New York, has no sidewalks or sewers. Permuth made an extensive study of the neighborhood and its workers, finding a kind of poetic beauty in this dystopian environment. He calls Yonkeros "a lyrical exploration of first world

consumerism, waste, and obsolescence as they intersect with third world ingenuity and survivalist strategies in the no-man's-land."¹² Ultimately, this series of photographs also acts as a eulogy for a community on the verge of displacement; in 2013 New York City officials announced plans to radically transform the site into a retail and entertainment hub, with thousands of new residential units.

8.11. Jaime Permuth, *Yonkeros*, 2010. Courtesy of the Artist.

Place is also the borderlands, territories near the US-Mexico border that have become the flashpoint of a contentious political debate in the era of Donald Trump. This region has long been one of pain and hardship for migrants who face dangerous conditions in attempting to cross to the United States, and for those who reside on either side and are challenged by the activities of violent drug cartels, environmental issues, and endemic poverty. Nevertheless, hybrid cultures have found ways to thrive in *la frontera*; this region can be seen as a transnational space where new social forms and spaces have been created, where customs blend and collide, where languages mix. The border is also a place of identities in flux and of the creation of improvised, hybrid cultural forms that evolve from hardship and separation as well as from resourcefulness and resistance. As Chicana cultural theorist Gloria Anzaldúa wrote, "The U.S.-Mexican border *es una herida abierta* [is an open wound] where the Third World grates against the first and bleeds. And before a scab forms it hemorrhages again, the lifeblood of two worlds merging to form a third country—a border culture."¹³

8.12. Chuy Benitez, the mariachi Sangre Joven, at Fiesta Mart on Wayside Drive, Second Ward, Houston, Texas, 2007. Courtesy of the artist.

Hailing from a binational family that has lived on both sides of the US-Mexico border, **Jesus "Chuy" Benitez** (b. 1983, El Paso, Texas; based in Houston, Texas) has worked extensively with panoramic photography, a format he was drawn to out of a desire to echo the qualities of the monumental Mexican murals he has studied as well as those he saw as a child growing up in El Paso, a city with a majority Mexican American population. The panorama format also allows him to capture in a single image the dynamics of a situation playing out before him, as well as to capture the texture of everyday life in Latinx communities—inside a home, an artist's studio, or a classroom. In a photograph of the interior of a Houston supermarket, the scene of an earnest young mariachi band serenading shoppers gives way to the more workaday activities of store employees and shoppers, many seemingly oblivious to the performance in their midst (figure 8.12). In another composition, of a family-owned chrome-plating shop, the panorama format allows multiple scenes to unfold—a grandfather interacting with a child, other children passing time,

and workers engaged in various activities. The politics of self-representation are equally important in his recording of people and place. As Benitez states, "'New' techniques of photography like the ones I use have kept ethnic communities in the United States undocumented within the national culture simply because members within the community cannot often afford the equipment necessary to create these advanced images."[14] By moving close to the scenes he is photographing and then using painstaking digital stitching, Benitez immerses the viewer in an expansive narrative, one that captures not so much a decisive moment as the sense of time and action unfolding. At the heart of Benitez's work is a commitment to reveal and magnify the richness of life along the borderlands, whether depicting people at home, an urban rodeo, or a couple in a warm embrace dancing at an outdoor Tejano concert. In doing so, he depicts the hybridity of cultural traditions present in a border state like Texas as yet another aspect of American culture.

Delilah Montoya is responsible for several distinct bodies of work (see also chapters 5 and 6), among them a series of color landscape photographs made in isolated locales along the border. A key image in the series, *Desire Lines, Baboquivari Peak, AZ*, 2004, is ostensibly a panoramic desert landscape that recalls

8.13. Delilah Montoya, *Humane Borders Water Station*, 2004. Inkjet print. © Delilah Montoya.

the work of nineteenth-century photographers whose expeditions to the West were made in tandem with the westward expansion, when lands inhabited by indigenous people were seen as open frontier awaiting settlement. Montoya, however, reveals this land as long occupied, as colonized, and as a site of active resistance. At the center of the photograph are large containers holding water, marked by a high flag that rises above them. A humanitarian gesture on behalf

of border-region organizations and volunteers, the water station is a poignant reminder of the thousands who have died of thirst and exposure while attempting to cross the desert landscape. Montoya, who has lived in three border states, sees the border as a political construct imposed over indigenous territory and natural ecosystems. Tellingly, she made this photograph in the Tohono O'odham Reservation, whose land defiantly straddles both sides of the US-Mexico border. *Desire Lines* is part of Sed: Trail of Thirst, a larger multimedia project produced in collaboration with artist/activist Orlando Lara that also includes photographs of the unmapped trails followed by migrants,

abandoned possessions found in the desert, and landscapes that reveal the Sonora Desert as a beautiful but vast and inhospitable region. A deeply political work of art, this project pays homage to migrants, especially those who have died making the perilous journey, as well as to the local people who have provided water and other basic aid along the way.

Montoya photographed the borderland region of the United States and Mexico between 2004 and 2009, during a decade that witnessed the apprehension of nearly eleven million southern border crossers and when thousands died of exposure, drowning, or violence in their attempts to enter the United States.[15] A decade later, the Trump administration implemented disastrous policies against those attempting to gain entry into the United States, even as government data has shown that illegal border crossings have drastically declined beginning in the 2010s.[16] The border landscapes that Montoya depicted represent an increasingly desperate zone thanks to "zero tolerance" and family separation policies, and to the prison-like conditions in which those seeking asylum—many of whom are refugees escaping violence in their Central American homelands—are held.

8.14. Caitlin O'Hara, photograph of Monica Dabdoub, de ocho años, fue la oradora más joven de la manifestación contra la separación de las familias en Nogales, Arizona, June 30, 2018. Courtesy of the artist and *Everyday La Frontera*.

Visual artists have reacted to the border crisis with ambitious public art projects, ranging from French artist JR's monumental portrait of a toddler peering over a border wall, to Mexican artist Marcos Ramírez Erre's thirty-three-foot-tall, two-headed Trojan-style horse placed on a border demarcation line. Photojournalists have also played a crucial role in exposing conditions and

8.15. Don Gregório Antón, *The Crossing*, from the series What I Forgot to Forget, 2018. Hammered infused aluminum print. Courtesy of the artist.

atrocities at the border; most notably, Julia Le Duc's photograph of a drowned father and daughter on the banks of the Rio Grande and John Moore's extensive coverage of border crossings and apprehensions, including the widely seen photo of a small child crying as her mother is searched by Border Patrol agents.

The Instagram feed **Everyday La Frontera** (@everydaylafrontera), founded in 2015 by Alonso Castillo, Eliseo Gaxiola, and Ernesto Peimberth, involves the contributions of numerous photographers, primarily Mexican but also Latinx and from other parts of the world, who document a broad spectrum of border realities. The accumulated posts include images of people traveling as part of caravans northward; emotional scenes of crowds gathered at border crossings; demonstrations and protests sometimes including children, such as Caitlin O'Hara's photograph of a young Monica Dabdoub (figure 8.14), age eight, draped with a "space" blanket of the kind given to separated children in detention centers; and the banality of waiting and attending to personal needs amid the harsh conditions of migration.[17]

In contrast, **Don Gregorio Antón**, who has long sought give form to the spiritual and the metaphysical, has devoted his recent work to the border, a sphere that for him is so haunting that he can only conjure it metaphorically. His series of constructed images printed on aluminum, What I Forgot to Forget, portrays not the specificities of a place but the inhumanity wrought by

geopolitical power. The images, some of monstrous beings and others more meditative in nature, are inspired by a story the young Antón heard from his grandfather, of seeing a child lost to the currents of the Rio Grande during a storm so heavy that its body seemed to be covered in white shrouds. In *The Crossing* (figure 8.15), 2018, Antón evokes the border as a kind of no-place, where the act of crossing slips from life to death, flesh to dissipation.

Geography is a key theme throughout this study of Latinx photography, ranging from George Rodriguez's depictions of East Los Angeles during a time of protest, to Perla de León's evocations of children's resiliency in the South Bronx when arson had reduced much of the area to rubble, to Erika Rodriguez's nuanced studies of the conditions of life in contemporary Puerto Rico. As such bodies of work suggest, for Latinx people, considerations about place, about the spaces we inhabit, are necessarily grounded in the fact that place also represents rupture and displacement. Over centuries, we have experienced colonization, migration, exile, and, more lately, the effects of gentrification and climate change. In response, these photographers have infused deep symbolism, both personal and political, into their representations of the land, of home, of the city, and of social spaces. For a figure like Miguel Gandert, who documents communities and customs in New Mexico that reach back centuries, the land itself, native land, is expressed as absolutely fundamental to the construction of identity. And in contrast, for Ana Mendieta and the early generation of Cuban exiles, land is associated with a deep sense loss and with a desire to reconcile heritage. In disparate ways, George Malave, in his photographs of Brooklyn street life in the 1960s, and Silvia Lizama, in her 2010s studies of the domestic architecture of South Florida suburbs, evince the ways in which immigrants assert their presence in new spaces. As much of this work also suggests, experiences of displacement and diaspora only intensify one's identification to place. The Greek geographer Theano Terkenli wrote, "Humans occupy space and use symbols to transform it into place; they are creatures of habit who appropriate place and context as home."[18] Likewise, these photographers frame geographies not only as physical realities but as liminal spaces infused with shared histories of struggle and of belonging, of collectivity, whether it be measured in terms of family, community, or nation.

9

Conceptual Statements

LATINX PHOTOGRAPHERS WHO CAME OF AGE IN THE
1960s and 1970s, as civil rights movements surged in
Chicanx and Puerto Rican communities, produced significant bodies of doc-
umentary work chronicling political activism and at the same time made
street photographs, portraits, and images meant to express pride and self-
determination. Members of this pioneering generation were motivated to take
up the camera as a form of social advocacy, compelled to record the momen-
tous shift toward greater political consciousness and action that they were
witnessing around them. As the political landscape changed in the 1980s and
1990s, a more emblematic form of image making arose, exemplified by imagery
that reflected a deep desire to affirm our presence, particularly in a time when
Latinx people remained largely invisible and excluded from the broader social
discourse in the United States—despite the gains made in the civil rights era.
Members of this generation began working with photography in new ways,
often constructing and assembling images (before the advent of digital tools),
pursuing forms of staged portraiture that acted as eloquent inquiries into cul-
tural identity and elaborating visual statements that layered time, place, and
hybrid notions of identity. But in this same period, other artists were consid-
ering the medium very differently, signaling ways in which photography was

moving into the broader arena of contemporary art, including as a component of conceptual image making and of performance, installation, and other visual art formats. Photographers were also experimenting with the medium in a more reflexive manner, creating images meant to consider the photographic medium's intrinsic qualities.

Felix Gonzalez-Torres (b. 1957, Guáimaro, Cuba; d. 1996, Miami, Florida), a visual artist who used varied, often minimal means to create his art, turned to photography for several key bodies of conceptually based work. Gonzalez-Torres was raised largely in Puerto Rico and arrived in the United States in 1979 with a fellowship to study art. In 1981, he took part in the Whitney Independent Study Program, where he became familiar with the critical theory that informed much art making in this period, including his own creative production. Also key to his evolution as an artist was his membership in Group Material, an artists' collective active in New York from 1979 to 1996 whose multimedia exhibitions focused on social and political issues while also acting as an institutional critique of the art world.

In a relatively brief career Gonzalez-Torres worked with a range of approaches and with nonconventional media, including strings of light bulbs, candy, offset prints, and billboards, to devise elegantly simple forms that conveyed meaning both personal and political. Wrapped candies precisely piled in the corner of a gallery or configured as a kind of carpet acted as an ephemeral sculpture of ever-shifting shape and density. The artist gave the exhibitor the right to determine the size and shape the work would take, the kind of candy used, and how the candy, which could be taken by visitors, was replenished (if at all). The conceptual framework of this kind of work provided his audience with agency—in deciding whether or not to participate in taking a candy (and slightly altering the work's form in doing so) and in considering its meaning, which was intentionally open-ended. For some, works like these symbolized life's inevitable diminishment and eventual end, particularly in light of the artist's death from AIDS-related causes at age thirty-eight, when he was at the height of his career.

Although his initial artistic training was in Puerto Rico, Gonzalez-Torres spent the majority of his career in the United States and considered himself an American artist. Nevertheless, Puerto Rico's populist graphic arts tradition influenced the artist, who consistently challenged the status of the artwork as

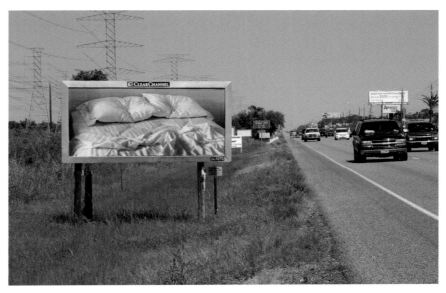

9.1. Felix Gonzalez-Torres, *Untitled*, 1991. Billboard, dimensions vary with installation. Photograph: Tom DuBrock. Installation location: Houston, Texas. From the exhibition: *Felix Gonzalez-Torres Billboard Project*, ArtPace, San Antonio, Texas, January–December 2010, curator Matthew Drutt. © Felix Gonzalez-Torres. Courtesy of the Felix Gonzalez-Torres Foundation.

unique and precious. He was inevitably also drawn to photography. In *Untitled* from 1991 (figure 9.1) he transformed a black-and-white photograph of a rumpled bed, clearly revealing the impressions of two bodies, into a billboard image that was seen in several New York locales and along New Jersey roadways. Evoking absence and loss, this elegiac image can be a memorial to his partner, Ross Laycock, who had died that year of an AIDS-related illness, but it remains open to other interpretive possibilities. An image removed from the usual gallery context (and art world audience) became a deeply personal and political statement in the public sphere. In its sheer simplicity, the work was a declaration of love and sensuality, of gay intimacy, for mass consumption.

Gonzalez-Torres studied art during the era of minimalism, an influence seen in his use of such everyday materials as candies and light bulbs in his sculptures, and in his perfect stacks of offset prints with photographic images of a

cloud-filled sky or of the sea, which could connote a multiplicity of meanings.[1] Many works in this series were meant to be infinitely reproduced. The prints are installed on a gallery floor and visitors may take a print, making them the object of a tangible exchange between the artist and his audience. With such a work Gonzalez-Torres not only anticipated the participatory, community-based forms of art that have been prevalent in the millennial era but also suggested the role that photography would play in these social practice projects.

Adál (Adál Maldonado; b. 1948, Utuado, Puerto Rico; based in Puerto Rico) was among the first Latinx artists to employ photography in conceptual projects. He arrived in New York at age seventeen in the mid-1960s and traveled west to study photography at the San Francisco Art Institute. Adál returned to New York in the 1970s and became active in the city's emerging photography scene, cofounding the Foto Gallery in SoHo with Alex Coleman while also making his own work—at that time, surreal photo collages. In that decade and into the 1980s, photography as an art form was undergoing significant reassessment. A new generation of artists, including Cindy Sherman, Barbara Kruger, Robert Mapplethorpe, and Carrie Mae Weems, were drawn to the medium to construct discursive statements on gender, race, consumerism, and other social issues. Clearly aware of the rise of photography as a critical tool and of its deepening link to contemporary art practice, Adál (who printed photographs for Mapplethorpe in the early 1970s) pursued projects that proposed new ways of thinking about the complexities of Puerto Rican identity. Reflecting on this complexity, he stated, "We are multilayered because so many different cultures and races came through Puerto Rico with the slave trade. We became a sort of fusion of all those experiences and ideas. I was raised to feel that I had many different dimensions that I could choose from."[2]

Adál's first series of published photographs, *The Evidence of Things Not Seen*, included photo collages that acted as a meditation on the medium itself. These dreamlike compositions offered plays of light and repetition, revealed images within images, and displayed the human figure alternately as a fragment, a ghostlike blur, or a reflection.[3] The subjects of these works included Adál himself and such photo-world luminaries as Duane Michals, André Kertész, and Lisette Model; the latter had conferred upon Adál his one-name moniker.

In the mid-1970s, during a period of fertile growth for Puerto Rican culture and cultural institutions in New York, Adál met the Nuyorican poet

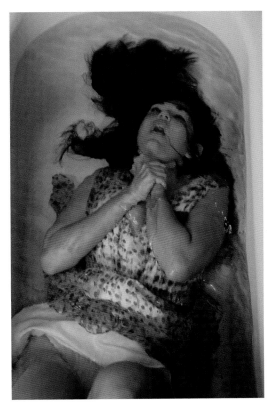

9.2. Adál, *A Puerto Rican Under Water,* 2017. Courtesy of the artist.

Pedro Pietri (1944–2004). With Pietri, a political activist and cofounder of the Nuyorican Poets Café in Manhattan's Lower East Side, Adál developed some of his most significant work, including the 1994 El Puerto Rican Embassy Project. This series of objects and images satirically addressed the political status of Puerto Rico and the marginalization of its people, through a passport for "*El* Spirit Republic *de* Puerto Rico" (declaring sovereignty to be "a state of mind"), trading cards featuring portraits of the ambassadors of the Republic, postage stamps, currency, and cans of antiterrorist spray, all projecting a Dadaist stance and absurdist challenge to the status quo.[4] An outgrowth of this project, Adál's Out of Focus Ambassadors Trading Cards are twenty digitally manipulated portraits depicting such figures as Tito Puente (Ambassador of Music), Antonio Martorell (Ambassador of Fine Arts), and other Puerto Rican cultural figures. The headshots are blurry, meant to satirically invoke the political invisibility of Nuyoricans as well as the colonial status of Puerto Rico, whose deep economic problems have long been the prime motivating factor in migration to the mainland. "I think there is for us a personal identity, and then there's a collective identity," the artist has stated. "I think that the collective identity for a Puerto Rican is what I call an 'out-of-focus identity' because it was caused by trauma . . . by a sort of mental colonization, first by Spain, and then by the United States."[5]

Beginning in 1990, Adál pursued a series of mostly black-and-white self-portraits that intended to mock the conventions of identity politics and the expectations for photographic portraiture to represent the authentic self. In *Conceptual Jíbaro Art,* he poses formally dressed in a tuxedo, with a plantain placed in front of his face, covering his mouth, mocking the high seriousness

of conceptual art. Portraiture has continued to act as a significant genre for the photographer, who has employed it to interrogate shifting identities, hybrid identities, and the impossibility of resolving an absolute sense of self. Most recently, Adál returned to a series he began in 1987 while still living in New York, Puerto Ricans Underwater (figure 9.2). He recognized the relevance of these images as Puerto Rico's financial crisis grew ever more dire, especially as a result of Hurricane Maria. In these works, Adál portrays numerous individuals, seen from above, in bathtubs, literally underwater, uncannily putting a tragicomic face on a dire situation.

Gory (Rogelio López Marín; b. 1953, Havana, Cuba; based in Miami, Florida), who began as a realist painter in Cuba in the early 1970s, had long utilized photography as an aid to painting. But in 1981, unable to complete a canvas on time for the opening of *Volumen 1*, a watershed exhibition of contemporary Cuban art in Havana, he presented the black-and-white photograph he was copying along with the unfinished canvas. With this gesture, Gory's artwork was no longer chiefly about representation; it became an inquiry into process and the relation between mimesis and creativity. Gory, who was also making photographs in the 1970s, increasingly turned to the medium after *Volumen 1*. As with his painting, he reframed the manner in which the photograph could be employed and interpreted, producing images with multiple negatives, tinting and airbrushing prints, and combining photographs with text. With such works Gory, who once worked as a photographer for the Cuban Cultural Ministry, became one of the first artists in that country to define photography in terms that moved beyond documentation and to delineate it as an aesthetic language on par with other fine art forms. In 1986 he completed what became a seminal work in the corpus of Cuban photography—*Es Sólo Agua en la Lágrima de un Extraño* (It's Only Water in a Stranger's Tear; figure 9.3). This series of nine photographic montages depicts the edge of a swimming pool filled with different bodies of water that create a kind of existential narrative on exile, a theme often visualized by images of the sea.

Gory settled in Miami after being granted permission to leave Cuba in 1992. He continued to work with photography, using photomontage, and later digital tools, to create phantasmagorical scenes that reflect his status as a migrant, his fascination with consumer culture, and his embrace of pop culture. In Gory's 2006 project Nowhere Land, he combined black and white with color in

9.3. Rogelio López Marín, *Es Sólo Agua en la Lágrima de un Extraño* (It's Only Water in a Stranger's Tear), 1986. Gelatin silver print. Courtesy of the artist.

surreal images focusing on elements of his tropical South Florida environment—his landscapes are haunted by large cars, sometimes covered with cloth and taking on the appearance of spectral forms; gaudy statuary; and ominous-looking billboards. Gory also photographed in New York, observing the city from the perspective of an outsider and often endowing the real and the banal with a sense of strangeness.

Arturo Cuenca (b. 1955, Holguín Cuba; based in New York) was also a central member of Cuba's groundbreaking Generation of the 1980s. Although the Cuban government tolerated the activities of these artists to a surprising degree during much of the decade, Cuenca was forced to leave the country in 1989 after making critical comments about the government at a conference of artists and writers. After a period in Mexico, in 1991 Cuenca settled in the United States, where he developed a conceptual approach to image making that drew on painting, photography, and writing. Many of his large-scale digital photographs of the early years of the twenty-first century depicted ships or bridges—objects that connote transit and transition, acts of connecting (people, places, objects) and of moving apart. Seen through a pall of mist, these images seemed to be not quite photographs, not quite paintings, but works that confused the conventions of each medium as well as the eye of the beholder. With their portrayals of iconic subject matter, these images reflect a kind of longing or recollection of memory, but for Cuenca they ultimately acted as metaphors

9.4. Arturo Cuenca, *Ciencia e Ideología: Che* (Science and Ideology: Che), 1987–88. Gelatin silver print, 49 × 72 in. Courtesy of the artist.

for knowledge and perception. "Knowledge and everything that reflects reality has to do with light, with the concept of photography as an image of light," he stated. "What I do in my photography is to imitate the mechanism of mental knowledge."[6]

With an analytical form of image making, Cuenca probed the realities of the Cuban culture of his formative years. His visual strategies became a politics of seeing; images combined blurred or otherwise semilegible words to suggest a lack of transparency, double meanings, misreadings, and intentional ambiguity. The 1988 *Ciencia e Ideología: Che* (Science and Ideology: Che; figure 9.4) depicts a large billboard proclaiming, "El revolucionario debe ser un trabajador infatigable" (The revolutionary must be an indefatigable worker), with a silhouette of Che Guevara alongside the words. Neither the image nor the words are presented clearly; the words are crisscrossed by the billboard's metal framework, while the image of Che is seen from the rear. With this work, Cuenca suggests that forms of obfuscation can act as effective forms of communication for those familiar with their practice. While slogans and

emblems help maintain the grip of power, art can act as a form of resistance and critique.

María Martínez Cañas (b. 1960, Havana, Cuba; based in Miami, Florida) left Cuba as an infant with her family, was raised in Puerto Rico, and came to the United States to attend college. She began taking pictures as a child, first with a Polaroid camera and then with a twin-lens Rolleiflex her mother carried from Cuba. Early on, Martínez Cañas was attracted to photographers whose work involved forms of manipulation and unconventional printing techniques. She began her own experiments with the medium as a college student, employing a range of techniques and processes that involved photomontage and collage, appropriation, and splicing together negatives. In her mature work, Martínez Cañas has acted as a semiotician, constructing images and endowing them with meaning that refers to her personal history, Cuba, exile, the natural world, and, more recently, the nature of the photographic image as an index of truth and reality.

A key early series by Martínez Cañas is the 1991–92 Quince Sellos Cubanos (Fifteen Cuban Stamps; figure 9.5), a portfolio of images in which she juxtaposed actual Cuban postage stamps from the 1930s to the 1970s with large-scale abstracted interpretations of the stamps' designs and of the people and places depicted on them—iconic scenes and well-known cultural figures and monuments. Such works suggested preoccupation with place and with themes of passage, communication, and national identity. "If a map is used to find and locate," she stated, "then a stamp is used to deliver (send; separate) and to bring closer (reconciliation). In this way, these stamps become an essential instrument in coming closer to my 'Cubanness.'"[7] In her enlarged reinterpretations of the stamps, what critic Donald Kuspit called "counter images," Martínez Cañas used the contours of buildings or faces as spaces to insert her own photographs or drawings.[8] For example, responding to a stamp with a map of North and South America, she rearranged the land masses and filled them with photographs of pre-Hispanic and colonial monuments, thus mapping relationships across space and time. She created collage-like effects with Rubylith, transparent acetate that acts as a masking film in the darkroom, which she could draw on, cut, and apply to photographic negatives. The forms she drew with the Rubylith were often angular and spiky, recalling the drawing style of the great pioneering Cuban modernist artist Wifredo Lam.

9.5 María Martínez Cañas, *Primer Sello Postal de las Américas*, from the Quince Sellos Cubanos Portfolio, 1991–92. Original Cuban stamp and gelatin silver print, 14 x 11 in. Edition of 15. Courtesy of the artist and Julie Saul Projects, New York.

In the same period Martínez Cañas created the Black Totems series, vertically formatted, abstract photomontages inspired by Lam, who fused traditional African and modern European forms in his painting. She again used Rubylith to create these complex assemblages, fabricating large-scale negatives (well before the era of digital photography) to make contact prints. The clear, untouched portions of the negative print as pure black, providing a rich ground for her assembled imagery.

Martínez Cañas's evolution as an artist parallels the tendency of other Cuban American artists of her generation to move beyond explorations of Cuba and cultural displacement. Her 2005 series Lies is based on an incident in the life of her father, a dealer of Latin American art who was unjustly accused of falsifying an authentication document. The images she produced

in response to this event are far from literal portrayals. Rather, Martínez Cañas appropriated vintage crime-scene photographs, digitally distorting them to such an extreme that they are nearly illegible and incapable of acting as indices of truth. These highly ambiguous images underscore the capacity for photographs to confound the borders between truth and fiction and to convey ambivalence and disquietude.

Manuel Acevedo (b. 1964, Newark, New Jersey; based in New York) initially worked as a street photographer in Newark, inspired by such iconic figures in the medium's history as Henri Cartier-Bresson, Bruce Davidson, and Robert Mapplethorpe. In an early project pursued through much of the 1980s, The Wards of Newark, Acevedo pictured in black and white the range of individuals who populated the struggling city—drug addicts, hustlers, parents and children, politicians, the homeless, senior citizens, and drag queens. He later developed a more layered visual approach, one that combines photography with projections, video, built forms, and interventions in both public and private spaces. Interested both in metaphysics and in creating work that is drawn from or responds to the physical space in which it is presented, Acevedo conceives of the photographic image as a three-dimensional, architectural experience. His work is bound by no signature style; rather, he elaborates modes distinct to each project.

For one body of work, Acevedo fabricated large-scale camera obscuras in rooms in community centers, churches, and homes, a means of creating site-specific dialogues with varied communities about the ways we perceive the world and share physical space. In an ambitious 2012 installation at Project Row Houses in Houston, *The House That Alhacen Built*, Acevedo paid homage to Ibn Al-Hacen (ca.965–ca. 1040 AD), the Arab scientist known for his early darkroom experiments and pioneering work in vision, optics, and light. Spaces featuring multiple projections, time-lapse animation, mirrors, and tape cast the overall installation as an architectural experience of light, perception, and self-awareness. It also included a ten-foot-long grid of close-ups of human eyes that, in their varying shape and character, suggested the endless variations of what we see and how we are seen. Acevedo took a very different approach with *Altered States #7* (figure 9.6), a 2016 work based on a photograph he took in Newark in 1998. He drew over a black-and-white image of a derelict, over-

9.6. Manuel Acevedo, *Altered Sites #7*, 1998, printed 2016. Inkjet print. Courtesy of the artist.

grown lot with a "Do Not Enter" sign, depicting a towerlike framework, a kind of minimal visionary architecture, that rises skyward. A bird in flight seems to hover within the structure. Transforming a corner of his struggling city into a place of imaginative musings, Acevedo also posits the photograph as a metaphorical starting point, an image that combines reality with pure invention.

Javier Carmona (b. 1972, Guanajuato, Mexico; based in Chicago, Illinois) creates elaborate scenes that may be confused as motion picture stills. He draws from the cinematic process, writing scripts, hiring actors, developing characters, and scouting locations, ultimately producing enigmatic scenes that hint at narratives and unspoken dialogues. Carmona often appears in these compositions, playing the character Xavier—an alternate spelling for "Javier"

that provides the photographer with some conceptual distance, allowing him to perform a different identity for the camera. He has called these images Epic Photography, taking inspiration from Bertolt Brecht's idea of Epic Theater, a form of drama meant to appeal to the intellect and objective reason rather to emotion or empathy. As Carmona has written, "Such an epic picture asserts a narrative not bound by time. Concerned with temporal location, performed gesture, and cinematic allusion, these works are presented as a common methodology, where the still photographer works much like a motion picture director."[9] In these images, individuals are often pictured alone, seemingly absorbed in thought and expressing longing—whether for connection with others or to reach a sense of resolution in these ambiguous narratives. In Love Streams: An Italian Play (figure 9.7), Carmona presents a sequence of photographs following a couple along an Italian seashore. The photos are arranged in chapters—"The Sea," "The City," "Inland," and "Reunion and Beyond." The couple's relationship is clearly fraught; their travels offer little respite from the anxiety their gestures and facial expressions convey. In discussing the work, Carmona notes, "The in-between moments . . . are the ones in which I think photography works best—when it resists explanation and revels in ambiguity. There's more to be learned by ambiguity than a straightforward recitation."[10]

While the audience for contemporary art has become increasingly aware of twentieth- and twenty-first-century figures in Latin America responsible for significant bodies of conceptual work, Latinx artists working in this realm have been largely overlooked, save perhaps for the groundbreaking films and performances of Rafael Montañez Ortiz (b. 1934), a Brooklyn-born Puerto Rican artist who was also the founder of El Museo del Barrio in New York, and the guerrilla performances of the Los Angeles–based Chicanx collective ASCO. Even lesser known are these Latinx *photographers* who approach their work through a conceptual framework and, in doing so, richly complicate the history of Latinx photography. They have expanded its scope to include the elaboration of idiosyncratic techniques and approaches to reflect on issues both personal and political, as well as on the nature of the photographic medium itself. Felix González-Torres's embrace of the reproducibility of the photographic image to engage in a form of exchange with his public, Gory's

9.7. Javier Carmona, *Untitled*, from Love Streams: An Italian Play, 2013. Archival pigment prints, 40 × 22 in. Courtesy of the artist.

pre-digital-era manipulations of imagery to challenge ideas of truth and objectivity, and María Martínez Cañas's use of Rubylith to merge photographic imagery with abstract form all became alternative means of image making that link photography to social practice art, to painting and collage, and to philosophy. While some of the photographers discussed in this chapter create bodies of work that closely parallel the concerns of other Latinx photographers—for example, Manuel Acevedo's manipulated photographs of Newark can be seen as an innovative extension of his earlier street photography documenting urban poverty—other photographers express a clear break with more conventional photographic languages, producing work that privileges idea over declarative statement, questioning over resolution. With different visual means, figures like Arturo Cuenca and Javier Carmona embrace ambivalence and ambiguity, seeing these as necessary spheres for the examination

of self and society, especially amid complicated social and political landscapes. By creating images focused less on preserving a moment or memory than on reinvention, these artists also underscore photography's potential to construct meaning as contingent and open ended and to imagine elusive realms.

10

Puerto Rico, Connected and Apart

THE HISTORY OF PHOTOGRAPHY IN PUERTO RICO IS A divided one, a story of *aquí y allá*. For photographers, the "here" and "there" typically stand for San Juan and New York but may also refer to other cities and towns on the island and stateside, depending on one's own place and perspective. While some Puerto Rican photographers who grew up on the island came permanently to cities like New York or Miami to attend school and then pursue careers, this chapter focuses on photographers who were born on the island and who have remained there. In fact, a relatively small number of photographic artists have had sustained careers in San Juan, where they exhibit in museums and galleries and have the support of a small collector base. What they lack, however, is recognition from a broader art world and the opportunity to participate in the critical discourse on contemporary art and photography, still largely driven by critics, curators, and gallerists in New York and a handful of other major cities. Artists in Puerto Rico have long faced the condition of not being accepted as American artists; their work is little seen in art spaces in the United States, although that condition has changed marginally with the greater interest paid to Puerto Rico after

Hurricane Maria.[1] To compound matters, they are also ignored by the Latin American art establishment. *Aquí y allá* is more than a logistical challenge of finding recognition and outlets for exposure; it also represents a dual focus that has profoundly shaped the creative outlooks and psyches of Puerto Rican artists over generations. Concepts of hybrid identity, the ability to negotiate freely between local and global culture and between tradition and contemporaneity, and a political landscape marked by divisions between advocates for statehood and independence have prompted generations of artists and photographers to produce layered, complex cultural statements.

In 1988 the Puerto Rican scholar Marimar Benítez wrote an influential essay, "The Special Case of Puerto Rico," presenting a comprehensive overview of twentieth-century art on the island. "After 89 years of U.S. rule," she stated, "Puerto Rico has shown a surprising resistance to Anglo-Saxon culture." And on the opposite spectrum, "art produced in Puerto Rico is all but unknown and has aroused little interest in the continental United States. . . . The cultural and political tensions between Puerto Rico and the United States have yet to be resolved, and Puerto Rican artists have symbolized these tensions in their work."[2] Much of what Benítez wrote then remains true today, but Benítez herself made a serious omission in surveying the art of Puerto Rico—its rich photographic history.

The history of photography in Puerto Rico began in 1844, just a few years after the invention of the photographic medium in 1839, with the establishment of a portrait studio in San Juan, then a small colonial outpost of the Spanish government. Portrait photography became immediately popular, and itinerant photographers began traveling to small towns on the island while permanent studios opened to serve members of the middle and upper classes in cities like San Juan, Ponce, and Mayagüez. In the 1860s a firm was established in Puerto Rico to produce cartes de visite and stereographic views. While foreigners were responsible for much of this work, an "F. Martinez" established one of the earliest portrait studios in Puerto Rico; we know that he worked in San Juan and followed the practice of that era of posing his affluent sitters before painted backdrops that he may have created himself—he stamped the back of his portraits "F. Martinez, Pintor al Oleo y Fotógrafo, Puerto Rico."

Heráclito Gautier (1838–89) represents another early instance of a successful native-born photographer. Gautier worked for some years as a photogra-

pher in Madrid and then returned to San Juan, where he opened a "galería de cristales" in 1870. The studio became known for cartes de visites, for portraits made for persons of "all classes and sizes," and for prices "inexpensive and moderate."[3] By the 1880s other native Puerto Ricans such as Eduardo López Cepero, Juan Terraforte, and Rafael Colorado were active as professional photographers. And in Ponce, J. J. Henna and E. López Molina were active in the 1880s. Both made portraits and street scenes in the city during an era of rapid development.

Even with the rise of native-born photographers in Puerto Rico, the majority of photographic work undertaken on the island well into the twentieth century was made by foreigners, with the foreign market in mind. The Spaniard Feliciano Alonso (?–1901), whose work bridges the years of Puerto Rico's status as a Spanish and then a US colony, arrived in Puerto Rico in 1871, worked with Gautier for some five years, and then opened his own studio in San Juan. Alonso, a key figure in Puerto Rico's early photographic history, produced portraits and a large collection of views of the island, including documentation of the arrival of US forces at the end of the nineteenth century and of the 1898 Spanish-American War. His photographs were published in a lavishly bound book, *Álbum de Puerto Rico*, broadly distributed in the United States during an era of incipient American imperialism.[4] Alonso was also a noted technical specialist who experimented with new printing techniques and with lighting.[5]

With the Spanish-American War, for the first time photography became the principal means by which a major US military conflict was documented. Photography had played a role in previous wars, particularly during the Civil War, when Haley Sims and Alexander Gardner re-created battle scenes and Mathew Brady photographed the bodies of fallen soldiers to raise awareness of the war's atrocities. In the 1860s, cameras and glass plates were heavy and cumbersome and exposures long, making documentation of movement and action technically impossible. But by the 1890s, lighter-weight cameras and the replacement of glass plates with celluloid film led to rapid advancements in the field of photojournalism. Moreover, the development of the halftone reproduction process in the 1870s and 1880s allowed for a practical means to publish and disseminate photographic images via newspapers and magazines. And increasingly, the press and government entities understood the power of images to shape public opinion, foment patriotism, and support political agendas. Magazines

like *Collier's Weekly* and *Leslie's Weekly* published photographs regularly and were avidly consumed by a large, curious public. And even in the early days of grainy black-and-white magazine illustrations, such photographs also had a sense of immediacy and veracity that wood engravings—even those based on photographs—could not fully convey.

In the wake of the Spanish-American War, the stateside media used both words and pictures to advance the position of the United States as a force for good that would civilize and modernize a rural backwater, one strategically located near the mainland. With the Jones Act, which came into effect in 1917, Puerto Ricans gained new rights, including US citizenship (although not the right to vote in federal elections), a reformed system of government, and new civil rights. At the same time, a common public school system based on the American model was established, new investments were made in the sugar and tobacco industries, and major investments improved the transportation and communication infrastructure.

Among the most comprehensive efforts to edify Americans about the nation's accomplishments in territorial expansion was the 1898 *Our Islands and Their People*, a two-volume book lavishly illustrated with 1,238 photographs, black and white with a few in color, of life in the Philippines, Hawaii, Cuba, and Puerto Rico.[6] The photographs were by Walter Townsend, a young photographer who had earlier worked for the Missouri Pacific Railway. Townsend traveled for eighteen months with a large-format camera and made thousands of glass-plate negatives for the project. The Puerto Rican images depict such scenes as local inhabitants, primarily peasants working or posing before their modest homes; colonial churches and civic monuments; landscapes, harbor and town views; and new infrastructure. And while the project was primarily educational, without an overt political agenda, the overall ensemble of photographs cast Puerto Rico as an orderly territory thanks to the imposition of American authority (suggested by photos of vaccine stations, military exercises, and US warships at anchor) with verdant resources and a peasant population that would benefit from the American presence.

In the early decades of the twentieth century, American photographers traveled to Puerto Rico to more openly promote tourism and investment. Underwood & Underwood, a New York firm that was the largest producer of stereographic images in the late nineteenth and early twentieth centuries, sold

boxed sets of views of Puerto Rico that aimed to "furnish a visual inventory of picturesque scenes and locales for potential tourists and investors." It contained photographic images, in their words, of "San Juan, Porto Rico. Humble home life of our Porto Rican cousins—their work and their sports. Places made famous by men of four centuries ago and by the men of a few years ago. Crops, industries and social customs."[7] In contrast to Townsend's photographs for *Our Islands and Their People*, these images included scenes of true impoverishment (children in ragged clothes, barefoot beggars, and rudimentary housing) but also focused on buildings and infrastructure (or lack thereof)—useful information for those considering setting up a business or investing in the island. The photographs were generally published without credit, but many were taken by H. A. Strohmeyer and H. W. Wyman, a team that worked across the United States for their own stereoview business, purchased by Underwood & Underwood in 1901.

Similarly, the Detroit Publishing Company, in operation from 1905 to the early 1930s and among the largest postcard distributors internationally in this era, published numerous scenes of Puerto Rico. They included scenic roadside views, thatched-hut rural housing, historic structures, everyday activities like laundering and bringing fruits to market, tropical landscapes, and views of San Juan. The photographs are occasionally credited to William Henry Jackson, whose collection of negatives of the American West and of the construction of the Union Pacific Railroad formed the basis of the Detroit Publishing Company's early business. But the firm employed many traveler-photographers, and no evidence exists that Jackson himself actually spent any time on the island. Widely distributed, such photographs played a central role in disseminating stereotypes of Puerto Ricans as exotic, uncivilized, and needy of US intervention. Firms like the Detroit Publishing Company and others, like the Waldrop Photo Company, were not above publishing derogatory scenes that exploited people wholly unaware of how their portrayals would be used. Both, for example, published postcards labeling dark-skinned children as "pickaninnies."[8]

There is no evidence that Puerto Ricans were employed by the firms responsible for creating these images of the island in the early decades of the twentieth century. Increasingly, however, they did work locally—for example, Luis de Casenave, an early photojournalist for the major daily newspaper *El Mundo*, as well the many photographers who worked for a popular weekly extant from

10.1. Detroit Publishing Company, Puerto Rican Natives, ca. 1903. Postcard printed from dry-plate negative.

1910 to 1952, *Puerto Rico Ilustrado*. Similar to American illustrated weeklies of the time, *Puerto Rico Ilustrado* chronicled life on the island, along with opinion pieces, international news, and photo essays, both entertaining and serious. Little is known about the photographers who worked for the weekly; if credited at all, they are listed only by their surnames—Casanova, Delgado, and Valiente, for example, in the 1910s. By the late 1920s, the Asociación de Fotógrafos de Puerto Rico had been established, offering further evidence of the growth of photography as a profession in Puerto Rico. Two impediments have made it difficult to study early photography in Puerto Rico: much of this work is unsigned or poorly documented, and worse, much has been damaged or destroyed as a result of the island's tropical environment.

The modern era in Puerto Rican photography began largely thanks to the Farm Security Administration, a government agency established as part of the

New Deal to address rural poverty during the Great Depression. Founded in the mid-1930s, the FSA included a photography program that sent such figures as Dorothea Lange, Walker Evans, Russell Lee, Gordon Parks, and Marion Post Wolcott across the United States to document the impact of the Depression.

Jack Delano (b. 1914, Kiev, Ukraine; d. 1997, Puerto Rico) was a member of this group and became a preeminent figure in the modern history of photography in Puerto Rico. The son of Russian émigrés, Delano came to the United States in the 1920s and initially studied music and illustration, but photography provided him with the most direct outlet for his socially oriented interests. He approached Roy Stryker, head of the FSA's Information Division, with photographs he had made in the late 1930s of Pennsylvania coal miners and coal-mining communities under the auspices of the WPA Federal Art Project. Stryker sent Delano to the Virgin Islands and Puerto Rico in 1941. For three months, coinciding with the onset of US participation in World War II, he documented everyday life and the social conditions he encountered on these islands when they were largely rural and essentially untouched by tourism.

Other photographers had earlier come to Puerto Rico under the FSA's auspices, including Edwin Rosskam (1903–85) and his wife, Louise (1910–2003),[9] who documented life on the island in the late 1930s, and Charles Rotkin (1916–2004), who photographed the island in the 1940s.[10] Delano ultimately worked on the island the longest, an experience that left an indelible impression on the young photographer. "I was fascinated and disturbed by so much of what I saw," he wrote about his first trip to Puerto Rico in 1941.[11] "I had seen plenty of poverty in my travels in the Deep South, but never anything like this." Unusual among documentary photographers in this period, Delano produced some of the photographs during this initial stay in color, as he had with his FSA work in the South and in New England. After military service in World War II he was awarded a Guggenheim Fellowship to work on a book about the island. Delano returned in 1947 and decided to make the island his permanent home.

Jack Delano eventually made a strong impact Puerto Rico's cultural scene. He also had a long career in the Puerto Rican television industry, as a filmmaker, and as a musical composer. With his wife, Irene (1919–82), he established a Graphic Arts Workshop under the auspices of Puerto Rico's Commission of Public Parks and Recreation. In addition to the innovative graphic arts program they ran, the couple also collaborated on children's books and films.

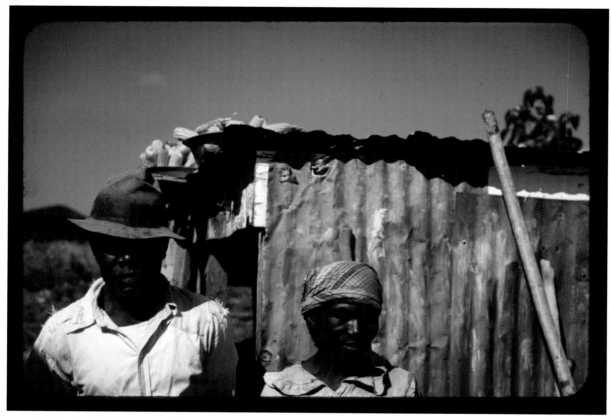

10.2. Jack Delano, tenant farmers in front of their house, December 1941 or January 1942. Library of Congress, Farm Security Administration: Office of War Information Color Slides and Transparencies Collection.

Irene also participated in her husband's photography career, though her contributions in that area are less widely known. She accompanied him on his FSA assignments, acting as his editor and collaborator and creating a note-taking system to accompany his photographs.[12]

Jack Delano is best known for his vivid and extensive photographic record of Puerto Rican life over the course of four decades. His oeuvre encompasses scenes of people at work in urban and rural settings, taking part in celebrations modern and traditional, and engaged in the activities of daily life. His ability as a storyteller, and the profoundly humanistic values that informed his work,

made him a cherished figure among later generations of artists and photographers on the island. His work could convey a starkly modern sensibility. He often photographed his subjects up close, emphasizing deep contrasts of light and shadow or accentuating a figure's form set against the landscape to endow the individual with a sculptural presence. In depicting peasants, positioning his camera from slightly below, he could capture a sense of monumentality wholly absent in the work of earlier photographers in Puerto Rico. Moreover, it is likely that Delano's color images were the first documentary images made in color in Puerto Rico; with such work, he could convey the vivid quality of life in this tropical environment. And although Delano came to Puerto Rico as an outsider, his work rejected the anthropological stance that marked the work of earlier foreign photographers. Dedicated to preserving local culture, he approached the people he photographed with great respect and familiarity, and he approached Puerto Rico with an intimate understanding of the enormous social changes taking place on the island beginning in the post–World War II era.[13]

The island of Puerto Rico was indeed in the midst of great change in these years. In 1952 it became a commonwealth or Estado Libre Asociado of the United States, a status that provided a new constitution and greater local political autonomy for its citizens. Nevertheless, Puerto Ricans were still denied the right to vote at the federal level, were required to register for military conscription when the draft was in force, and remained subject to numerous governmental regulations. Puerto Ricans had begun to migrate to the United States in great numbers beginning in the late 1940s, at the conclusion of World War II. Settling primarily in New York, they were motivated to leave the island because of the widespread poverty that had lingered since the Great Depression—the focus of the first wave of FSA photographers—as well as by the availability of jobs in the growing US postwar economy. In the same period, Puerto Rico's first elected governor, Luis Muñoz Marín, made efforts to attract new investment and jobs to Puerto Rico. Operation Bootstrap (or Operación Manos a la Obra, as it is known in Puerto Rico) brought new industries to the island, diversifying its agrarian economy and causing many socioeconomic indices to rise. But this drive toward modernization was accompanied by the collapse of the island's sugar industry, and the profits from new industries rarely stayed in Puerto Rico—the companies were owned by US concerns. As

a result, emigration escalated, from nearly seventy thousand persons in the 1940s to nearly nine hundred thousand in the 1960s.[14] It was in this environment of economic and social change that Delano documented a wide gamut of Puerto Rican life—agrarian peasants and female factory workers; tropical landscapes and the streets of San Juan; ramshackle slum dwellings and modern supermarkets; and above all, deeply sensitive portraits.

Contemporary, consciously artistic photography by Puerto Ricans based on the island begins in earnest with **Héctor Méndez Caratini** (b. 1949, San Juan, Puerto Rico; based in San Juan), whose long career has encompassed both documentary and more experimental modes of creating imagery. If any one figure emerged as heir to Jack Delano and his commitment to directing the medium to express the character of a place culturally, socially, and spiritually, it is Méndez Caratini. After studying photography in New York in the early 1970s, he returned to Puerto Rico to produced his first sustained bodies of work, images chronicling everyday life in small towns and rural areas. Méndez Caratini's early work was, he has noted, influenced by Delano and his form of social documentation. He was also driven by the awareness that he lacked knowledge of Puerto Rico's history, and he began to study with Ricardo Alegría, the renowned scholar and cultural anthropologist.[15] Méndez Caratini's curiosity and growing knowledge of the world close at hand led to his creation of numerous sustained bodies of work, some in color and others in black and white, examining such subjects as Taíno (indigenous Puerto Rican) rock engravings; *vaqueros*, followers of the bull-riding tradition that began in the Spanish colonial era; *mascarada*, the tradition of making masks and wearing them in religious festivals; the decaying colonial coffee-growing haciendas still found in interior mountainous regions of Puerto Rico (many seriously damaged by Hurricane Maria in 2017); and similarly, the island's old, abandoned sugarcane plantations. Méndez Caratini has also dedicated much of his work to documenting the African presence in Puerto Rico, including Afro-Caribbean spiritual practices in Loíza Aldea, a town settled by freed African slaves that continues to practice Yoruba-based religious rituals.[16] In later work, he traveled through Cambodia, Thailand, and the Himalayas to photograph architectural monuments, sacred spaces, and the heads of Buddha statues, presented in intensely colored prints that blend an anthropological approach with surrealism.

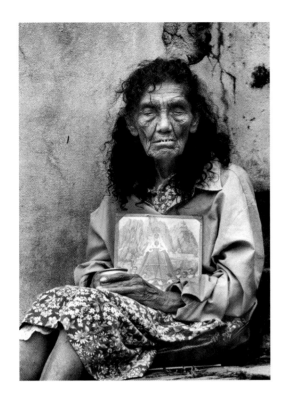

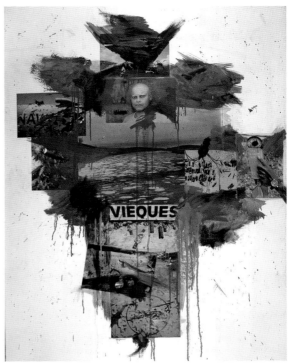

10.3. (*left*) Héctor Méndez Caratini, *Devotee of the Virgin of the Monserrat, Hormigueros*, Puerto Rico, 1979. Courtesy of the artist.

10.4. (*right*) Héctor Méndez Caratini, *Vía Crucis IV,* from the series Vieques: Crónicas del Calvario, Puerto Rico, 2000. Courtesy of the artist.

In 1999–2000 Méndez Caratini produced a series of mixed-media work that represented a striking departure from his earlier, documentary-based practice. Vieques: Crónicas del Calvario (Vieques: Chronicles of the Calvary; figure 10.4) was created at a moment when protests against the US Navy's occupation of a portion of the island for use as a weapons testing ground was reaching a fevered pitch. The series consists of large-scale collages combining photographs, texts, and painted passages. Each tells a story about everyday life on the small island, the military's damaging impact on the environment and on the health of the local population, small local protests, and larger, well-organized acts of civil

disobedience.[17] Méndez Caratini ordered the series in the manner of a Via Crucis—a Stations of the Cross—evoking parallels between the convictions and acts of political protestors to Christian spiritual pilgrimage and sacrifice.[18] In retrospect, his Vieques project can be seen as a vital contribution to a heroic, ultimately successful grassroots campaign that played a decisive role in the navy's departure from the island in 2003. Méndez Caratini has also played a significant role in Puerto Rico as a promoter of the photographic medium. He is a past president of the Consejo Puertorriqueño de Fotografía and often represented the island at major photography conferences in Latin America, most notably the Coloquio Latinoamericano de Fotografía (held in Mexico City and Cuba in the 1970s and 1980s), which brought together leading photographers from throughout the Americas.

The generation of photographers that arose in Puerto Rico in the 1980s began moving away from the documentary mode prevalent in earlier decades, many to experiment with varied approaches to constructing and manipulating imagery. They endowed their work with meaning in ways that revealed their familiarity with the critical dialogues around the photographic medium emanating out of New York, where some had studied, as well as in Puerto Rico. Of special significance is **Frieda Medín** (b. 1949, San Juan, Puerto Rico; based in Puerto Rico), a rare example of a female photographer active on the island in the 1970s and 1980s whose work spans photography, film, and installation. After basic studies in photography in Puerto Rico in the early 1980s, Medín developed a practice that combined a kind of private performance with self-portraiture to create images that critiqued the position of women in society and, more broadly, the state of Puerto Rican culture. She produced work by combining negatives, tearing prints, and incorporating recycled materials and found objects into what she called "abandoned altars," not being familiar with the concept of installation at the time.[19] With such approaches, Medín challenged the primacy of the formalist tendencies associated with photography in Puerto Rican up until that period. Her first series of self-portraits from 1984, Imágenes Arrancadas (Torn-Out Images), were made in an abandoned house that she worked in over the course of a year. She pursued the work, she has stated, as a solitary exploration of social mores and belief systems that failed her. The process of creating the work became a means of exorcising confusion, anger, and guilt over institutionalized religion.[20] In *Rumbos*, a small group of

black-and-white images within the Imágenes Arrancadas project, Medín also critiqued the objectification of the female body within the realm of photography and, more broadly, in Puerto Rico's patriarchal culture. In *Rumbos III* (figure 10.5), a woman turns her face away from the camera and lies on the floor, bespeaking the aftermath of violence. The body is fragmented and nearly engulfed by shadowy forms that the photographer created by burning away parts of her negative. The violence Medín expressed in such images is both physical and psychological; as she has stated, this work was meant to portray the inner psyche as well as to confront the realities of a society that represses women.[21] Moreover, with this work she aimed to create a thesis about the female body. The body itself is subject matter, seen from a woman's point of view, not from the male gaze. The controversy generated by this work among Puerto Rico's small art community when it was exhibited in San Juan in 1984 contributed to Medín's withdrawal from the art world. She spent time in New York studying filmmaking and in the 1990s produced the 16mm film *Aurelia.* Through negative images, jump cuts, and a fragmented soundtrack, a multiple-voice dialogue of female consciousness, she constructed her protagonist's inner being—her thoughts, conflicts, and memories.[22]

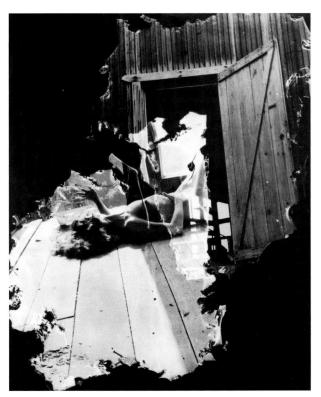

10.5. Frieda Medín Ojeda, *Rumbos III*, 1984. 19½ × 15½ in. Courtesy of the Collection OAS Art Museum of the Americas.

Víctor Vázquez (b. 1950, San Juan, Puerto Rico; based in San Juan), one of Puerto Rico's most significant contemporary artists, emerged as a photographer in the early 1990s. He long focused his practice around the construction of images, often using models and props that carry symbolic meaning. An early body of work Vázquez made while living in New York, the 1991 El Reino de Espera (The Realm of Waiting), combined grainy, sepia-toned prints, images printed as photographic

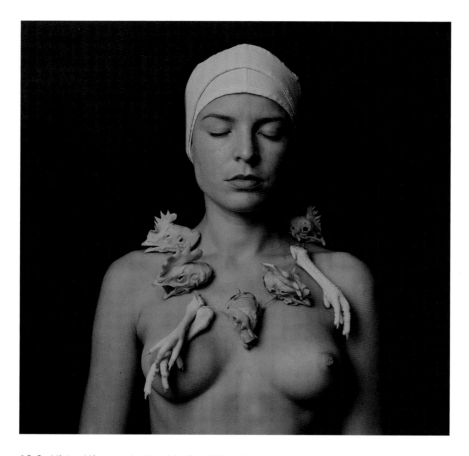

10.6. Víctor Vázquez, *La Ave María*, 1996. Black-and-white painted photograph, 36¼ × 36¼ in. Courtesy of the artist.

negatives, and compositions resulting from other kinds of darkroom manipulation. This elegiac study chronicles the slow death of a friend, Santiago Barreiro, from AIDS. The photographs offer a profoundly intimate, emotional narrative exploring the relationship between life and death—a theme Vázquez often turned to in later bodies of work. Among the most poignant images in the series is a disarmingly direct photograph of the soles of Barreiro's feet, with no other part of the body visible as a result of the camera angle. The composition recalls the power of Italian Renaissance painter Andrea Mantegna's

Dead Christ (ca. 1480); echoing the painting, Vázquez's photograph captures the sense of the body's gravity and the starkness of the human form in death.[23]

In Puerto Rico, Vázquez went on to produce an influential body of large-scale color photographs in the 1990s with themes focusing on Afro-Caribbean culture, popular religious practices derived from Santería, and human connections to the natural world. Elaborately composed, the subjects in these ritualistic images wore masks, plants, chickens, or feathers, elements in Afro-Caribbean spiritual practices. Much of his oeuvre of this decade, in fact, evokes a quest for spiritual redemption. Once a student of religion, Vázquez drew from symbols and rituals connected with animism, spiritism, and Santería to create images that suggest the plurality of influences that have shaped Puerto Rican culture and the continuing vitality of these traditions in the Caribbean. This work also held personal meaning for Vázquez, who sought to decontextualize the symbols he employed and to speak universally about the duality of life and death, our relationship with nature, and how we, as humans, experience and convey our essential selves.

La Ave María (figure 10.6), 1996, portrays a woman bearing the claws and heads of chickens on her shoulders and breasts. The animal parts conjure Santería and ritual acts of sacrifice, just as the title of the work refers to Catholic prayer. Here, Vázquez created a syncretic image, a union of Western and Afro-Caribbean spiritual beliefs. The title also carries dual meaning—it can be literally translated as "The Bird Mary" while also referring to the Latin Hail Mary, *Ave Maria.* Ultimately, Vázquez overlays new, personal meaning, suggesting the value of private, individual ritual, liberated from any particular belief system. The woman's closed eyes and serene countenance signal a transformative moment brought about by a deeply personal, recuperative communion with nature and the subconscious.

In work of the early twenty-first century, Vázquez took a more conceptual approach to image making. In the 2002–6 series Liquids and Signs, he created a sequence of photographs that poetically combine images related to knowledge (an open book resting on a bed of earth, placed on a chair), human consciousness (a nude woman covered with small sheets of paper marked with hand-drawn symbols), mortality (a hand holding a candle, flanked by images of a blood-marked wall), and ritual (a nude man, whose body is painted black in the first image and white in subsequent images, stands and then submerges

his head into a bucket). Such enigmatic scenes symbolically express knowledge as primal, beyond the intellectual or cultural. As in earlier bodies of work, Vázquez denotes perception as a process that necessarily draws from mind and body, sensuality and thought. While still working with photography, in later years he also combined large-scale images in multimedia installations that have addressed social and political issues of critical importance to Puerto Ricans.

Néstor Millán (b. 1960, San Germán, Puerto Rico; based in Puerto Rico) photographed the nude figure—his own body and those of other men—to create pensive, erotically charged compositions. Through various forms of image manipulation, his works seem to capture dream states or imagined reveries. Two series from this decade, Con Otros Hombres (With Other Men) and Against Straight Lines, show Millán and members of his social circle in poses that are almost ritualistic in sensibility, conveying the tension between desire and repression. These black-and-white images are by turns hauntingly beautiful, frightening, and enigmatic. Millán developed a range of approaches to heighten the emotional quality of his images. His subjects are seen in shadow or in partial focus, and he often scratched or damaged his negatives or paper prior to printing. He expressed the desire to conjure a fusion of "reality and unreality," as well as a fragmented sense of space and time.[24] Through this work, Millán expressed the body as a site of vulnerability and fragility, reflecting the anxiety that permeated gay men's lives when the AIDS crisis was at its height. Although Millán later turned to painting and printmaking, he continued to concentrate on the human form, typically envisioning his emblematic figures as sensual beings immersed in opulent, imagined landscapes.

The work of photographers like Frieda Medín in the 1980s and Víctor Vázquez and Néstor Millán in the following decade represented the presence of a small but active photography scene centered in San Juan. Earlier, in 1973, a small group of New York–based Puerto Rican photographers, who would soon form the photographers collective En Foco in the Bronx, organized the first major exhibition of Puerto Rican photography. Curated by photographer Geno Rodriguez and presented at El Instituto de Cultura Puertorriqueña in San Juan, *Dos Mundos: The Worlds of the Puerto Ricans* included work by twelve photographic artists based both stateside and on the island. Played an influential role in promoting the presence of Puerto Rican photographers as well in providing a crucial bridge

10.7. Néstor Millán, *Sumario de Silencios*, 2000. Manipulated silver gelatin print on Ilford Multigrade FB paper, 19¾ × 15¾ in. Courtesy of the artist.

between Puerto Rican photographers on the island and in New York.[25] Another significant exhibition focusing on the concept of photography as a form of artistic expression was the 1985 *Nueva Fotografía Puertorriqueña* presented at the Museo de la Universidad de Puerto Rico. It included the work of fourteen photographers based in New York and Puerto Rico: Pablo Cambó, Ángel Franco, José R. Gaztambide, Felix Gonzalez-Torres, Carlos Guzmán, Mario Kalisch, Héctor Méndez Caratini, María Martínez Cañas, Frank X. Méndez, Frieda Medín, Rafael Ramírez, Sophie Rivera, Naomi Simonetti, and Ramón Vilá. Others working actively with the medium in these decades include Nitza Luna (b. 1959), known for elegant, formal compositions of tropical plant life, and John Betancourt (b. 1949), a photographer of urban scenes who was also active as a promoter of photography.

One photographer, Ramón Aboy Miranda (1950–86) transformed his historic family home into Casa Aboy, which in 1976 became Puerto Rico's first photography gallery (known as Galería Fotográfica PL 900) as well as a cultural center. Particularly in its early years, Casa Aboy exhibited the work of local and international photographers, offering a rare space on the island where photography was studied, exhibited, and validated as an art form. María Martínez Cañas had her first solo exhibition there, in 1977, while she was still living on the island. And in 1981, Felix Gonzalez-Torres, also then living in Puerto Rico, mounted a photo installation, *La Imagen como Producto/Poder* (The Image as Product/ Power), utilizing a series of blurry Polaroid prints.[26] Nevertheless, the Puerto Rican photography scene has remained relatively modest, especially because

10.8. Erika P. Rodríguez, *Miguel Quiñones, a military veteran, poses outside his home in Barrio Bubao in Utuado*, October 25, 2017. Courtesy of the artist.

the kinds of institutional frameworks that exist stateside—photography centers and museums, a broad collector base, and commercial galleries specializing in the medium—are lacking on the island, making careers in the field difficult to sustain.

A member of a younger generation, **Erika P. Rodríguez** (b. 1988, Puerto Rico; based in San Juan, Puerto Rico) exemplifies the new urgency in turning to the documentary mode to make conditions of life in Puerto Rico visible—after PROMESA, after Hurricane Maria, and after continued economic decline. Rodríguez, who has lived on the West Coast of the United States as well as in Puerto Rico, directs her work toward chronicling Puerto Rico in a time of crisis. Nevertheless, she focuses on the everyday, picturing the ways in which Puerto Ricans' sense of identity is changing as people adjust to existing in a state of crisis, whether striving to maintain common routines and pastimes or confronting radical change in their way of life. As someone who

intimately understands the island's social fabric, she also aims to show the complexities and contradictions that underscore Puerto Ricans' dual status as American citizens and colonized people. Rodríguez has photographed family life, celebrations, and moments of relaxation, with images that are very personal and that neither stereotype nor exoticize life on the island. She has also depicted Fourth of July celebrations, an ironic proposition for people who are not fully independent. At the same time, she uses the camera as a tool of social critique to document the impact of Puerto Rico's economic crisis and, more recently, conditions in the wake of Hurricane Maria. Through deeply humanistic images, Rodríguez has aimed to express what a contemporary form of colonization looks like—the sadness of families separating as some leave for the mainland, empty storefronts, demonstrations outside federal buildings, and portraits of elderly people who make do with less and less as costs inevitably rise on the island.

Afterword

I HAVE ONLY A SINGLE PHOTOGRAPH OF MY PATERNAL
grandmother, Virginia Estrada (née Bravo; figure A.1), as a
young woman. It dates to circa 1930, when she was eighteen years old and living in a modest wooden bungalow in Boyle Heights, a neighborhood just east of downtown Los Angeles. She poses on the small porch of her family's home and is beautifully dressed, with carefully set curls and wearing a Spanish-style shawl, its long fringe hanging to her ankles. This photograph must have been taken to mark a special occasion—perhaps her marriage to my grandfather Charles Estrada. The home no longer exists; it was torn down to make way for a sprawling, now rundown Depression-era rental apartment complex not far from Estrada Courts, known for the murals painted by Chicanx artists on the facades of its buildings in the 1970s. In those days, Boyle Heights had yet to become the almost exclusively Mexican American neighborhood in which I was raised. In the 1930s, it was home to an unusually diverse population of Mexican Americans, about a third of the city's Jewish population, Russians, and Japanese Americans, many of whom had fled San Francisco after the Great Earthquake of 1906. This area of Los Angeles still had the feeling of a small town, although it was facing rapid development in the 1930s. Bridges were being constructed across the nearby Los Angeles River to the west, linking Boyle Heights to the city's civic center. Nearby railway arteries were spurring industrial development along each side of river, and new immigrants provided a ready supply of cheap labor.

I know little about my family's early history in the United States; some of my ancestors came north around the time of the Mexican Revolution, but

others arrived earlier. In fact, I had never seen a photograph of any member of my family taken as early as the 1930s until my uncle and the family historian, Richard Estrada, sent me a copy of my grandmother's portrait. For me, this single photo evokes our family's history in the United States, now spanning over a century. It also reminds me of the basic fact that my family history is a piece of larger histories—of the Mexican American community of Boyle Heights, of Los Angeles, of a not yet fully written, multicultural American history.

A.1. Portrait of Virginia Estrada, ca. 1930. Courtesy of the author and the Estrada Family, Los Angeles, California.

In researching the work of Latinx photographers, I have been struck by the frequency with which so many spoke of old family photographs like the one of my grandmother as a key source of early creative inspiration. They may have had little exposure to the fine arts as children, but they did have treasured pictures that preserved the memory of individuals and families and the ways of life they represented. These personal images have also come to be seen as a powerful form of agency, embodying the preservation of marginalized histories and existing as an alternative cultural and historic record. Many of the photographic artists discussed in *Latinx Photography in the United States* pay homage to familial histories in work that asserts, now in a more vocal and public way, the myriad values, experiences, and perspectives of Latinx people. Some have incorporated old family photos into new compositions, while others examine the narratives of their own family histories across time and space. Cuban American photographers and others who have come to the United States in exile have often turned to photography to convey both personal and cultural dimensions of family separation—visualizing one's current condition is to evoke absence as much as presence. The theme of family has also absorbed many Chicanx photographers, who ponder their relationship (or lack thereof) to Mexico.

The preponderance of visual references to family and family history among Latinx photographers is not simply a turn to nostalgia; it is also a recognition that such images present an enormous range of experiences that would otherwise be unrecognized or ignored. It is unsurprising, then, that Latinx photographers have long understood the value of their work; it brings forth the voices of another America, one that is growing rapidly in numbers and social influence. The view of American life presented by the mass media in the 1960s and 1970s, the same period when Latinx youths were becoming politicized, might have been more aspirational than real, particularly the idealized visions of middle-class domesticity promulgated on popular television series, but it did not reflect our reality. Nor did the news media, which seemed intent in those days on fostering negative stereotypes. But photos made by everyday people of their families, of celebrations, and of important benchmarks in their lives filled a gap, recording what it has meant, generation after generation, to be a Puerto Rican, Cuban American, Chicanx, or Mexican American in the United States.

Moreover, looking back, and reflecting a consciousness of history, becomes a key strategy for looking forward. Contemplating one's personal and social history, examining the role of the past in an individual's current life, and mapping the complexities of a bicultural outlook become creative means of affirming one's place in the contemporary world. In the 1980s, the Chicana artist and scholar Amalia Mesa-Bains stated, "Our art functions both as collective memory and alternative chronicle. In this sense, multicultural art, if nurtured, can become a powerful tool to recognize the desired historical self. The great paradox is that without this historical self, no meaningful future can ever be constructed."[1]

In the last decade, with the rise of social media—especially the visually oriented Instagram—the photographic image is more omnipresent and more public than ever before. The nearly 100 million photographs and videos posted daily on Instagram daily offer one telling statistic. This utter democratization of the medium, largely made possible by the ubiquity of smartphone cameras, has enabled the dissemination of a much broader and richer visual record of society than we have ever seen. Regardless of their social position or access to institutional power, individuals view photography as a key means of communication and personal expression. With its capacity to be shared among vast

A.2. Guadalupe Rosales, Mind Crime Hookers Party Crew posing on the 6th Street Bridge, Boyle Heights, 1993. Courtesy of the artist.

networks, photography holds the possibility of displaying a universe of social ideas, political positions, and spiritual values held by everyday people, by those who work with the camera and by those who stand freely before its lens.

One influential model of photography's broadened impact as a democratic form of expression is **Veteranas and Rucas**, an archive on Instagram (@Veteranas_and_Rucas) founded by Guadalupe Rosales in 2015, initially to share her extensive documentation of the Los Angeles party crew scene she took part in as an adolescent. An alternative to gangs and drugs, the party crew focused on house parties and on techno, house, and new wave music. A decade later, Rosales attempted to investigate this history and found little information online. But she had photographs, old party flyers, and magazines (*Low Rider*, *La Raza*) that could be shared. Today, *Veteranas and Rucas* acts as a crowdsourced collection focused on documenting Latinx youth cultures in East Los Angeles and other Southern California neighborhoods in the 1990s; it also contains photos of an earlier vintage submitted by followers. About this project, Rosales has stated:

I wanted to read and look at images of brown bodies on the dance floor and backyard parties, cruising the boulevard or anything that had documented the (sub)culture that existed in the midst of violence, unfortunately I wasn't finding anything. With very little success, I started an Instagram feed, titled Veteranas and Rucas[,] and posted photos from my own personal collection as reference. Within a week of my initial posting, people began to submit their own photos through email and messaging them through Instagram, perhaps because they felt an intimate connection to mine even though we had never met before and yet our lives were now exposed as parallel. This digital archive was proof that my desire and need to find material about this particular part of my life was also important to others—I describe the Instagram feed as a digital archive of previously inaccessible images of an unrepresented, unstudied group of people.[2]

And its impact? As of this writing, Rosales has more than 250,000 Instagram followers. Photography, aligned with social media, has made possible the preservation of memories of a youth subculture of the 1990s spread across Southern California, now more broadly expanded to reflect the Chicanx community over generations. This is not simply a social media phenomenon; it suggests the real desire, across countless groups, to see reflections of their own lives preserved and shared. In the hands of anyone, the camera can become a tool for self-historicization and self-affirmation. The photographers in *Latinx Photography in the United States* have likewise deployed their considerable talents toward documenting and constructing images of communities that have been ignored, underrecognized, or misrepresented. In sum, their work plays a crucial role in the process of documenting and informing, of constructing and imagining, a broader *American* history. For Latinx photographers to receive the serious study and documentation their work deserves will require scholars, curators, critics, gallerists, and collectors—in other words, the art world writ large—to broaden their purview. Only then will a more inclusive picture of the history of American art—one consistent with our past and present realities—be brought forth.

fin

Notes

PREFACE

1 As of 2015, according to the US Census Bureau.

2 Similarly, I employ the term *Chicanx* rather than *Chicano* or *Chicana*.

3 Vicki Ruiz, *From out of the Shadows: Mexican Women in Twentieth-Century America* (New York: Oxford University Press, 1998), xvi.

4 Despite their names, both Chicago's National Museum of Mexican Art and San Francisco's Mexican Museum devote substantial programming to Latinx artists.

5 See John Beardsley and Jane Livingston, *Hispanic Art in the United States* (New York: Abbeville Press; Houston: Museum of Fine Arts, Houston, 1987). For the curators' response to criticism of the exhibition, see Jane Livingston and John Beardsley, "The Poetics and Politics of Hispanic Art: A New Perspective," in *Exhibiting Cultures: The Poetics and Politics of Museum Display*, ed. Ivan Karp and Steven Lavine (Washington, DC: Smithsonian Institution Press, 1987).

6 The 2017 edition of Pacific Standard Time included two exhibitions focusing on Latinx photographers: *Laura Aguilar: Show and Tell* at the Vincent Price Art Museum, East Los Angeles College, Monterey Park, and *La Raza*, Autry Museum of the American West, Los Angeles. Others, like *Cuba Is* at the Annenberg Space for Photography, Los Angeles, featured Cuban and non-Cuban photographers, while *Photography in Argentina, 1850–2010: Contradiction and Continuity* at the Getty Center, Los Angeles, and *Point/Counterpoint: Contemporary Mexican Photography*, Museum of Photographic Arts, San Diego, included work by photographers based in Latin American countries.

7 The photographers were Monica Almeida (who later became an accomplished photojournalist and the Los Angeles bureau photographer for the *New York Times*), Laura Aguilar, Christina Fernandez, Harry Gamboa Jr., José Galvez,

Frank Romero (a pioneering Chicanx artist best known for his paintings), Alejandro Rosas, and Ricardo Valverde.

8 *From the West* was preceded by a pioneering, now essentially forgotten exhibition and the first to focus on photography by Chicanx artists, *Con Cariño: Photos of Another America*, presented in 1981 at the Friedrich-Alexander University in Erlangen, Nuremberg, Germany.

9 These early exhibitions included *La Familia*, 1979, *Vapors*, 1980, *The Return: Four Photographers from Puerto Rico*, 1985, *A Decade of En Foco*, 1986, *Latina*, 1988, and *Island Journey: An Exhibition of Puerto Rican Photography*, presented at the Hostos Center for Arts and Culture, the Bronx, New York, 1995. In subsequent years En Foco presented numerous solo and group exhibitions in venues throughout New York.

10 Curated by E. Carmen Ramos, the exhibition included photographs by Manuel Acevedo, Oscar Castillo, Frank Espada, Anthony Hernandez, Perla de León, Hiram Maristany, Ruben Ochoa, John Valadez, Winston Vargas, and Camilo José Vergara.

11 The curators were Kathy Vargas and Robert Buitrón (Chicano/Mexican American), Charles Biasiny-Rivera (Puerto Rican), and Ricardo Viera (Cuban American). The overall project was organized by Wendy Watriss, cofounder and senior artistic adviser of FotoFest.

12 I curated an exhibition of selections from this collection that traveled to six venues in the United States between 2010 and 2013. See the exhibition catalog, Elizabeth Ferrer, curator, *En Foco / In Focus: Selected Works from the Permanent Collection* (Bronx, NY: En Foco, 2012).

13 Bruce Davidson, *East 100th Street* (Los Angeles: St. Ann's Press, 2003).

14 According to the press release issued by the Museum of Modern Art in conjunction with the exhibition of Davidson's photographs, the photographer worked with community leader Edwin Suarez, who provided him with introductions to the street's residents. In addition, Davidson gave some two thousand prints to residents in appreciation for their cooperation.

15 A. D. Coleman, "Two Critics Look at Davidson's 'East 100th St.' What Does It Imply?," *New York Times*, October 11, 1970.

16 Philip Dante, "But Where Is Our Soul," *New York Times*, October 11, 1970.

17 According to exhibition curator Allon Schoener, two African American museum staff members, Don Harper and Reginald McGhee, were involved in exhibition planning. In addition, a community advisory committee included Mel Patrick, a Harlem resident and senior staff member in Manhattan borough president Percy Sutton's administration. "A Retrospective Walk through 'The Harlem

on My Mind' Exhibition at the Metropolitan Museum of Art, 1969," accessed December 15, 2017, http://harlemonmymind.org/retrospective.html.

18 "Minorities: Pocho's Progress," *Time*, April 28, 1967, 24–25.

19 Elizabeth Ferrer, "Is There a History of Latino Photography?," paper presented at the Society for Photographic Education Annual Meeting, Philadelphia, March 2010. In the course of research conducted for this paper, I found that among the roughly one thousand photographers represented by the one hundred commercial galleries in the United States that were then members of AIPAD, a prestigious association of international photography dealers, only ten were Latinx. While galleries not affiliated with AIPAD represent Latinx photographers, the level of gallery representation for Latino photographers is disproportionately low. In fact, photography galleries in the United States are more likely to represent Mexican and other Latin American photographers than locally based Latinx photographers.

CHAPTER 1. ROOTS AND ANTECEDENTS, 1840–1960S

1 Dolores Rivas Bahti, "Latino Photography," in *Encyclopedia of Latino Culture: From Calaveras to Quinceañeras*, ed. Charles Tatum (Santa Barbara: ABC-CLIO/ Greenwood, 2013), 798–802.

2 Rubén G. Mendoza, "Vallejo, Epifania de Guadalupe (1835–1905)," in *Latinas in the United States: A Historical Encyclopedia*, vol. 3, ed. Vicki L. Ruiz and Virginia Sánchez Korrol (Bloomington: Indiana University Press, 2006), 783.

3 Peter E. Palmquist and Thomas R. Kailbourn, *Pioneer Photographers of the Far West: A Biographical Dictionary, 1840–1865* (Stanford: Stanford University Press, 2000), 558.

4 Palmquist and Kailbourn, *Pioneer Photographers of the Far West*, 568.

5 Evelyn S. Cooper, "The Buehmans of Tucson: A Family Tradition in Arizona Photography," *Journal of Arizona History* 30, no. 3 (Autumn 1989): 251–78. Other photographers who worked for the Buehman Studio were Helindaro Bolaños (active 1907–11), Robert Antillon (active 1914), and Pablo Beltran (active 1915–16), but scant information exists on these figures.

6 Jeremy Rowe, "Dudley P. Flanders 'Trip through Arizona,'" http://vintagephoto .com/reference/flanders/article.html. I am most grateful to Jeremy Rowe for information he provided about Rodrigo and other early Arizona photographers.

7 In addition to *Pioneer Photographers of the American West*, see "Langdon's List of 19th and Early 20th Century Photographers," www.langdonroad.com, an online directory of photographers active in the United States from 1844 to 1950.

8 One of the best-known nineteenth-century portrait studios in Mexico was

operated by Romualdo García. See Claudia Canales, *Romualdo García, un fotógrafo, una ciudad, una época* (Guanajuato: Museo de la Alhóndiga de Granaditas, 1998).

9 Maria-Cristina García, "Murillo, Jesús," in *Handbook of Texas Online*, accessed October 26, 2015, http://tshaonline.org/handbook/online/articles/fmu35.

10 For information on Mora, see *Broadway Photographs*, accessed June 11, 2017, http://broadway.cas.sc.edu/content/jose-maria-mora.

11 Martí's archive of over ten thousand photographs is held by the Center for Puerto Rican Studies at Hunter College of the City University of New York.

12 In addition to the photographers discussed here, mention must also be made of Benedict Fernández (b. 1936, New York). Fernández was raised in East Harlem by a Puerto Rican immigrant father and Italian American mother and began to pursue photography while portraying fellow laborers at the Bethlehem Steel Shipyard in New Jersey and at the Brooklyn Navy Yard in the 1950s and early 1960s. He turned to photography on a full-time basis later in the 1960s when he powerfully recorded protests against the military draft and the Vietnam War. Fernández became best known for his extensive documentation of Martin Luther King Jr. in the final year of his life. He was also an influential and beloved teacher who established the Photo Film Workshop in New York, which offered local youth the opportunity to study photography at no charge. The photographer Ángel Franco (see chapter 3) described his participation in these workshops as a watershed event in his decision to become a photographer.

13 Candelario was born to an English father and a Hispanic mother. He was later adopted by his maternal grandfather, Jesús Sito Candelario. According to Van Deren Coke, Jesús Candelario disliked Anglos and would allow only Spanish to be spoken at home. See Van Deren Coke, "John S. Candelario," in *Three Generations of Hispanic Photographers Working in New Mexico: John Candelario, Cavalliere Ketchum, Miguel Gandert*, exhibition catalog (Taos: Harwood Foundation Museum of the University of New Mexico, 1993), 3–7.

14 Stephanie Lewthwaite, *A Contested Art: Modernism and Mestizaje in New Mexico* (Norman: University of Oklahoma Press, 2015), 140.

15 Jesse Fernández, "Biography," https://jesseafernandez.com/biography.

CHAPTER 2. THE RISE OF A LATINX CONSCIOUSNESS IN AMERICAN PHOTOGRAPHY, 1960S–1980S

1 Recent scholarship on Chicanx history and activism in the United States includes Lee Bebout, *Mythohistorical Interventions: The Chicano Movement and Its Legacies* (Minneapolis: University of Minnesota Press, 2011), Mario T. García and Sal Castro, *Sal Castro and the Chicano Struggle for Educational Justice* (Chapel

Hill: University of North Carolina Press, 2011), Edward J. McCaughan, *Art and Social Movements: Cultural Politics in Mexico and Aztlán* (Durham, NC: Duke University of Press, 2012), Carlos Muñoz Jr., *Youth, Identity, Power: The Chicano Movement* (New York: Verso, 2007), and Rafael Pérez-Torres, *Critical Uses of Race in Chicano Culture* (Minneapolis: University of Minnesota Press, 2006). For older sources, some written during the peak years of Chicano activism, see Rodolfo Acuña, *Occupied America: A History of Chicanos* (New York: Harper and Row, 1988), Rudolfo Anaya and Francisco Lomeli, eds., *Aztlán: Essays on the Chicano Homeland* (Albuquerque: University of New Mexico Press, 1989), and Juan Gómez-Quiñones, *Mexican Students por La Raza: The Chicano Student Movement in Southern California, 1967–1977* (Santa Barbara: Editorial La Causa, 1978).

2 For more information on the Royal Chicano Air Force, see Ella Diaz, *Flying under the Radar with the Royal Chicano Air Force: Mapping a Chicano/a Art History* (Austin: University of Texas Press, 2017).

3 The United Farm Workers of America, AFL-CIO, archive is housed at the Reuther Library, Wayne State University, Detroit, MI. It includes photographs, videos, oral histories, essays, memorabilia, graphics, cartoons, and other materials. See https://libraries.ucsd.edu/farmworkermovement/category/commentary /ufw-photoswayne-state-archives. In addition, the Farmworker Movement Documentation Project, founded in 2003 by LeRoy Chatfield, has published thousands of images by the photographers noted here. This online resource is maintained by the Library of the University of California San Diego and can be accessed at https://libraries.ucsd.edu/farmworkermovement.

4 *Malcriado* is available at https://libraries.ucsd.edu/farmworkermovement /archives. For more information on photography in *Malcriado,* see Colin Gunckel, "Building a Movement and Constructing Community: Photography, the United Farm Workers, and *El Malcriado,*" *Social Justice* 42, nos. 3–4 (2015): 29–45.

5 A valuable source of information on this topic is the University of Washington's Mapping American Social Movements Project, Chicano Newspapers and Periodicals 1966–1979, at http://depts.washington.edu/moves/Chicano_news_map .shtml.

6 *La Raza*'s archive of nearly twenty-five thousand photographic images is housed at the Chicano Studies Research Center at UCLA.

7 For more information on *La Raza,* see Colin Gunckel, *La Raza,* exhibition catalog (Los Angeles: UCLA Chicano Studies Research Center Press, 2020). Sources on Raul Ruiz, *La Raza* editor, photographer, and leader of the Chicano civil rights movement, include "I Am a Mexicano: The Legacy of Chicano Journalist and Activist Raul Ruiz," KCET *Artbound,* June 28, 2019 (www.kcet.org/shows/ artbound/i-am-a-mexicano-the-legacy-of-chicano-journalist-and-activist-raul

-ruiz), and Gustavo Arellano, "Raul Ruiz, Journalist and Activist for the Chicano Movement in L.A., dies at 78," *Los Angeles Times*, June 15, 2019.

8 SNCC Digital Gateway, "Maria Varela," accessed December 20, 2017, https://snccdigital.org/people/maria-varela.

9 "Photographer Maria Varela Reflects on Her Work Covering the Civil Rights Movement," New Mexico PBS, KNME-TV, *New Mexico in Focus*, June 2, 2017, https://www.youtube.com/watch?v=_X_URg76Pnk.

10 George Rodriguez and Josh Kin, *Double Vision: The Photography of George Rodriguez* (Los Angeles: Hat and Beard Press, 2018), 23.

11 For information on the Primer Coloquio Latinoamericano de Fotografía, see *Hecho en Latinoamerica: Memorias del Primer Coloquio Latinoamericano de Fotografía* (Mexico City: Consejo Mexicano de Fotografía, 1978).

12 Louis Carlos Bernal et al., *Espejo: Reflections of the Mexican American*, exhibition catalog (Oakland: Oakland Museum, 1978), unpaginated.

13 Oscar Castillo in Steve Saldivar, "Why Oscar Castillo's Photos of Chicano Life and Protest Are Essential for Understanding L.A.," *Los Angeles Times*, December 5, 2012.

14 "Oscar Castillo and Harry Gamboa Jr. in Conversation at the Fowler Museum at UCLA," UCLA Chicano Studies Research Center, March 27, 2012, https://bit.ly/2LDflnJ.

15 Carlos Flores, "Capturing the Images of Chicago's Puerto Rican Community," *Centro Journal* 13, no. 2 (2001), www.redalyc.org/articulo.oa?id=37711308010.

16 Flores, "Capturing."

17 Michael T. Kaufman, "Puerto Rican Group Seizes Church in East Harlem in Demand for Space," *New York Times*, December 29, 1969, 26.

18 Ralph Ortiz, "Culture and the People," *Art in America*, May–June, 1971, 27.

19 Jason Espada, "A Sketch of Frank Espada's Life," *Living in Beauty: Writing, Music, and Spoken Word by Jason Espada* (website), August 29, 2016, http://jasonespada.com/a-sketch-of-frank-espadas-life.

20 The Puerto Rican diaspora in Hawaii was earlier documented by Blase Camacho Souza (1918–2008). Camacho Souza's grandparents migrated from Puerto Rico to Hawaii to work on sugarcane plantations. A librarian born in Hawaii, Camacho Souza worked to preserve the experience of the thousands of Puerto Rican migrants in Hawaii, who arrived beginning in 1899, when a devastating hurricane in Puerto Rico, combined with recruitment efforts by Hawaiian sugarcane plantations, attracted many to the Pacific island. Camacho Souza's documentation includes photographs and is preserved in the Archives of the Puerto Rican Diaspora, Centro de Estudios Puertorriqueños at Hunter College CUNY, New York.

21 See Frank Espada, *The Puerto Rican Diaspora: Themes in the Survival of a People* (San Francisco: Frank Espada, 2006). Espada's archives are held at Library of Congress, and a large collection of his prints and negatives is housed at the David M. Rubenstein Rare Book and Manuscript Library at Duke University.

22 Frank Espada, quoted in David Gonzalez, "Parting Glance: Frank Espada," *Lens* (blog), *New York Times*, February 20, 2014.

23 For more information about Maristany's participation in the Young Lords, see Holly Block et al., *¡Presente! The Young Lords in New York*, exhibition catalog (Bronx, NY: Bronx Museum of the Arts, 2015).

24 See the untitled timeline of the history of El Museo del Barrio, accessed September 26, 2019, www.elmuseo.org/wp-content/uploads/2014/02/Timeline.pdf.

25 See Holland Cotter, "From Every Angle, a Rising Revolution," *New York Times*, April 22, 2005. Cotter called Maristany's images of protest "the photographic version of a flaming heart."

26 Hiram Maristany, phone conversation with the author, October 2, 2018.

27 Maximo Colón, quoted in David Gonzalez, "Not an Objective Observer," *New York Times*, October 23, 2015.

28 Bolivar Arellano's archive is held in Columbia University's Latino Arts and Activism Archive.

CHAPTER 3. DOCUMENTS, 1970S–PRESENT

1 Peter Bunnell, quoted in *Newsweek*, October 21, 1974, 69.

2 Roger Cabán, quoted in Tracy Fitzpatrick, *Art and the Subway: New York Underground* (New Brunswick: Rutgers University Press, 2009), 196.

3 Geno Rodriguez, email correspondence with the author, January 20, 2009. Rodriguez parted company with other En Foco members early in its history; his name is usually excluded from histories of the organization. See Taller Boricua and the Puerto Rican Art Movement in New York, "History of Taller Boricua 1969–2010," accessed September 3, 2016, https://tallerboricuatimeline .wordpress.com.

4 René Gelpi, "A Loner Looks In," *Nuestro*, October 1977, 33–36.

5 Franco, quoted in Rachel Cerroti, "Seis del Sur: Six Nuyorican Photographers Reclaim the Identity of the Bronx," *ivoh*, March 21, 2016, https://ivoh.org/story /seis-del-sur-six-nuyorican-photographers-reclaim-the-identity-of-the-bronx.

6 Conzo's archive of over ten thousand negatives has been preserved by the Cornell Hip Hop Collection, Cornell University, Ithaca, New York. It may be accessed online at http://rmc.library.cornell.edu/hiphop/conzo.html.

7 David Gonzalez, "From the Archive: Bronx Street Art," *Lens* (blog), *New York Times*, August 24, 2009.

8 Selections from Gonzalez's series were published in "Faces in the Rubble," *New York Times*, August 21, 2009.

9 Carmen Ramos, "Meet the Artist: Perla de León on 'South Bronx Spirit,'" Smithsonian American Art Museum, December 4, 2017, https://americanart.si.edu/artist/perla-de-leon-31062.

10 Luis Carle, quoted in Jake Naughton, "Gay Life in New York, between Oppression and Freedom," *Lens* (blog), *New York Times*, June 22, 2017.

11 David Travis, "Don't Dream These Things: The Life and Career of Luis Medina," in Luis Medina and David Travis, *Facts and Fables by Luis Medina, Photographer*, exhibition catalog (Chicago: Art Institute of Chicago, 1993), 15.

12 Daniel Kestenholz, "Substance above Style: Documentary Photographer Joseph Rodriguez: 'A Cheap Camera Saved My Life,'" *Theme*, March 25, 2013, https://the.me/substance-above-style-documentary-photographer-joseph-rodriguez-a-cheap-camera-saved-my-life.

13 Joseph Rodriguez, in Gaia Squarci, "Joseph Rodriguez: Twenty Years of Portraits from Another America," *New Yorker*, June 7, 2012.

14 Joseph Rodriguez, Artist Statement, accessed February 20, 2017, www.josephrodriguezphotography.com.

15 Franco received the Pulitzer Prize as part of the staff of the *New York Times* that covered the terrorist attack in New York on September 11, 2001, making him the first Puerto Rican photographer to receive this award.

16 James Estrin and Ángel Franco, "Cops, Neighbors, and a Camera in Between," *Lens* (blog), *New York Times*, June 24, 2010.

17 Ángel Franco, interview with the author, September 30, 2019.

18 Camilo Cruz, Artist Statement, accessed July 22, 2018, http://camilocruzart.com.

19 Camilo Cruz, "Camilo Cruz," Chats about Change: Critical Conversations on Art and Politics in Los Angeles (website), November 18, 2014, http://chatsaboutchangela.org/camilo-cruz-2.

20 David Gonzalez, quoted in Samy Nemir Olivares, "One Voice from the South Bronx: Q&A with *New York Times* Reporter David Gonzalez," *Centro Voices*, October 22, 2014, http://centropr.hunter.cuny.edu/centrovoices.

21 Ricky Flores, "En Foco/In Focus: Ricky Flores," interview by Collette McGruder, *Integral Education: The CIIS Blog*, November 29, 2012, accessed April 19, 2016, http://blog.ciis.edu/my_weblog/2012/11/en-focoin-focus-ricky-flores.html#.

CHAPTER 4. LA CHICANX

1 See Margarita Nieto, "Le démon des anges: A Brief History of the Chicano-Latino Artists of Los Angeles," in *Le Démon des Anges*, exhibition catalog

(Nantes, France: Centre de Recherché pour le Développement Culturel, 1989), 217–33.

2 Eric Gibson, "Politically Correct 'Chicano' Is a Radical Dud," review of CARA, *Washington Times*, June 21, 1992, D8.

3 Other important exhibitions involving Chicanx art in this era included the 1993 *La Frontera/The Border: Art about the Mexico/United States Border Experience*, organized by the Centro Cultural de la Raza and the Museum of Contemporary Art, San Diego, and *Ceremony of Spirit: Nature and Memory in Contemporary Latino Art*, curated by Amalia Mesa-Bains for the Mexican Museum, San Francisco, in 1993. Also including the work of Mexican, Cuban, Puerto Rican, Panamanian, Brazilian, and Chilean artists, *Ceremony of Spirit* was a groundbreaking project linking artists of Latin American heritage in the United States.

4 Malaquias Montoya and Lezlie Salkowitz-Montoya, "A Critical Perspective on the State of Chicano Art," *Metamorfosis: Northwest Chicano Magazine of Literature Art and Culture* 3, no. 1 (1980): 6–7.

5 Shifra M. Goldman, "Response: Another Opinion on the State of Chicano Art," *Metamorfosis: Northwest Chicano Magazine of Literature Art and Culture* 4, no.1 (1980/1981): 2–7.

6 "John Valadez—In His Own Words," Latinopia, March 6, 2010, http://latinopia .com/latino-art/john-valadez.

7 Teresa Puente, "John Valadez Champions Chicano Art," *Chicago Now*, July 5, 2013, www.chicagonow.com/chicanisima-latino-politics-news-and -culture/2013/07/john-valadez-champions-chicano-art.

8 Gamboa wrote, "The purpose of the No Movie was to create photographic pseudodocumentary evidence to corroborate the actuality of the individuals and events framed within the context of reality. The image was an implicit fragment of a continuous action, similar to that of an individual frame of a movie. However, no preceding nor succeeding 'actions' accompanied the images contained within No Movie. The fluctuating propagandistic value of each No Movie depended on its venue of exhibition and/or publication as well as on the gullibility of its audience." Harry Gamboa Jr., "In the City of Angels, Chameleons, and Phantoms: Asco, a Case Study of Chicano Art in Urban Tones," in *Chicano Art: Resistance and Affirmation, 1965–1985*, exhibition catalog, ed. Richard Griswold del Castillo, Teresa McKenna, and Yvonne Yarbro-Bejarano (Los Angeles: Wight Art Gallery, UCLA, 1991), 121–30. In fact, one such image, of a male figure seemingly shot down in the middle of a street, was screened by a local TV station as evidence of rampant gang violence in Los Angeles.

9 Some thirty-five years later, the Los Angeles County Museum of Art embraced

this act as part of its history. The 2008 exhibition *Phantom Sightings: Art after the Chicano Movement* opened with Harry Gamboa Jr.'s photographic documentation of this action.

10 Harry Gamboa Jr., "Light at the End of Tunnel Vision," in Harry Gamboa Jr., *Urban Exile: Collected Writings of Harry Gamboa Jr.*, ed. Chon A. Noriega (Minneapolis: University of Minnesota Press, 1998), 106.

11 From a telephone interview with Esperanza Valverde, September 6, 2019.

12 I am grateful to Esperanza Valverde for providing me with insights into Ricardo Valverde's life and oeuvre. For an overview of his work see Cecilia Fajardo-Hill et al., *Ricardo Valverde: Experimental Sights, 1971–1996* (Los Angeles: UCLA Chicano Studies Research Center Press, 2014).

13 "Oral History Interview with Elsa Flores, 1997 Feb. 18–Apr. 30," Archives of American Art, Smithsonian Institution, https://www.aaa.si.edu/collections /interviews/oral-history-interview-elsa-flores-13559.

14 "Oral History Interview with Elsa Flores."

15 "Isabel Castro," artist biography, in Cecilia Fajardo-Hill and Andrea Giunta, *Radical Women: Latin American Art, 1969–1985*, exhibition catalog (Los Angeles: Hammer Museum, University of California, 2017), 321.

16 Laura Aguilar, Artist Statement, in *Women Artists of the American West*, accessed August 23, 2015, https://cla.purdue.edu/academic/rueffschool/waaw/Corinne /Aguilar.htm.

17 As noted in Laura Aguilar, "Human Nature," *Boom California* 5, no. 2 (Summer 2015), https://boomcalifornia.com/2015/08/11/human-nature.

18 Chon Noriega in "Harry Gamboa Jr.: Chicano Male Unbonded," KCET Online, September 20, 2017, https://m.youtube.com/watch?v=Z5PLyNANL8Q.

19 The proposition was ruled to be unconstitutional in 1999 because it violated the federal government's authority over immigration policies.

CHAPTER 5. STAGING SELF, NARRATING CULTURE

1 Miguel Luciano, "The Amnesia of History: A Discussion with Juan Sanchez," June 22, 2001, *National Forum* 81, no. 3 (Summer 2001), 27, *Gale Academic One-file*, https://go.gale.com/ps/anonymous?id=GALE%7CA78438422.

2 For more information on Con Safo, see Ruben C. Cordova, *Con Safo: The Chicano Art Group and the Politics of South Texas* (Los Angeles: UCLA Chicano Studies Research Center Press, 2009).

3 Robert C. Buitrón and Kathy Vargas, "Mexican American Photography in the U.S.," in *Fotofest '94* (Houston: Fotofest, 1994), 18.

4 Letter from Kathy Vargas to Lucy Lippard, January 14, 1991, quoted in Lucy Lip-

pard and MaLin Wilson-Powell, *Kathy Vargas: Photographs, 1971–2000*, exhibition catalog (San Antonio: Marion Koogler McNay Art Museum, 2000), 23.

5 Don Gregorio Antón, email correspondence to the author, November 2017.

6 Delilah Montoya, Artist Statement, in *Women Artists of the American West*, accessed July 26, 2019, www.cla.purdue.edu/academic/rueffschool/waaw/ressler/artists/montoyastat.html.

7 Also see Delilah Montoya, "Using a Cultural Icon to Explore a People's Heart," *Nieman Reports*, June 15, 2001, https://niemanreports.org/articles/using-a-cultural-icon-to-explore-a-peoples-heart.

8 Delilah Montoya, Artist Statement, "Guadalupe en Piel," accessed May 22, 2016, www.delilahmontoya.com/ArtistStatement.html#Guadalupe.

9 María Magdalena Campos-Pons, unpublished interview with Ricardo Viera, July 1997.

10 María Magdalena Campos-Pons, "Becoming FeFa," *Atlántica: Journal of Art and Thought* 57 (2016), unpaginated, www.revistaatlantica.com/en/issue/57-en.

11 "Interview with the Artist," in Christina Fernandez, *Ruin*, exhibition catalog (Los Angeles: Los Angeles Center for Photographic Studies, 1999), unpaginated.

12 For more information on this tradition and its contemporary interpretations, see Tere Romo, "The Chicanization of Mexican Calendar Art," paper presented at the Interpretation and Representation of Latino Cultures: Research and Museums Conference, Smithsonian Institution, November 20–23, 2002, Sematic Scholar (website).

13 Robert Buitrón, "El Corrido de Happy Trails (Starring Pancho y Tonto)," in *From the West: Chicano Narrative Photography*, exhibition catalog, ed. Chon Noriega (San Francisco: Mexican Museum, 1995), 24.

14 Chuck Ramirez, quoted in Elizabeth Ferrer, "Every Picture Tells a Story," in René Paul Barilleaux, Elizabeth Ferrer, and Edward Hayes, *Chuck Ramirez: All This and Heaven Too*, exhibition catalog (San Antonio: McNay Art Museum, 2017), 18.

15 Martine Gutierrez, Artist Statement, accessed November 20, 2017, www.martinegutierrez.com.

16 bell hooks, "Choosing the Margin as a Space of Radical Openness," in *Yearnings: Race, Gender and Cultural Politics* (Brooklyn: South End Press, 1989), 206–7.

CHAPTER 6. FAMILY

1 "El Plan Espiritual de Aztlán," in *Aztlán: Essays on the Chicano Homeland*, ed. Rudolfo Anaya and Francisco Lomelí (Albuquerque: University of New Mexico Press, 1989), 1–5.

2 Nereida García Ferraz, "Not the Golden Age," in María de los Angeles Torres, *By Heart / De Memoria: Cuban Women's Journeys In and Out of Exile* (Philadelphia: Temple University Press, 2003).

3 Groana Melendez, "Groana Melendez," *Nueva Luz* 14, no. 3 (2010): 2–9.

4 Groana Melendez, email to the author, October 1, 2019.

5 Karen Miranda-Rivadeneira, Artist Statement, accessed March 8, 2017, www .karenmiranda.com.

6 Miranda-Rivadeneira, Artist Statement.

7 Rachelle Mozman, Artist Statement, accessed June 26, 2016, www. rachellemozman.com.

8 "Contemporary Casta Portraiture: *Nuestra 'Calidad,'*" in Delilah Montoya, *Contemporary Casta Portraiture: Nuestra "Calidad"* (Houston: Arte Público Press, 2017), 17.

CHAPTER 7. THE ARCHIVE

1 Jacques Derrida and Eric Prenowitz, *Archive Fever: A Freudian Impression* (Chicago: University of Chicago Press, 1996).

2 Muriel Hasbun, quoted in Frank Van Riper, "Muriel Hasbun and the 'Layering of Memories,'" *Washington Post*, undated [March 4, 2004?], accessed July 22, 2017, www.washingtonpost.com/wp-srv/photo/essays/vanRiper/040304.htm.

3 Jeff [Gates] and Muriel Hasbun, "Five Questions with Photographer Muriel Hasbun," *Eye Level* (blog), Smithsonian American Art Museum, December 12, 2013, https://americanart.si.edu/blog/eye-level/2013/12/564/five-questions -photographer-muriel-hasbun.

4 See Ken Gonzales-Day, *Lynching in the West, 1850–1935* (Durham, NC: Duke University Press, 2006).

5 Ken Gonzales-Day, Artist Statement, accessed January 15, 2020, www. kengonzalesday.com/projects/erased-lynchings.

6 Luis Delgado, Fernando Castro, and Miguel Mestres, *Stratigraphies* (San Francisco: Malulu Editions, 2016).

7 Pablo Delano, "Digital: Pablo Delano," *National Gallery of Jamaica Blog*, April 21, 2016, https://nationalgalleryofjamaica.wordpress.com/tag/pablo-delano. PROMESA, the Puerto Rico Oversight, Management, and Economic Stability Act—designated as S.2328—was passed by the 114th Congress in 2016. It provided for a bankruptcy-like restructuring of the Commonwealth's debt, established an oversight board, and enacted other measures that in effect reduce Puerto Rico's autonomy with the intent of combating the Puerto Rican economic crisis.

8 Pablo Delano, Artist Statement, accessed February 26, 2020, http://museumof theoldcolony.org/about/about-the-museum.

9 Renée Mussai, "Archive Desire, Creole Impulse: Reflections on the Importance of Collecting Visual Evidence," in Elizabeth Ferrer, curator, *En Foco / In Focus: Selected Works from the Permanent Collection*, exhibition catalog (Bronx, NY: En Foco, 2012), 94.

10 See Isabella Herrera, "Preserving Latinx History through Vintage Photos," *New York Times*, August 23, 2019.

11 Jorge N. Leal, quoted in Marco Hassan, "This Instagram Is an Archive of Rock en Español's Golden Years in Los Angeles," *Remezcla*, May 9, 2018, https://remezcla.com/features/music/rock-archivo-la-instagram.

CHAPTER 8. GEOGRAPHIES

1 According to 2010 census data, the median income for all Americans is $50,046. The median income in the United States' poorest state, Mississippi, is $36,851.

2 Petra Barreras del Rio and John Perrault, eds., *Ana Mendieta: A Retrospective* (New York: New Museum of Contemporary Art, 1987).

3 Ana Mendieta, "Personal Writings," in Gloria Moure, *Ana Mendieta* (Santiago de Compostela: Centro Galego de Arte Contemporánea; Barcelona: Ediciones Polígrafa, 1996), 167–222; 186.

4 Mendieta used photography in other bodies of work, beginning with work she created as a graduate student in the Intermedia Program at the University of Iowa. In her Facial Hair Transplants series of 1972, she questioned conventions of gender and beauty through a performative transformation. In a series of color photographs, fellow student Morty Sklar is shown shearing off pieces of his beard, which Mendieta then glues to her face to create a beard and mustache. In a related series of photographs of the same year, Untitled (Facial Cosmetic Variations), she employed wigs, makeup, and pantyhose pulled over her face to alter her appearance sometimes to grotesque levels, placing Mendieta within the company of other important female artists who have enacted forms of physical transformation in their artwork, such as Frida Kahlo and Cindy Sherman. A year later, she reenacted the rape and murder of a fellow University of Iowa student, Sarah Ann Ottens. Students arrived at her apartment to find Mendieta as she staged the event, bloody, half nude, and bound with rope. Mendieta documented the performance with a series of five color photographs.

5 Mario Algaze, *A Respect for Light: The Latin American Photographs, 1974–2008* (New York: Glitterati, 2014), 13.

6 Algaze, *A Respect for Light*, 9.

7 Silvia Lizama, Artist Statement, in *Cuba-USA: Notes on Photography, 1970–1990,* exhibition catalog, Marc Zuver, curator (Washington, DC: Fondo del Sol Cultural Center, 1991).

8 Silvia Lizama, email correspondence with the author, November 26, 2017.

9 Silvia Lizama, Artist Statement, accessed November 26, 2017, http://silvializama .com.

10 References to the camera obscura were made in Chinese texts as early as 300 BC. Actual experiments with pinholes were carried out by the Arab Ibn al-Haytham (Alhazen), who lived circa AD 965–1040.

11 Abelardo Morell, "The Visual Delights of the Camera Obscura" (video), CBS News, January 2017, www.abelardomorell.net/project/camera-obscura.

12 Jaime Permuth, Artist Statement: Yonkeros, accessed July 15, 2016, www. jaimepermuth.net/yonkeros.

13 Gloria E. Anzaldúa, *Borderlands / La Frontera: The New Mestiza* (San Francisco: Spinsters / Aunt Lute Books, 1987).

14 Chuy Benitez, correspondence with the author, July 1, 2013.

15 US Customs and Border Protection, "United States Border Patrol Southwest Border Sectors Total Illegal Alien Apprehensions by Fiscal Year (Oct. 1st through Sept. 30th)," 2018.

16 In 2000, 1.6 million migrants were apprehended along the border. That number declined to 304,000 by 2017. US Customs and Border Protection, "United States Border Patrol Southwest Border Sectors Total Illegal Alien Apprehensions."

17 Dominique Riofrio, "Photographers Capture Day-to-Day Reality of Border Regions," *Medium.com,* September 11, 2017, https://medium.com/re-picture /photographers-capture-day-to-day-reality-of-border-regions-ea90b7d31732.

18 Theano S. Terkenli, "Home as a Region," *Geographical Review* 85, no. 3 (July 1995): 324–34.

CHAPTER 9. CONCEPTUAL STATEMENTS

1 Gonzalez-Torres's stacks also include sheets with text, black borders, or reproductions of newspaper clippings, as well as blank sheets with no image or text.

2 Adál, quoted in James Estrin, "Puerto Rican Identity, In and Out of Focus," *Lens* (blog), *New York Times,* August 28, 2012.

3 See Adál Alberto Maldonado, *The Evidence of Things Not Seen* (New York: Da Capo Press, 1975).

4 Adál's visual interpretations of "El Spirit Republic de Puerto Rico" evolved out of concepts developed by Eduardo Figueroa, founder of the New Rican Village based in the Lower East Side of New York, and the poet Reverend Pedro Pietri.

Much of this work is available on the artist's website, www.elpuertorican embassy.org.

5 Adál, quoted in Estrin, "Puerto Rican Identity."

6 Arturo Cuenca, quoted in Nina Menocal, "La fotografía es todo en mi obra," in *Fin*, exhibition catalog (Mexico City: Galería Nina Menocal, 1993), 16–17.

7 Artist Statement, in Ricardo Viera, "American Voices: Cuban Photography in the U.S.," in Fotofest, *Fotofest '94: The Fifth International Festival of Photography* (Houston: FotoFest, 1994), 60.

8 Donald Kuspit, "Cuba of Her Mind," in *Cuba of Her Mind: María Martínez Cañas's Photographic Constructions*, exhibition catalog (Los Angeles: Iturralde Gallery, 1994).

9 Javier Carmona, Artist Statement, accessed July 26, 2019, www.javiercarmona .com.

10 Javier Carmona, quoted in Stacia Yeapanis, "OtherPeoplesPixels Interviews Javier Carmona," December 10, 2015, *OtherPeoplesPixels Blog: Website for Artists by Artists*, https://blog.otherpeoplespixels.com/otherpeoplespixels-interviews -javier-carmona.

CHAPTER 10. PUERTO RICO, CONNECTED AND APART

1 As an example, the 2019 Whitney Biennial contained the work of an unprecedented five artists based in Puerto Rico, three individual artists and one collaborative group made up of two sisters.

2 Marimar Benitez, "The Special Case of Puerto Rico," in *The Latin American Spirit: Art and Artists in the United States, 1920–1970*, exhibition catalog, ed. Luis Cancel (New York: Bronx Museum of the Arts, 1988), 72–105.

3 Quoted in Alonso Robisco, *Colección de Fotografía Antigua: Blog sobre Fotografía Antigua y Sus Fotógrafos*, August 7, 2014, http://photoblog.alonsorobisco .es/2014/08/foto-antigua-retrato-de-caballero.html.

4 Alonso's photographs were published in a widely circulated book of this period, his 1904 *Álbum de Puerto Rico* (reprinted by Doce Calles, Consejo Superior de Investigaciones Científicas, Madrid, 2007).

5 See the introduction by Libia González López in the facsimile edition of Alonso's *Álbum de Puerto Rico*.

6 William S. Bryan, ed., *Our Islands and Their People as Seen with Camera and Pencil*, 2 volumes (St. Louis, New York: N. D. Thompson, 1899).

7 Jorge Duany, *The Puerto Rican Nation on the Move: Identities on the Island and in the United States* (Chapel Hill: University of North Carolina Press, 2002), 93.

8 Hilda Lloréns, *Imaging the Great Puerto Rican Family: Framing Nation, Race, and*

Gender during the American Century (Lanham, MD: Lexington Books, 2014), 10–12.

9 The Rosskams had a long association with Puerto Rico. In 1937 they traveled to the island under the auspices of *Life* magazine to cover the trial of a Puerto Rican nationalist charged with violence. Their story was never published, but as a result of the poverty they witnessed, they committed themselves to return. They did so in 1945, and working with the Puerto Rico Office of Information, Louise photographed laborers on coffee and tobacco plantations and in sugarcane fields. She also documented the political activities of Popular Democratic Party leader Luis Muñoz Marín, who became the first elected governor of Puerto Rico in 1949. See Beverly W. Brannan, "Louise Rosskam (1910–2003)," Library of Congress, Prints and Photographs Division, 2011, https://www.loc.gov/rr/print/coll/womphotoj/rosskamessay.html. Also see "Oral History Interview with Edwin and Louise Rosskam, 1965 August 3," Archives of American Art, Smithsonian Institution, www.aaa.si.edu/collections/interviews/oral-history-interview-edwin-and-louise-rosskam-13112.

10 In addition to his work for the FSA, Charles Rotkin was also chief photographer for the government of Puerto Rico for three years during the 1940s.

11 Jack Delano, *Photographic Memories* (Washington, DC: Smithsonian Institution Press, 1997).

12 This information was provided by Irene Delano in Richard Doud, "Oral History Interview with Jack and Irene Delano, 1965 June 12," conducted for the Archives of American Art, Smithsonian Institution.

13 Jack Delano's photographs are included in many public collections; the main archive of his Puerto Rican works is at the Library of Congress. In Puerto Rico, collections can be found at the Archivo General de Puerto Rico and the Fundación Luis Muñoz Marín. Photographs by Delano are also in the collections of the International Museum of Photography, George Eastman House, Rochester, New York; the Museum of Modern Art, New York; and the New York Public Library, New York. For an overview of his work, see Jack Delano, *Puerto Rico Mío: Four Decades of Change* (Washington, DC: Smithsonian Institution Press, 1990). Also see his autobiography *Photographic Memories* (Washington, DC: Smithsonian Institution Press, 1997).

14 Virginia Sanchez Korrol, "History of Puerto Ricans in the US—Part Four," Center for Puerto Rican Studies, Hunter College, accessed September 3, 2016, https://centropr.hunter.cuny.edu/education/story-us-puerto-ricans-part-four.

15 Héctor Méndez Caratini, quoted in "Entrevista entre el curador Ricardo Viera y el fotógrafo," accessed December 8, 2017, www.hectormendezcaratini.com.

16 Méndez Caratini also documented the Afro-Caribbean cults María Lionza in Venezuela and Gagá and Vodun in the Dominican Republic, as well as Afro-Bahian religions in Brazil.

17 The US Navy detonated untold numbers of bombs during its occupation of Vieques. The decomposition of military ordinance resulted in the contamination of soil, coastline, and groundwater and led to markedly higher levels of cancer among the local population than in the rest of Puerto Rico. One environmental study noted that vegetables and plants growing on Vieques contained evidence of cadmium, lead, copper, and other contaminants.

18 The entire series is published on the Zone Zero website. See www.zonezero .com/exposiciones/fotografos/vieques/indexsp.html.

19 Frieda Medín, text message to the author, October 4, 2019.

20 Frieda Medín, text message to the author, October 4, 2019.

21 Frieda Medín, telephone conversation with the author, October 2, 2019.

22 See Frances Negrón-Muntaner, "Of Lonesome Stars and Broken Hearts: Trends in Puerto Rican Women's Film/Video Making," in *New Latin American Cinema*, vol. 2, ed. Michael T. Martin (Detroit: Wayne State University Press, 1997), 251–52.

23 Luis Rafael Sánchez and Domingo García, *El Reino de la Espera* (San Juan: Galería Latinoamericana, 1991).

24 From a statement accompanying a portfolio of the artist's work, see "Nestor Millan," *Nueva Luz* 2, no. 3 (1988), 22.

25 *Dos Mundos: Worlds of the Puerto Ricans* traveled to Puerto Rico after being seen at the no-longer extant Huntington Hartford Gallery of Modern Art at the New York Cultural Center and at the Corcoran Gallery, Washington, DC.

26 Elvis Fuentes, "Breve Cronología de Félix González Torres en Puerto Rico, 1978–88," *Revista del Instituto de Cultura Puertorriqueña, Segunda Serie* 5, no. 10 (2004), 50–59.

AFTERWORD

1 Amalia Mesa-Bains, quoted in Guillermo Gómez-Peña, "The Multicultural Paradigm: An Open Letter to the Arts Community," *High Performance* no. 47 (Fall 1989): 21.

2 Guadalupe Rosales, "Why I Started This Project," Veteranas and Rucas (website), accessed August 19, 2017, www.veteranasandrucas.com.

Bibliography

This bibliography includes main works cited and provides the reader with additional sources on the photographers and topics discussed in *Latinx Photography in the United States*.

GENERAL

Acuña, Rodolfo. *Occupied America: A History of Chicanos.* New York: Harper and Row, 1988.

Alonso, Feliciano. *Álbum de Puerto Rico.* 2nd ed. Madrid: Consejo Superior de Investigaciones Científicas; Doce Calles, 2007.

Anaya, Rudolfo, and Francisco Lomeli, eds. *Aztlán: Essays on the Chicano Homeland.* Albuquerque: University of New Mexico Press, 1989.

Anzaldúa, Gloria. *Borderlands / La Frontera: The New Mestiza.* San Francisco: Spinsters/Aunt Lute Books, 1987.

Arellano, Juan Estevan. "La Querencia: La Raza Bioregionalism." *New Mexico Historical Review* 7, no. 1 (1997): 31–37.

Arizona Historical Society. *Journal of Arizona History* 30, no. 3 (1989).

Avila, Glenn, and Laura Aguilar. *L.A. Iluminado: Eight Los Angeles Photographers.* Los Angeles: Otis Parsons Gallery, 1991.

Barnet-Sánchez, Holly, and Tim Drescher. *Give Me Life: Iconography and Identity in East LA Murals.* Albuquerque: University of New Mexico Press, 2016.

Beardsley, John, and Jane Livingston. *Hispanic Art in the United States.* Exhibition catalog. New York: Abbeville Press; Houston: Museum of Fine Arts, Houston, 1987.

Bebout, Lee. *Mythohistorical Interventions: The Chicano Movement and Its Legacies.* Minneapolis: University of Minnesota Press, 2011.

Berger, Maurice, *Modern Art and Society: An Anthology of Social and Multicultural Readings.* New York: Icon Editions / HarperCollins Publishers, 1994.

Biasiny-Rivera, Charles. "Nueva Luz Commemorative Issue." *Nueva Luz* 7, no. 2 (2001).

Block, Holly, Johanna Fernández, Yasmin Ramírez, Rocío Aranda-Alvarado, Libertad O. Guerra, Wilson Valentín-Escobar, and Frances Negrón-Muntaner. *¡Presente! The Young Lords in New York*. Exhibition catalog. Bronx, NY: Bronx Museum of the Arts, 2015.

Borges, Jorge Luis. *The Aleph and Other Stories, 1933–1969*. New York: Bantam Books, 1971.

Brizuela, Natalia, and Jodi Roberts. *The Matter of Photography in the Americas*. Stanford: Stanford University Press, 2018.

Bryan, William S., ed. *Our Islands and Their People as Seen with Camera and Pencil*. Introduced by Major-General Joseph Wheeler. With special descriptive matter and narratives by José de Olivares. Photographs by Walter B. Townsend. St. Louis, New York: N. D. Thompson, 1899.

Buitrón, Robert. *Picarte: Photography Beyond Representation*. Exhibition catalog. Phoenix: Heard Museum, 2002.

Canales, Claudia. *Romualdo García, un fotógrafo, una ciudad, una época*. Guanajuato: Museo de la Alhóndiga de Granaditas, 1998.

Cancel, Luis, ed. *The Latin American Spirit: Art and Artists in the United States, 1920–1970*. Exhibition catalog. New York: Bronx Museum of the Arts, 1988.

Chatfield, LeRoy, comp. "Farmworker Movement Documentation Project: Primary Source Accounts by the UFW Volunteers Who Built the Movement." UC San Diego Library, 2012. https://libraries.ucsd.edu/farmworkermovement.

Chavoya, Ondine, et al. *ASCO—Elite of the Obscure: A Retrospective, 1972–1987*. Exhibition catalog. Ostfildern, Germany: Hatje Cantz, 2011.

Coleman, A. D. "Two Critics Look at Davidson's 'East 100th St.' What Does It Imply?" *New York Times*, October 11, 1970.

Congdon, Kristin, and Kara Kelly Hallmark. *Artists from Latin American Cultures: A Biographical Dictionary*. Westport, CT: Greenwood, 2002.

Cooper, Evelyn S. "The Buehmans of Tucson: A Family Tradition in Arizona Photography." *Journal of Arizona History* 30, no. 3 (Autumn 1989): 251–78.

Cordova, Ruben C. *Con Safo: The Chicano Art Group and the Politics of South Texas*. Los Angeles: UCLA Chicano Studies Research Center Press, 2009.

Cotter, Holland. "From Every Angle, a Rising Revolution." *New York Times*, April 22, 2005.

Cruz, Camilo. "Camilo Cruz." Chats about Change: Critical Conversations on Art and Politics in Los Angeles (website), November 18, 2014. http://chatsaboutchangela.org/camilo-cruz-2.

Cuba-USA: Notes on Photography, 1970–1990. Exhibition catalog. Marc Zuver, curator. Washington, DC: Fondo del Sol Cultural Center, 1991.

Dante, Philip. "But Where Is Our Soul." *New York Times*, October 11, 1970.

Davidson, Bruce. *East 100th Street*. Los Angeles: St. Ann's Press, 2003.

Delano, Pablo. "Digital: Pablo Delano." *National Gallery of Jamaica Blog*, April 21, 2016. https://nationalgalleryofjamaica.wordpress.com/tag/pablo-delano.

De Los Angeles Torres, María. *By Heart / De Memoria: Cuban Women's Journeys In and Out of Exile*. Philadelphia: Temple University Press, 2003.

Derrida, Jacques, and Eric Prenowitz. *Archive Fever: A Freudian Impression*. Chicago: University of Chicago Press, 1996.

Diaz, Ella. *Flying under the Radar with the Royal Chicano Air Force: Mapping a Chicano/a Art History*. Austin: University of Texas Press, 2017.

Duany, Jorge. *The Puerto Rican Nation on the Move: Identities on the Island and in the United States*. Chapel Hill: University of North Carolina Press, 2002.

En Foco Inc. *Nueva Luz: A Photographic Journal*. Bronx: En Foco Inc., 1985–.

Fajardo-Hill, Cecilia, and Andrea Giunta. *Radical Women: Latin American Art, 1969–1985*. Exhibition catalog. Los Angeles: Hammer Museum, University of California, 2017.

Ferrer, Elizabeth. "Is There a History of Latino Photography?" Paper presented at the Society for Photographic Education Annual Meeting, Philadelphia, March 2010.

———, curator. *En Foco / In Focus: Selected Works from the Permanent Collection*. Exhibition catalog. Bronx, NY: En Foco, 2012.

Fitzpatrick, Tracy. *Art and the Subway: New York Underground*. New Brunswick: Rutgers University Press, 2009.

Foster, David William. *Picturing the Barrio: Ten Chicano Photographers*. Latino and Latin American Profiles. Pittsburgh: University of Pittsburgh Press, 2017.

Fotofest. *Fotofest '94: The Fifth International Festival of Photography*. Exhibition catalog. Houston: Fotofest, 1994.

García, Maria-Cristina. "Murillo, Jesús." In *Handbook of Texas Online*. Texas State Historical Association. Accessed October 26, 2015. http://tshaonline.org/handbook/online/articles/fmu35.

García, Mario T., and Sal Castro. *Sal Castro and the Chicano Struggle for Educational Justice*. Chapel Hill: University of North Carolina Press, 2011.

Goldman, Shifra. *Dimensions of the Americas: Art and Social Change in Latin America and the United States*. Chicago: University of Chicago Press, 1995.

———. "Response: Another Opinion on the State of Chicano Art." *Metamorfosis: Northwest Chicano Magazine of Literature Art and Culture* 4, no.1 (1980/1981): 2–7.

Goldman, Shifra M., and Tomás Ybarra-Frausto. *Arte Chicano: A Comprehensive Annotated Bibliography of Chicano Art, 1965–1981*. Berkeley: University of California Chicano Studies Publications Unit, 1985.

Gómez-Peña, Guillermo. "The Multicultural Paradigm: An Open Letter to the Arts Community." *High Performance* no. 47 (Fall 1989): 21.

Gómez-Quiñones, Juan. *Mexican Students por La Raza: The Chicano Student Movement in Southern California, 1967–1977*. Santa Barbara: Editorial La Causa, 1978.

Gonzalez, David. "Not an Objective Observer." *New York Times*, October 23, 2015.

González, Rita, Howard N. Fox, and Chon A. Noriega. *Phantom Sightings: Art after the Chicano Movement*. Exhibition catalog. Berkeley: University of California Press; Los Angeles: Los Angeles County Museum of Art, 2008.

Griswold del Castillo, Richard, Teresa McKenna, and Yvonne Yarbro-Bejarano, eds. *Chicano Art: Resistance and Affirmation, 1965–1985*. Exhibition catalog. Los Angeles: Wight Art Gallery, UCLA, 1991.

Gunckel, Colin. "Building a Movement and Constructing Community: Photography, the United Farm Workers, and *El Malcriado*." *Social Justice* 42, no. 3–4 (2016): 29–45.

———, ed. *La Raza*. Exhibition catalog. Los Angeles: UCLA Chicano Studies Research Center Press, 2020.

Hassan, Marco. "This Instagram Is an Archive of Rock en Español's Golden Years in Los Angeles." *Remezcla*, May 9, 2018. https://remezcla.com/features/music/rock-archivo-la-instagram.

Hecho en Latinoamérica: Memorias del Primer Coloquio Latinoamericano de Fotografía. Mexico City: Consejo Mexicano de Fotografía, 1978.

Hecho en Latinoamérica: Segundo Coloquio Latinoamericano de Fotografía. Mexico City: Consejo Mexicano de Fotografía, 1981.

Herrera, Isabella. "Preserving Latinx History through Vintage Photos." *New York Times*, August 23, 2019.

hooks, bell. "Choosing the Margin as a Space of Radical Openness." In *Yearnings: Race, Gender and Cultural Politics*. Brooklyn: South End Press, 1989.

Kuusinen, Asta M. *Shooting from the Wild Zone: A Study of the Chicana Art Photographers Laura Aguilar, Celia Álvarez Muñoz, Delilah Montoya, and Kathy Vargas*. Helsinki: Helsinki University Press, 2006.

Le Démon des Anges. Exhibition catalog. Nantes, France: Centre de Recherché pour le Développement Culturel, 1989.

Lippard, Lucy R. *Mixed Blessings: New Art in Multicultural America*. New York: Pantheon Books, 1990.

Livingston, Jane, and John Beardsley. "The Poetics and Politics of Hispanic Art: A New Perspective." In *Exhibiting Cultures: The Poetics and Politics of Museum Display*, edited by Ivan Karp and Steven Lavine. Washington, DC: Smithsonian Institution Press, 1987.

Lloréns, Hilda. *Imaging the Great Puerto Rican Family: Framing Nation, Race, and Gender during the American Century*. Lanham, MD: Lexington Books, 2014.

Martinez, Elizabeth Sutherland. *500 años del pueblo chicano = 500 Years of Chicano History in Pictures*. Albuquerque: South West Organizing Project, 1994.

———. *500 Years of Chicana Women's History = 500 años de historia de las chicanas.* New Brunswick, NJ: Rutgers University Press, 2008.

McCaughan, Edward J. *Art and Social Movements: Cultural Politics in Mexico and Aztlán.* Durham, NC: Duke University of Press, 2012.

Montoya, Malaquias, and Lezlie Salkowitz-Montoya. "A Critical Perspective on the State of Chicano Art." *Metamórfosis: Northwest Chicano Magazine of Literature Art and Culture* 3, no. 1 (1980): 6–7.

Moraga, Cherríe. "Queer Aztlán: The Re-formation of Chicano Tribe." In *The Last Generation: Prose and Poetry.* Boston: South End Press, 1993.

Muñoz, Carlos, Jr. *Youth, Identity, Power: The Chicano Movement.* New York: Verso, 2007.

Noriega, Chon A., ed. *From the West: Chicano Narrative Photography.* Exhibition catalog. San Francisco: Mexican Museum, 1995.

Noriega, Chon A., Eric Avila, Karen Mary Davalos, Chela Sandoval, and Rafael Pérez-Torres, eds. *The Chicano Studies Reader: An Anthology of Aztlán, 1970–2000.* Los Angeles: Chicano Studies Research Center Publications, 2001.

Noriega, Chon, Terezita Romo, and Pilar Tompkins Rivas, eds. *L.A. Xicano.* Exhibition catalog. Los Angeles: UCLA Chicano Studies Research Center Press, 2011.

Nueva fotografía puertorriqueña. Exhibition catalog. San Juan: Museo de la Universidad de Puerto Rico, 1985.

Olmedo-González, Renato. "Making Muralist Jokes: Asco's Contestation of the Mural and Its Challenge to Chicano/a Aesthetics." *Utah Historical Review* 4 (2014). http://epubs.utah.edu/index.php/historia/article/view/1172.

"Oral History Interview with Edwin and Louise Rosskam, 1965 August 3." Archives of American Art, Smithsonian Institution. www.aaa.si.edu/collections/interviews/oral-history-interview-edwin-and-louise-rosskam-13112.

Ortiz, Ralph. "Culture and the People." *Art in America*, May–June, 1971, 27.

Palmquist, Peter E., and Thomas R. Kailbourn. *Pioneer Photographers of the Far West: A Biographical Dictionary, 1840–1865.* Stanford: Stanford University Press, 2002.

Pérez-Torres, Rafael. *Critical Uses of Race in Chicano Culture.* Minneapolis: University of Minnesota Press, 2006.

Poupeye, Veerle. *Caribbean Art.* London: Thames and Hudson, 1998.

Ramos, Carmen, E. *Our America: The Latino Presence in American Art.* Exhibition catalog. Washington, DC: Smithsonian American Art Museum, 2014.

Rasmussen, Waldo, Fatima Bercht, and Elizabeth Ferrer. *Latin American Artists of the Twentieth Century.* Exhibition catalog. New York: Harry N. Abrams and the Museum of Modern Art, 1992.

Robisco, Alonso. *Colección de Fotografía Antigua: Blog sobre Fotografía Antigua y Sus Fotógrafos*, August 7, 2014. http://photoblog.alonsorobisco.es/2014/08/foto-antigua-retrato-de-caballero.html.

Rodríguez, Richard T. *Next of Kin: The Family in Chicano/a Cultural Politics.* Durham, NC: Duke University Press, 2009.

Rodríguez Puerto, Kirenia. "Lente boricua: arte y fotografía del siglo XX." In *Cuadernos Americanos* 156 (2016), 61–87. www.cialc.unam.mx/cuadamer/textos/ca156-61.pdf.

Rowe, Jeremy. "Dudley P. Flanders 'Trip Through Arizona.'" http://vintagephoto.com /reference/flanders/article.html.

Ruiz, Vicki. *From out of the Shadows: Mexican Women in Twentieth-Century America.* New York: Oxford University Press, 1998.

Ruiz, Vicki L., and Virginia Sánchez Korrol, eds. *Latinas in the United States: A Historical Encyclopedia.* Bloomington: Indiana University Press, 2006.

Sánchez Korrol, Virginia. "History of Puerto Ricans in the US—Part Four." Center for Puerto Rican Studies, Hunter College, accessed September 3, 2016. https:// centropr.hunter.cuny.edu/education/story-us-puerto-ricans-part-four.

Sontag, Susan. *On Photography.* New York: Farrar, Straus and Giroux, 1978.

Taller Boricua and the Puerto Rican Art Movement in New York. "History of Taller Boricua 1969–2010." Accessed September 3, 2016. https://tallerboricuatimeline .wordpress.com.

Tatum, Charles, ed. *Encyclopedia of Latino Culture: From Calaveras to Quincañeras.* Santa Barbara: ABC-CLIO/Greenwood, 2013.

Terkenli, Theano S. "Home as a Region." *Geographical Review* 85, no. 3 (July 1995), 324–34.

Time magazine. "Minorities: Pocho's Progress." April 28, 1967, 24–25.

Wilde, Betty, and Charles Biasiny-Rivera. *Island Journey: An Exhibition of Puerto Rican Photography.* Exhibition catalog. Bronx, NY: Hostos Art Gallery, 1995.

Ybarra-Frausto, Tomás. "The Chicano Movement/The Movement of Chicano Art." In *Exhibiting Cultures: The Poetics And Politics of Museum Display*, edited by Ivan Karp and Steven D. Lavine, 129–50. Washington, DC: Smithsonian Institution Press, 1992.

INDIVIDUAL PHOTOGRAPHERS

Manuel Acevedo

Bissen, Sara. "Manuel Acevedo—'In Newark, I can imagine a new building but in decay. The way I see it, the completion is relative.'" *Biourbanism*, March 14, 2017. International Society of Biourbanism. www.biourbanism.org/manuel-acevedo -newark-can-imagine-new-building-decay-way-see-completion-relative.

Cotter, Holland. "Ephermeral Magic Mirrors the Life of a Bronx Center." *New York Times*, August 18, 2010.

Stetler, Carrie, and Manuel Acevedo. "The Wards of Newark." *Hycide*, undated. https://hycide.com/the-wards-of-newark.

Adál

"Adál." *Nueva Luz* 5, no. 2 (1998): 2–11.

Estrin, James. "Puerto Rican Identity, In and Out of Focus." *Lens* (blog), *New York Times*, August 28, 2012.

Jackson, Jhoni. "Powerful Photo Series 'Puerto Ricans Underwater' Is a Biting Metaphor for an Island Drowning in Debt." *Remezcla*, November 28, 2016. http://remezcla .com/features/culture/puerto-ricans-underwater-photos-adal-maldonado.

Maldonado, Adál Alberto. *The Evidence of Things Not Seen*. New York: Da Capo Press, 1975.

Laura Aguilar

Aguilar, Laura. Artist Statement. In *Women Artists of the American West*, accessed August 23, 2015. https://cla.purdue.edu/academic/rueffschool/waaw/Corinne/Aguilar.htm.

———. "Human Nature." *Boom California* 5, no. 2 (Summer 2015). https://boom california.com/2015/08/11/human-nature.

———. *Laura Aguilar: Life, the Body, Her Perspective*. Los Angeles: University of California, Chicano Studies Research Center, 2009. DVD.

Campbell, Andy. "Laura Aguilar, Vincent Price Art Museum, Los Angeles." *Artforum*, January 2018. https://www.artforum.com/print/reviews/201801/laura -aguilar-73194.

Epstein, Rebecca, ed. *Laura Aguilar: Show and Tell*. Curated by Sybil Venegas. Exhibition catalog. Seattle: University of Washington Press, 2017.

Hulick, Diana Emery. "Laura Aguilar." *Latin American Art* 5, no. 3 (1993): 52–54.

Jones, Amelia. "Bodies and Subjects in the Technologized Self-Portrait: The Work of Laura Aguilar." *Aztlán* 23, no. 2 (October 1998): 203–19.

Kuusinen, Asta M. "Comadres Corporation in Labor: Stillness and Motion by Laura Aguilar." In *Shooting from the Wild Zone: A Study of the Chicana Art Photographers Laura Aguilar, Celia Álvarez Muñoz, Delilah Montoya, and Kathy Vargas*, 149–67. Helsinki: Helsinki University Press, 2006.

Laura Aguilar Papers and Photographs, 1981–1995. Stanford University, Stanford, California.

Yarbro-Bejarano, Yvonne. "Laying It Bare: The Queer/Colored Body in Photography by Laura Aguilar." In *Living Chicana Theory, edited by* Carla Trujillo, 277–305. Chicana/Latina Studies Series. Berkeley, CA: Third Woman Press, 1998.

Max Aguilera Hellweg

Aguilera-Hellweg, Max. "La Frontera Sin Sonrisa." In *The Late Great Mexican Border, Reports from a Disappearing Line*, edited by Bobby Byrd. El Paso: Cinco Puntos Press, 1996.

———. *Humanoid*. New York: Blast Books, 2017.

Aguilera-Hellweg, Max, and Richard Selzer. *The Sacred Heart: An Atlas of the Body Seen Through Invasive Surgery*. New York: Bulfinch Press, 1997.

"Max Aguilera-Hellweg." *Nueva Luz* 5, no. 1 (1997): 2–11.

Mario Algaze

Algaze, Mario. *Portfolio Mario Algaze*. Essay by Carol McCusker. Miami Beach: Di Puglia Publisher, 2010.

———. *A Respect for Light: The Latin American Photographs, 1974–2008*. New York: Glitterati, 2014.

Algaze, Mario, and Leah Ollman. *Mario Algaze: Cuba 1999–2000*. New York: Throckmorton Fine Art, 2000.

McCusker, Carol. *Three Visions from Peru*. New York: Throckmorton Fine Art, 2002.

Don Gregorio Antón

"Don Gregorio Antón." *Nueva Luz* 5, no. 2 (1998): 12–21.

Ollin Mecatl: The Measure of Movements. Essay by Hannah Frieser. Exhibition catalog. *Contact Sheet* 145 / Syracuse: Light Work, 2008.

Woodall, Cameron. "Don Gregorio Antón." *Mental Mastication*, November 16, 2005. http://cameronwoodall.blogspot.com/2005/11/don-gregorio-anton.html.

Chuy Benitez

Boryga, Andrew. "Panoramic Photos Show the Decisive Minute." *Lens* (blog), *New York Times*, January 8, 2015.

Louis Carlos Bernal

Bernal, Louis Carlos. *Barrios*. Curated by Ann Simmons-Meyers. Exhibition catalog. Tucson: Pima Community College, in association with the University of Arizona Library, 2002.

Bernal, Louis Carlos, Morrie Camhi, Abigail Heyman, Roger Minick, and Neal Slavin. *Espejo: Reflections of the Mexican American*. Oakland: Oakland Museum, 1978.

"Louis Carlos Bernal." Center for Creative Photography. 2014. https://ccp.arizona.edu /artists/louis-carlos-bernal.

Robert Buitrón

Buitrón, Robert. "Malinche y Pocahontas, Breaking Out of the Picture." In *Born of Resistance: Cara a Cara Encounters with Chicana/o Visual Culture*, edited by Scott L. Baugh and Víctor A. Sorell, 208–14. Tucson: University of Arizona Press, 2015.

"Robert C. Buitrón." *Nueva Luz* 4, no. 2 (1993): 12–21.

Romo, Tere. "The Chicanization of Mexican Calendar Art." Paper presented at the Interpretation and Representation of Latino Cultures: Research and Museums Conference, Smithsonian Institution, Washington DC, November 20–23, 2002. Sematic Scholar (website). https://pdfs.semanticscholar.org/1c46 /989ae770416a01ebe5902971edf1d92349b3.pdf.

Maria Magdalena Campos-Pons

Campos-Pons, María Magdalena. "Becoming FeFa." *Atlántica: Journal of Art and Thought* 57 (2016), unpaginated. www.revistaatlantica.com/en/issue/57-en.

Campos-Pons, María M., and William Luis. "Art and Diaspora: A Conversation with María Magdalena Campos-Pons." *Afro-Hispanic Review* 30, no. 2 (2011): 155–66.

Freiman, Lisa, ed. *María Magdalena Campos-Pons: Everything Is Separated by Water.* New Haven: Yale University Press, 2007.

Harris, Michael D. "Meanwhile the Girls Were Playing: Maria Magdalena Campos-Pons." *NKA: Journal of Contemporary African Art* 13, no. 1 (2001): 48–55.

John Candelario

Coke, Van Deren. *Three Generations of Hispanic Photographers Working in New Mexico: John Candelario, Cavalliere Ketchum, Miguel Gandert.* Exhibition catalog. Taos: Harwood Foundation Museum of the University of New Mexico, 1993.

Lewthwaite, Stephanie. *A Contested Art: Modernism and Mestizaje in New Mexico.* Norman: University of Oklahoma Press, 2015.

Luis Carle

Naughton, Jake. "Gay Life in New York: Between Oppression and Freedom." *Lens* (blog), *New York Times*, June 22, 2017.

Javier Carmona

Yeapanis, Stacia. "OtherPeoplesPixels Interviews Javier Carmona," December 10, 2015. *OtherPeoplesPixels Blog: Website for Artists by Artists.* https://blog.otherpeoples pixels.com/otherpeoplespixels-interviews-javier-carmona.

Oscar Castillo

Castillo, Oscar, and Colin Gunckel. *The Oscar Castillo Papers and Photograph Collection.* Los Angeles: UCLA Chicano Studies Research Center Press, 2011.

Gamboa, Harry, Jr. "Reflecting Youthful Optimism in Double Negatives: The Photographic Archive of Oscar Castillo." In *L.A. Xicano*, edited by Chon A. Noriega,

Terezita Romo, and Pilar Tompkins Rivas, 62–69. Los Angeles, CA: UCLA Chicano Studies Research Center Press, 2011.

"Icons of the Invisible: Oscar Castillo and Mapping Another L.A." In *L.A. Xicano*, edited by Chon A. Noriega, Terezita Romo, and Pilar Tompkins Rivas, 128–39. Los Angeles: UCLA Chicano Studies Research Center Press, 2011.

Saldivar, Steve. "Why Oscar Castillo's Photos of Chicano Life and Protest Are Essential for Understanding L.A.," *Los Angeles Times*, December 5, 2012.

Isabel Castro

Fajardo-Hill, Cecilia, and Andrea Giunta. *Radical Women: Latin American Art, 1969–1985*. Exhibition catalog. Los Angeles: Hammer Museum, University of California, 2017.

Maximo Colon

Block, Holly, Johanna Fernández, Yasmin Ramírez, Rocío Aranda-Alvarado, Libertad O. Guerra, Wilson Valentín-Escobar, and Frances Negrón-Muntaner. *¡Presente! The Young Lords in New York*. Exhibition catalog. Bronx, NY: Bronx Museum of the Arts, 2015.

Arturo Cuenca

Cuenca, Arturo. *Arturo Cuenca: A Decade of Photographs, 1983–1993*. Exhibition catalog. New York: INTAR Latin American Gallery, 1993.

Cuenca, Arturo, and Gerardo Mosquera. *Arturo Cuenca: Modernbundo*. Mexico City: Galería de Arte Mexicano, 1990.

Menocal, Nina. "La fotografía es todo en mi obra." In *Fin*. Mexico City: Galería Nina Menocal, 1993.

Jack Delano

Delano, Jack. *Photographic Memories*. Washington, DC: Smithsonian Institution Press, 1997.

———. *The Photographs of Jack Delano*. Washington, DC: Giles, 2010.

———. *Puerto Rico Mío: Four Decades of Change*. Washington, DC: Smithsonian, 1990.

Doud, Richard. "Oral History Interview with Jack and Irene Delano, 1965 June 12." Washington, DC: Archives of American Art, Smithsonian Institution, 2018. https://www.aaa.si.edu/collections/interviews/oral-history-interview-jack-and-irene-delano-13026.

Gonzalez, David. "Jack Delano." *Lens* (blog), *New York Times*, October 13, 2011.

Jack and Irene Delano Collection, Latino Arts and Activism Archive, Rare Book and Manuscript Library, Columbia University, New York.

Rivera, Nelson. *Visual Artists and the Puerto Rican Performing Arts, 1950–1990: The Works of Jack and Irene Delano, Antonio Martorell, Jaime Suárez, and Oscar Mestey-Villamil*. New York: P. Lang, 1997.

Perla de León

Noriega, Chon A., Mari Carmen Ramírez, and Pilar Tompkins Rivas. *Home—So Different, So Appealing*. Exhibition catalog. Los Angeles: Los Angeles County Museum of Art, 2017.

Luis Delgado Qualtrough

Delgado, Luis. *Unfathomable Humanity*. San Francisco: Califrisco Press, 2006.

Delgado, Luis, Fernando Castro, and Miguel Mestres. *Stratigraphies*. San Francisco: Malulu Editions, 2016.

Fabry, Alexis, and María Wills. *Pulsions urbaines, 1962–2017: L'Amérique Latine en mouvement*. Exhibition catalog. Arles: Les Recontres de la Photographie, 2017.

Frank Espada

Espada, Frank. *The Puerto Rican Diaspora: Themes in the Survival of a People*. San Francisco: Frank Espada, 2006.

Espada, Jason. "A Sketch of Frank Espada's Life." *Living in Beauty: Writing, Music, and Spoken Word by Jason Espada* (website), August 29, 2016. www.jasonespada.com/a-sketch-of-frank-espadas-life.

Frank Espada Photographs and Papers, 1946–2010. Rubenstein Library, Duke University, Durham, NC.

Gonzalez, David. "Parting Glance: Frank Espada." *Lens* (blog), *New York Times*, February 20, 2014.

———. "Showcase: The Puerto Rican Diaspora," *Lens* (blog), *New York Times*, November 5, 2009.

Christina Fernandez

Fernandez, Christina. *Ruin*. Exhibition catalog. Los Angeles: Los Angeles Center for Photographic Studies, 1999.

Noriega, Chon A., ed. *From the West: Chicano Narrative Photography*. Exhibition catalog. San Francisco: Mexican Museum, 1996.

Noriega, Chon A., Mari Carmen Ramírez, and Pilar Tompkins Rivas. *Home—So Different, So Appealing*. Exhibition catalog. Los Angeles: Los Angeles County Museum of Art, 2017.

Carlos Flores

Flores, Carlos. "Capturing the Images of Chicago's Puerto Rican Community." *Centro Journal* 13, no. 2 (2001). www.redalyc.org/articulo.oa?id=37711308010.

Elsa Flores

Carlos Almaraz and Elsa Flores Papers, 1946–1996. Washington, DC: Archives of American Art, Smithsonian Institution, 2018. https://www.aaa.si.edu/collections /carlos-almaraz-and-elsa-flores-papers-5408.

Noriega, Chon A., curator. *East of the River: Chicano Art Collections Anonymous.* Exhibition catalog. Santa Monica, CA: Santa Monica Museum of Art, 2000.

"Oral History Interview with Elsa Flores, 1997 Feb. 18–Apr. 30." Washington, DC: Archives of American Art, Smithsonian Institution, 2018. https://www.aaa.si.edu /collections/interviews/oral-history-interview-elsa-flores-13559.

Ángel Franco

Cerroti, Rachel. "Seis del Sur: Six Nuyorican Photographers Reclaim the Identity of the Bronx." *ivoh*, March 21, 2016. https://ivoh.org/story/seis-del-sur-six-nuyorican -photographers-reclaim-the-identity-of-the-bronx.

Estrin, James, and Ángel Franco. "Cops, Neighbors, and a Camera in Between." *Lens* (blog), *New York Times*, June 24, 2010.

Harry Gamboa Jr.

Chavoya, C. Ondine, Rita González, David E. James, Amelia Jones, Chon A. Noriega, Jesse Lerner, and Deborah Cullen. *ASCO—Elite of the Obscure: A Retrospective, 1972–1987.* Exhibition catalog. Ostfildern, Germany: Hatje Cantz, 2011.

Gamboa, Harry, Jr. *Urban Exile: Collected Writings of Harry Gamboa Jr.* Ed. Chon A. Noriega. Minneapolis: University of Minnesota Press, 1998.

"Harry Gamboa Jr.: Chicano Male Unbonded." KCET Online, September 20, 2017. https://m.youtube.com/watch?v=Z5PLyNANL8Q. Video.

Harry Gamboa Jr. Papers, 1968–1995. Oakland: Online Archive of California, 2018.

Harry Gamboa Jr. Photographs, 1971–1995. Department of Special Collections and University Archives, Stanford University Special Collections, Stanford, CA.

"Oral History Interview with Harry Gamboa Jr., 1999 Apr. 1–16." Washington, DC: Archives of American Art, Smithsonian Institution, 2018. https://www.aaa.si.edu /download_pdf_transcript/ajax?record_id=edanmdm-AAADCD_oh_216608.

Miguel Gandert

Coke, Van Deren. *Three Generations of Hispanic Photographers Working in New Mexico:*

John Candelario, Cavalliere Ketchum, Miguel Gandert. Exhibition catalog. Taos: Harwood Foundation Museum of the University of New Mexico, 1993.

Gandert, Miguel A. *Nuevo Mexico Profundo: Rituals of an Indo-Hispano Homeland*. Santa Fe: Museum of New Mexico Press, 2000.

———. "Retratos de Mestizaje: A Photographic Survey of Indo-Hispanic Traditions of the Rio Grande Corridor." In *Nuevomexicano Cultural Legacy: Forms, Agencies, and Discourses*, edited by Francisco A. Lomeli, Victor A Sorell, and Genaro M. Padilla, 73–90. Albuquerque: University of New Mexico Press, 2002.

Howarth, Sam, Enrique R. Lamadrid, and Miguel A. Gandert. *Pilgrimage to Chimayo: Contemporary Portrait of a Living Tradition*. Santa Fe: Museum of New Mexico Press, 1999.

Kurland, Catherine L., and Enrique R. Lamadrid. *Hotel Mariachi: Urban Space and Cultural Heritage in Los Angeles*. Albuquerque: University of New Mexico Press, 2013.

Miguel Gandert Photographs, circa 1975–1998. Department of Special Collections, Stanford University Libraries, Stanford, CA.

René Gelpi

Gelpi, René. "A Loner Looks In." *Nuestro*, October 1977, 33–36.

Ken Gonzales-Day

Fox, Howard N. "Ken Gonzales-Day." In *Phantom Sightings: Art After the Chicano Movement*, edited by Rita González, Howard N. Fox, and Chon A. Noriega, 160–63. Berkeley: University of California Press, 2008.

Gonzales-Day, Ken. *Hang Trees*. Claremont, CA: Pomona College Museum of Art, 2006.

———. *Lynching in the West, 1850–1935*. Durham, NC: Duke University Press, 2006.

David Gonzalez

Gonzalez, David. "Faces in the Rubble." *New York Times*, August 21, 2009.

———. "From the Archive: Bronx Street Art." *Lens* (blog), *New York Times*, August 24, 2009. https://lens.blogs.nytimes.com/2009/08/24/archive-3.

Felix Gonzalez-Torres

Corrin, Lisa. *Felix Gonzalez-Torres*. London: Serpentine Gallery, 2000.

Drutt, Matthew. *Felix Gonzalez-Torres: Billboards*. San Antonio: Radius Books/Artpace, 2015.

Elger, Deitmar, et al. *Felix Gonzalez-Torres*. Catalogue Raisonné. Ostfildern: Hatje Cantz, 1997.

Fuentes, Elvis. "Breve Cronología de Félix González Torres en Puerto Rico, 1978–88." *Revista del Instituto de Cultura Puertorriqueña, Segunda serie* 5, no. 10 (2004), 50–59.

———. "Félix González-Torres in Puerto Rico: An Image to Construct." *Art Nexus* no. 59, vol. 4 (2005), 91–94.

Rosen, Andrea. "Untitled (The Neverending Portrait)." In *Felix Gonzalez-Torres: Catalogue Raisonné*, edited by Dietmar Elger. Ostfildern, Germany: Cantz Verlag, 1997.

Spector, Nancy, *Felix Gonzalez-Torres*. Exhibition catalog. New York: Solomon R. Guggenheim Museum, 2007.

Gory

Camnitzer, Luis. *New Art of Cuba*. Austin: University of Texas Press, 1994.

"Gory." *Nueva Luz* 8, no. 3 (2003).

Wride, Tim B. *Shifting Tides: Cuban Photography after the Revolution*. Exhibition catalog. Los Angeles: Los Angeles County Museum of Art, 2001.

Pedro Guerrero

Guerrero, Pedro E. *A Photographer's Journey*. New York: Princeton Architectural Press, 2007.

———. *Picturing Wright: An Album from Frank Lloyd Wright's Photographer*. New York, NY: Pomegranate Press, 1993.

Johnson, Suzanne D., dir. *Pedro E. Guerrero: Portrait of an Image Maker*. Documentary. Gnosis Ltd., 2012.

Yardley, William. "Pedro Guerrero, Who Captured Art in Photos, Dies at 95." *New York Times*, September 13, 2012.

Martine Gutierrez

Scott, Andrea K. "A Trans Latinx Artist's High-Fashion Critique of Colonialism." *New Yorker*, October 20, 2018.

Muriel Hasbun

Afshar, Sareh. "Tracing the Image, Imagining the Trace: Seeing Through, Looking Between, Feeling Muriel Hasbun's X post facto." *E-Misférica Multimedios* 9, nos. 1, 2 (2012).

Gates, Jeff. "Preparing for Our America: Close to Home: Muriel Hasbun and Washington D.C.'s Salvadoran Community." *EyeLevel*, September 14, 2013. https://americanart.si.edu/blog/eye-level/2013/12/584/preparing-our-america-close-home-muriel-hasbun-and-washington-dcs.

[Gates], Jeff, and Muriel Hasbun. "Five Questions with Photographer Muriel Hasbun." *Eye Level* (blog), Smithsonian American Art Museum, December 12, 2013. https://

americanart.si.edu/blog/eye-level/2013/12/564/five-questions-photographer-muriel-hasbun.

Grundberg, Andy. "Protegida (Watched Over): Muriel Hasbun's Postmemory Project." Review of *Memento: Muriel Hasbun Photographs*, exhibition, Corcoran Gallery of Art, Washington, DC, March 6–June 7, 2004. http://memento.murielhasbun.com/Asset.asp?AssetID=2653&AKey=HL568XD9.

Hirsch, Marianne. *The Generation of Postmemory: Writing and Visual Culture after the Holocaust*. New York: Columbia University Press, 2012.

Ramos, Carmen E. *Our America: The Latino Presence in American Art*. Exhibition catalog. Washington, DC: Smithsonian American Art Museum, 2014.

Rassmussen, Jack. *The Looking Glass: Artist Immigrants of Washington*. Exhibition catalog. Washington, DC: Alper Initiative for Washington Art, American University Museum, 2016.

Roth, Paul. *Memento: Muriel Hasbun Photographs*. Exhibition catalog. Washington, DC: Corcoran Gallery of Art, 2004.

Martina Lopez

Lopez, Martina. *Digital Allegory*. Syracuse, NY: Light Work, 1999.

Skopik, Steve. "Digital Photography: Truth, Meaning, Aesthetics." *History of Photography* 27, no. 3 (2003): 264–71.

Travis, David. "Between Reason: Martina Lopez." In *Between Reason*, exhibition brochure. South Bend: Crossroads Gallery for Contemporary Art, 2013.

Adál Maldonado

Maldonado, Adál. *The Evidence of Things Not Seen*. New York: Da Capo Press, 1975.

Luis Mallo

Mallo, Luis. *In Camera 2001–2002*. Exhibition catalog. New York: Praxis International Art, 2003.

Yochelson, Bonnie. "Hand Signals." *New York Times*, October 29, 2008.

Hiram Maristany

AFineLyne. "Mapping Resistance: The Young Lords in El Barrio—Images by Hiram Maristany, Presented by Miguel Luciano." *GothamToGo: Art and Culture* (website), May 19, 2019. https://gothamtogo.com/mapping-resistance-the-young-lords-in-el-barrio-images-by-hiram-maristany-presented-by-miguel-luciano.

Block, Holly, Johanna Fernández, Yasmin Ramírez, Rocío Aranda-Alvarado, Libertad O. Guerra, Wilson Valentín-Escobar, and Frances Negrón-Muntaner. *¡Presente!*

The Young Lords in New York. Exhibition catalog. Bronx, NY: Bronx Museum of the Arts, 2015.

Luciano, Felipe, and Hiram Maristany. "The Young Lords Party, 1969–1975." *Caribe* 7, no. 4 (1983): 1–32.

María Martínez Cañas

Brooks, Johnson. *Photography Speaks: 150 Photographers on their Art.* Norfolk, VA: Chrysler Museum of Art, 2004.

"Cuba: Image and Imagination." *Aperture*, no. 141 (Fall 1996).

Flores, Tatiana. "Inscribing into Consciousness: The Work of Caribbean Art." In *Relational Undercurrents: Contemporary Art of the Caribbean Archipelago*, edited by Tatiana Flores and Michelle A. Stephens. Long Beach, CA: Museum of Latin American Art, 2017.

Kuspit, Donald. *Cuba of Her Mind: María Martínez Cañas's Photographic Constructions.* Exhibition catalog. Los Angeles: Iturralde Gallery, 1994.

"María Martínez Cañas." *Nueva Luz* 9, no. 3 (2003).

Frieda Medín

Fajardo-Hill, Cecilia, and Andrea Giunta. *Radical Women: Latin American Art, 1969–1985.* Exhibition catalog. Los Angeles: Hammer Museum, University of California, 2017.

González-Torres, Félix. "Frida [sic] Medin: Una imagen reconstruida." *El Mundo, Puerto Rico Ilustrado*, April 3, 1988.

Medín, Frieda. *Imágenes arrancadas.* Exhibition catalog. San Juan: Liga de Arte, 1984.

Negrón-Muntaner, Frances. "Of Lonesome Stars and Broken Hearts: Trends in Puerto Rican Women's Film/Video Making." In *New Latin American Cinema*, vol. 2, edited by Michael T. Martin, 252. Detroit: Wayne State University Press, 1997.

Luis Medina

Medina, Luis, and David Travis. *Facts and Fables by Luis Medina, Photographer.* Exhibition catalog. Chicago: Art Institute of Chicago, 1993.

Groana Melendez

"Groana Melendez." *Nueva Luz* 14, no. 3 (2010): 2–9.

Héctor Méndez Caratini

Alegría-Pons, José Francisco. *Gagá y Vudú en la República Dominicana.* San Juan: Ediciones El Chango Prieto, 1993.

Caratini, Héctor Méndez. *The Eye of Memory: Three Decades, 1974–2003.* San Juan: Museo de Arte de Puerto Rico, 2004.

———. *Haciendas Cafetaleras de Puerto Rico*. San Juan: Museo de Arte e Historia del Municipio de San Juan, 1998.

———. *Orixás: Cachoeira e Salvador Bahía, Brasil*. Ponce: Museo de Arte de Ponce, 1997.

———. *Tradiciones: Album de la Puertorriqueñidad*. San Juan: Brown, Newsom, and Córdova, 1990.

———. *Vaqueriando: Rodeo Caliente*. Exhibition brochure. San Juan: Instituto de Cultura Puertorriqueña, 2002.

Rodríguez Juliá, Edgardo. "El arte de Héctor Méndez Caratini." *El Nuevo Día*, June 9, 2018. https://www.elnuevodia.com/opinion/columnas/elartedehector mendezcaratini-columna-2427060.

Vieques: Crónicas del Calvario. Zone Zero (website). www.zonezero.com/exposiciones /fotografos/vieques/indexsp.html.

Viera, Ricardo, and Héctor Méndez Caratini. "Entrevista entre el curador Ricardo Viera y el fotógrafo," accessed December 8, 2017. www.hectormendezcaratini.com.

Ana Mendieta

Ana Mendieta. Barcelona: Ediciones Polígrafa, 2001.

Del Rio, Petra Barreras, and John Perreault, eds. *Ana Mendieta: A Retrospective*. Exhibition catalog. New York: New Museum of Contemporary Art, 1987.

Moure, Gloria. *Ana Mendieta*. Santiago de Compostela: Centro Galego de Arte Contemporánea; Barcelona: Ediciones Polígrafa, 1996.

Viso, Olga M. *Ana Mendieta: Earth Body Sculpture and Performance 1972 -1985*. Exhibition catalog. Washington, DC: Hirshhorn Museum and Sculpture Garden Smithsonian Institution, 2004.

Tony Mendoza

Mendoza, Tony. *Cuba: Going Back*. Austin: University of Texas Press, 1999.

———. *Ernie: A Photographer's Memoir*. San Francisco: Chronicle Books, 2001.

———. *Flowers*. Portland, OR: Nazraeli Press, 2007.

Néstor Millán

"Nestor Millan." *Nueva Luz* 2, no. 3 (1998): 22–31.

Karen Miranda-Rivadeneira

Dykstra, Jean. "Portfolio: Karen Miranda de Rivadeneira." *Photograph* (Jan.–Feb. 2018).

Ferrer, Elizabeth. "Karen Miranda-Rivadeneira." *Contact Sheet 172: Light Work Annual 2013* (August).

Gonzalez, David. "Visualizing Magic Realism in Ecuador." *Lens* (blog), *New York Times*, January 4, 2018.

Lockward, Alanna, and Karen Miranda Rivadeneira. *Other Stories / Historia Bravas: Karen Miranda Rivadeneira*. London: Autograph, 2018.

"New Works / Crossing Boundaries." Special issue. *Nueva Luz* 17, no. 2 (2013).

Delilah Montoya

Biasiny-Rivera, Charles. "Delilah Montoya: Portfolio." *Nueva Luz* 5, no. 3 (1998).

Buitrón, Robert, ed. *Chicanolandia*. Exhibition catalog. Phoenix: Mars Art Space, 1993.

Galindo, Delma Leticia, and María Dolores Gonzales, eds. *Speaking Chicana: Voice, Power, and Identity*. Tucson: University of Arizona Press, 1999.

Montoya, Delilah. Artist Statement. In *Women Artists of the American West*, accessed July 26, 2019. www.cla.purdue.edu/academic/rueffschool/waaw/ressler/artists/montoyastat.html.

———. *Codex Delilah: A Journey from Mechica to Chicana*. San Francisco: Mexican Museum, 1992.

———. *Contemporary Casta Portraiture: Nuestra "Calidad."* Houston: Arte Público Press, 2017.

———. "The Pinto's Flayed Hide: La Guadalupana by Delilah Montoya." In *Shooting from the Wild Zone: A Study of the Chicana Art Photographers Laura Aguilar, Celia Álvarez Muñoz, Delilah Montoya, and Kathy Vargas*, edited by Asta M. Kuusinen, 218–35. Helsinki: Helsinki University Press, 2006.

———. "Using a Cultural Icon to Explore a People's Heart." *Nieman Reports*, June 15, 2001. https://niemanreports.org/articles/using-a-cultural-icon-to-explore-a-peoples-heart.

———. *Women Boxers: The New Warriors.* Houston: Arte Público Press, 2006.

Abelardo Morell

Morell, Abelardo. *Abelardo Morell*. New York: Phaidon Press, 2005.

———. *Abelardo Morell*. New York: Edwyn Houk Gallery, 2018.

———. *Abelardo Morell and the Camera Eye*. San Diego: Museum of Photographic Arts, 1999.

———. *A Book of Books*. New York: Bulfinch Press, 2002.

———. *Camera Obscura: Monograph.* New York: Bulfinch Press, 2004.

Siegel, Elizabeth, Brett Abbott, and Paul Martineau. *Abelardo Morell: The Universe Next Door*. Chicago: Art Institute of Chicago, 2013.

Rachelle Mozman

Aranda-Álvarado, Rocio. "Bodies of Color: Images of Women in the Works of Firelei Baez and Rachelle Mozman." *Small Axe* 7, no. 4 (March 2017).

"Rachelle Mozman." *Nueva Luz* 16, no. 1 (2012): 20–27.

Eduardo Muñoz

Ferrer, Elizabeth. "Eduardo Muñoz." *Art Lies* 34 (spring 2002).

Jaime Permuth

"Jaime Permuth." *Nueva Luz* 15, no. 3 (2011): 16–23.
Permuth, Jaime. *Yonkeros.* Madrid: La Fábrica, 2013.

Chuck Ramirez

Barilleaux, René Paul, Elizabeth Ferrer, and Edward Hayes. *All This and Heaven Too.* Exhibition catalog. San Antonio: McNay Art Museum, 2017.
Colpitt, Francis. "Chuck Ramirez in Memoriam." *Art Lies* 68 (2017).
Ruiz-Healy, Patricia. "Reminiscing about Chuck Ramirez: A Conversation between Patricia Ruiz-Healy . . . and Ethel Shipton . . . , recorded July 4, 2017." In *Chuck in Context*, edited by Patricia Ruiz-Healy. San Antonio: Ruiz-Healy Art, 2017. https://www.dropbox.com/s/h6nhntouxle2vm9/2017_Catalogue_Chuck%20in%20Context_Ruiz-Healy%20Art.pdf?dl=0.
Siegel, Katy. "First Take: Katy Siegel on Chuck Ramirez." *Artforum*, January 2003.

Sophie Rivera

Vapors: *Photographs by Sophie Rivera and Rafael Ramirez.* Exhibition catalog. Bronx, NY: En Foco Press, 1980.

George Rodriguez

Rodriguez, George, and Josh Kun. *Double Vision: The Photography of George Rodriguez.* Los Angeles: Hat and Beard Press, 2018.

Joseph Rodriguez

Rodriguez, Joseph A. *East Side Stories: Gang Life in East L.A.* New York: PowerHouse Books, 2002.
———. *Juvenile.* New York: PowerHouse Books, 2004.
———. *Still Here: Stories after Katrina.* New York: PowerHouse Books, 2008.
Squarci, Gaia. "Joseph Rodriguez: Twenty Years of Portraits from Another America." *New Yorker*, June 7, 2012.

Juan Sánchez

Anreus, Alejandro. "An Icon of Resistance." *Ars Atelier* (Spring 1999): 5.
Ferrer, Elizabeth. *¿Juan Sánchez: What's the Meaning of This?* Exhibition catalog. Brooklyn, NY: BRIC, 2015.

Hobbs, Jack A., and Duncan, Robert L. *Arts, Ideas, and Civilization*. Englewood Cliffs, NJ: Prentice Hall, 1992.

Juan Sánchez: Printed Convictions (Convicciones Grabadas); Prints and Related Works on Paper (Grabados y Obras en Papel). Jersey City, NJ: Jersey City Museum, 1998.

Luciano, Miguel. "The Amnesia of History: A Discussion with Juan Sanchez." June 22, 2001. *National Forum* 81, no. 3 (Summer 2001), 27, *Gale Academic Onefile*, https://go.gale.com/ps/anonymous?id=GALE%7CA78438422.

Wilkinson, Michelle Joan. "Haciendo Patria: The Puerto Rican Flag in the Art of Juan Sánchez." *Small Axe* 8, no. 2 (September 2004): pp. 61–83.

John Valadez

Canejo, Cynthia Marie. "Chicano Art and Beyond: John Valadez and the Effects of Photomontage." *Delaware Review of Latin American Studies* 17, no. 3 (2016).

"John Valadez—In His Own Words." Latinopia, March 6, 2010. http://latinopia.com/latino-art/john-valadez.

John Valadez interview with Karen Mary Davalos, November 19 and 21 and December 3, 7, and 12, 2007, Los Angeles, California. CSRC Oral Histories Series, no. 10. Los Angeles: UCLA Chicano Studies Research Center Press, 2013.

"Oral History Interview with John Valadez, 1996 November 25–1997 May 12." Washington, DC: Archives of American Art, Smithsonian Institution, 2018. https://www.aaa.si.edu/collections/interviews/oral-history-interview-john-valadez-13565.

Valadez, John, Kathryn Kanjo, and Cris Scorza. *Santa Ana Condition: John Valadez*. Exhibition catalog. San Diego: Museum of Contemporary Art, 2012.

Ricardo Valverde

Durón, Armando. "Ricardo Valverde's 'Solo Landing.'" *Brooklyn & Boyle*, May 2014. www.brooklynboyle.com/2014/05/ricardo-valverdes-solo-landing.html.

García, Ramón. "Ricardo Valverde." *A Ver: Revisioning Art History* 8 (July 2013).

Fajardo-Hill, Cecilia, Armando Cristeto Patiño, and Jesse Lerner. *Ricardo Valverde: Experimental Sights, 1971–1996*. Foreword by Karen Rapp and Chon A. Noriega. Exhibition catalog. Los Angeles: UCLA Chicano Studies Research Center Press, 2014. www.chicano.ucla.edu/files/Valverde_catalog.pdf.

Richard Valverde Digital Image Collection, UCLA Chicano Studies Research Center Library, Los Angeles, CA.

Kathy Vargas

"Kathy Vargas." *Nueva Luz* 4, no. 2 (1993): 2–11.

Lippard, Lucy, and MaLin Wilson-Powell. *Kathy Vargas: Photographs, 1971–2000*. Exhibition catalog. [San Antonio]: Marion Koogler McNay Art Museum, 2001.

Vargas, Kathy. "Behold the Unblinking Eye: My Alamo." In *Shooting from the Wild Zone: A Study of the Chicana Art Photographers Laura Aguilar, Celia Álvarez Muñoz, Delilah Montoya, and Kathy Vargas*, edited by Asta M. Kuusinen. Helsinki: Helsinki University Press, 2006.

———. "Revisiting My Alamo." In *Born of Resistance: Cara a Cara Encounters with Chicana/o Visual Culture*, edited by Scott L. Baugh and Víctor A. Sorell, 190–207. Tucson: University of Arizona Press, 2015.

Víctor Vázquez

Alonso, Rodrigo, Rosina Cazali, María A. Lovino, and Liliana Martínez. *No Sabe / No Contesta: Prácticas Fotográficas. Contemporáneas desde Ameríca Latina*. Buenos Aires: Ediciones Arte y Arte, 2008.

Brodsky, Marcelo, Julio Pantoja, Diana Taylor, and Rossana Reguillo. *Body Politics: Prácticas del cuerpo en la fotografía latino americana*. Buenos Aires: DAP, 2009.

Castellote, Alejandro, Juan Antonio Molina, and Iván de la Nuez. *Mapas abiertos*. Barcelona: Lunwerg, 2003.

Fajardo-Hill, Cecilia, Idurre Alonso, and Alejandro Castellanos. *Changing the Focus, 1995–2005: Latin American Photography*. Long Beach: Museum of Latin American Art, 2011.

Ferrer, Elizabeth. "Víctor Vázquez." *Art Nexus* 2, no. 51 (December 2003): 96–101.

Hartup, Cheryl, Michelle Dalmace, and Antonio Zaya. *Víctor Vázquez, 1989–2007*. Exhibition catalog. Ponce: Museo de Arte de Ponce, 2007.

Melis, Wim, curator. *Mundos Creados: Photography from Latin America*. Groningen: Noorderlicht, 2002.

Purcell, Marilú. *Contexto Puertorriqueño: Del Rococo Colonial al Arte Global*. Santurce: Museo de Arte de Puerto Rico, 2007.

Sánchez, Luis Rafael, and Domingo García. *El Reino de la Espera*. San Juan: Galería Latino Americana, 1990.

Sánchez, Suset, and Caroline Picart. *Dislocation, Encounter, Displacement*. Exhibition catalog. Philadelphia: Seraphin Gallery, 2010.

Still Life: The Body as Object in Contemporary Photography. Exhibition brochure. New York: American Society, 1995.

Victor Vazquez, en Busca del Rostro Perdido. Exhibition brochure. Havana: Bienal de la Habana, 1995.

Zaya, Antonio. *Liquids and Signs*. Exhibition catalog. Madrid: Walter Otero Gallery, 2005.

Veteranas and Rucas

Rosales, Guadalupe. "Why I Started This Project." *Veteranas and Rucas* (website), accessed August 19, 2017. www.veteranasandrucas.com.

Index of Latinx Photographers

Page numbers in *italic* refer to illustrations.

General Index

Page numbers in *italic* refer to illustrations.

Vietnam War, 16, 20, 25, 38, 67, 69,
204n12; Chicano Moratorium, 20, 23,
25, 70
Virgin of Guadalupe, 16, 27, *91*, 92–93

Waldrop Photo Company, 179
war photography, 177
Washington, DC, *34*, 135; *CARA* exhibi-
tion, 66; Hasbrun, 122–23; March on
Washington (1963), 33, 34

Weems, Carrie Mae, 162
Weston, Edward, 10
Works Progress Administration (WPA),
181
Wright, Frank Lloyd, 11
Wyman, H. W., 179

Yampolsky, Mariana, xx
Young Lords, 28–39, *40*, 84–85

The Jacob Lawrence Series on American Artists